photo-offset lithography

by

Z. A. Prust

Professor of Technology
Division of Technology
Arizona State University, Tempe

South Holland, Illinois
THE GOODHEART-WILLCOX COMPANY, INC.
Publishers

Example of four-color printing produced by the photo-offset lithographic process, taken from the textbook Small Gas Engines by Al Roth.

Copyright 1977
by

THE GOODHEART-WILLCOX CO., INC.

No part of this book may be reproduced in any form
without violating the copyright law. Printed in U.S.A.
Library of Congress Catalog Card Number 77—21607.
International Standard Book Number 0—87006—240—9.

23456789—77—54321098

Library of Congress Cataloging in Publication Data

Prust, Z. A.
 Photo-offset lithography.

 Includes index.
 1. Photolithography. I. Title.
TR940.P77 686.2'325 77—21607
ISBN 0—87006—240—9

INTRODUCTION

This text will acquaint the beginner with the printing process called photo-offset lithography. Each unit is exploratory and should be considered as a part of the total process.

During the last few years, photo-offset lithography has become the major graphic communications process in the United States. No task is too large or too small for the offset method. It is used on large web presses and on small office duplicators.

Along with this growth in popularity there have been many technological changes. These changes continue within the industry and make graphic communications careers very exciting. These jobs are essential to our vast communications system.

The units are planned to carry you through the tasks required to complete a printed product. Photographs and illustrations are used to help you understand each idea and each step more clearly.

Now, let us look at the challenging graphic communications industry.

Z. A. Prust

CONTENTS

Good example of an architectural rendering reproduced in four colors by the photo-offset lithographic process, taken from the textbook ARCHITECTURE by Clois Kicklighter.

Unit 1

LOOKING AT THE PROCESS

Graphic communications is very much a part of nearly everyone's life. What would the world be like without printed books, newspapers, magazines, posters, paper money, labels to identify products or contents, printing on packages, gift wrapping, greeting cards, business cards, business forms and checks.

That is only the beginning. We can add many more items to this list, but you can already see how indispensable printing is.

Many of these items are made by the process we call photo-offset lithography. By this printing method, we are able to put an image on such common materials as paper, plastic and metal.

The image can be just a word or words. But many times we combine words, pictures or illustrations (drawings) on a printed page. In the units to follow you will learn how this is done.

FLAT SURFACE PRINTING

One problem is the confusing "labels" or names given the process. You will hear such terms as: "lithography," "offset," "photo-offset," "offset lithography" or "photo-offset lithography." These are all names used loosely for the same process.

To add to the confusion, there is a more technically correct term, PLANOGRAPHY. Planography means printing from a flat surface. It works because of the principle that oil and water do not readily mix. Part of the surface is oily and the other parts are kept wet. If you place an image on this flat surface and, in place of oil, use printing ink, the ink will adhere to

the image area. The image may be words, drawings or photographs. The non-image area must be moistened so that ink will not adhere (stick) to it.

If this is hard to understand, take a crayon and draw on a piece of clean aluminum. Now moisten the aluminum with water. Note that the moisture will not adhere to the crayon drawing. If you put ink on the image area of the aluminum sheet before the moisture dries, the printing ink will adhere to the crayon lines. But it will not stick to the aluminum sheet surface. The ink can now be transferred to material such as paper. See Fig. 1-1.

This very simple technique, just described, shows how this kind of printing works. We can

Fig. 1-1. Transferring ink to paper. The top roller has the plate attached to it. The second roller picks up the image and transfers it to the paper as the paper moves through the second and third rollers. Do you see that the middle roller turns in a different direction?

7

apply this same principle to production techniques used in the graphic communications industry.

We shall attach an IMAGE CARRIER (printing plate) to a cylinder on a printing press. The image carrier will come in contact with moisture rollers and then ink rollers. The inked image is rolled against a second cylinder covered by a blanket (a rubber or synthetic surfaced piece of cloth). The plate image is transferred to this blanket. Another cylinder holds the paper and presses it tightly to the image on the blanket. The result is the transfer of an image to paper, as shown in Fig. 1-2.

Placing an image on the paper takes only a few seconds. But to prepare all of the materials necessary to have a finished product requires time and many steps.

HOW LITHOGRAPHY BEGAN

The term LITHOGRAPHY has been with us for some time. It started when a young Bohemian playwright, Alois Senefelder, invented lithography in 1798. Lithography means "stone writing."

Senefelder found that he could print off stone on which he had laid an oily image. When an inked roller was passed over the wet stone surface, only the oily parts would pick up the ink. By pressing a sheet of paper over the stone he got a good printing impression. By first wetting and then inking the stone he could get many more impressions as good as the first.

The method was slow and required great patience. Little wonder that stone was replaced long ago as an image carrier. But the name "litho" (meaning stone) remains and the principle behind the process is the same: oil and water do not readily mix.

As the carrier changed, so have other parts of the process. In Senefelder's time, pictures had to be drawn by artists. Nearly 65 years later, the first photograph was reproduced on the printing press. Since then, photography and

Fig. 1-2. Examples of products printed by photo-offset lithography.

lithography have become inseparable. Lithographic printing could not survive without photography. It is used both to produce the original picture and to prepare the picture as an ink carrying image for the press.

Another change is in the types of printing equipment. Today's presses, Fig. 1-3, are very large and run at very high speeds to meet the needs of production for thousands of impressions an hour.

THE PROCESS CAMERA

The camera used to prepare copy for reproduction on the modern press is much larger than the one used to take pictures. Its job is to reproduce the tonal range (varying degress of whiteness and blackness) of the photograph and other copy that must be printed. The same kind of camera is capable of reproducing colored photographs. The camera is usually called a COPY or PROCESS CAMERA.

By teaming up photography with the lithographic process, we have the photo-offset lithographic process. Because of this close relationship, we will use the term PHOTO-OFFSET LITHOGRAPHY as the title of the process and of this book.

TEST YOUR KNOWLEDGE — UNIT 1

1. What process is based on the principle that water and oil do not mix?
2. Lithography was invented in _____ by _____ _____.
3. The first image carrier was a piece of _____. Lithography really means _____ _____.
4. The technical term for printing from a flat surface is:
 a. Offset.
 b. Photo-offset.
 c. Photo-offset lithography.
 d. Planography.
 e. Screen printing.
5. Explain what a process camera is used for.

SUGGESTED ACTIVITIES — UNIT 1

1. Visit a photo-offset lithographic plant in your community. During the visit, look for the many types of printed products they are producing.
2. Look around your home and list all of the items that have been printed.
3. Prepare a statement on the impact printing has upon the community in which you live.

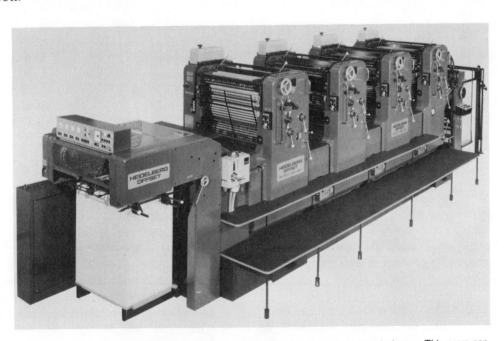

Fig. 1-3. An example of a large press used in the graphic communications industry. This press can print four colors as the paper passes through one time. (Heidelberg Pacific, Inc.)

GENERAL SAFETY RULES

To the student: the material following should be read carefully before you proceed to a study of the process in photo-offset lithography. Then you should refer to it repeatedly as you study each part of the process in later units. You will find it contains a wealth of information that will make the graphic communications laboratory a safer, healthier place for you to work and learn.

Most accidents can be prevented. If a person slips because of an oil spot on the floor, this is an accident even though there was no injury. In our technological society, the safety and health of the individual must be considered in everything we do. Protectivity is as important as productivity. Ask yourself: "Am I doing this the safe way?"

Accident prevention does not just happen, it requires the cooperative effort of all workers. Planning is essential and the results will be positive action.

In order for an accident program to work, everyone must believe that safety is important. This means everyone from top-level management to all the personnel in the facility.

Safety must be built into every job that is performed in the plant. Organizing for safety is not an easy job, but involving people is often the key. All personnel must know their safety role in the company.

It is the responsibility of management to provide a safe and healthful working environment. Management establishes a policy and they expect employees to follow that policy. It might be required that safety glasses be worn in certain areas. This is a safeguard and might save an eye. Management expects that you will follow this policy. It is for your protection.

When an accident-free work place is a reality, work stoppages do not occur and the quality of work is better. How can we accomplish this accident-free work place? It might be almost impossible but we can work toward this goal by following the suggested safety practices and the key elements necessary in an accident prevention program.

ENVIRONMENTAL AND HEALTH CONTROL

Environmental conditions vary but the following conditions are necessary to promote optimum safety and health in every area of the facility.

1. Illumination which meets established standards.
2. Ventilation with adequate intake and exhaust.
3. Temperature and humidity control.
4. Noise control:

Duration per day, hour	Sound level in decibels (dBA)
8	90
6	92
4	95
3	97
2	100
1	105
3/4	108
1/2	110
1/4 or less	115

5. Color comfort.
6. Walls, ceilings and floors constructed of material conducive to safety within the facility.
7. Windows and doors designed for safety — consideration shall be given to size, location, operation and material which meet established standards.
8. Layout which provides safe work space and passing distance as they relate to equipment and other stationary objects.
9. Marked safety zones.

10. Colors shall be used to point out physical hazards.
 a. Red shall be used for:
 Fire protection.
 Safety containers for combustibles.
 Machine emergency stop bars.
 Electrical switch only.
 b. Orange shall be used to designate dangerous parts of machines or devices. Switch boxes are painted orange.
 c. Yellow designates caution.
 d. Green designates safety and first aid.
 e. Blue designates that a machine is under repair.
 f. Purple designates radiation hazards.
 g. Traffic and housekeeping patterns are designated by black, white or a combination of black and white.

HOUSEKEEPING

All personnel are responsible for good housekeeping. It specifically relates to the orderliness and cleanliness of the facility. The following housekeeping practices are essential for accident prevention:
1. Equipment arrangement must be planned.
2. Traffic lanes shall be kept free of obstacles.
3. Approved waste and scrap containers shall be provided and emptied daily.
4. Materials shall be stored in an approved way.
5. Keep hand tools in excellent condition.
6. Hand tools shall be properly stored.
7. Floor areas shall be kept free of litter.
8. Provide drip pans where needed.
9. All machines shall be kept clean.
10. Glass and metal scraps should be placed in a separate container.
11. Properly cap all chemicals.
12. Store solvents in approved containers and cabinets.

HEALTH AND SANITATION

Many hazards to health are found in the graphic communications plant. Safeguarding your health is important. The following measures shall be followed:
1. Avoid exposures, above allowable limits, to gases, vapors, mists, dust and fumes.
2. Wash your hands after finishing a task using a contaminant.
3. Keep hands and foreign materials from your mouth.
4. Wear personal protective equipment.
5. Keep personal protective equipment clean.
6. Handle all chemicals and solvents with care.

FIRE PREVENTION

Faulty practices such as poor housekeeping, improper use of solvents and unsafe behavior could cause fires. The following practices shall be followed to prevent and/or control fires.
1. Oily and solvent rags shall be kept in self-closing approved containers.
2. Flammable materials shall be stored in approved cabinets and never used near an open flame.
3. Fire extinguishers shall be identified and installed with hangers or brackets.
4. Fire extinguishers should be strategically located.
5. Regularly inspect fire extinguishers.
6. Plan evacuation routes.
7. All electrical equipment shall be properly grounded.
8. Instruct as to proper use of fire extinguisher types.
9. Directions and information labels shall face out.

MATERIALS HANDLING AND STORAGE

Personal injury is common where personnel handle materials improperly. The following materials handling and storage practices are essential elements for accident prevention:
1. Avoid lifting heavy objects by yourself, seek help or use mechanical devices.
2. Materials shall not protrude from shelves.
3. Storage of material shall not create a hazard.
4. No one is permitted to ride on a hand truck.
5. Store all combustible material in approved cabinets.
6. Use combustibles in very limited quanities. Standards establish limits.
7. Limit stacking of material, make sure it is secure against sliding or collapsing.
8. Label all containers.

Most of the foregoing topics are very general. The following safety and health practices are more specific and relate to the units in the book.

SAFETY IN GRAPHIC ARTS DESIGN

1. Avoid leaning back, or tilting on stool or chair.
2. Carry pointed and sharp equipment in a safe manner.
3. Avoid carrying sharp objects in pockets.
4. Blades shall be used only with an approved handle or holder.
5. Drawers shall be closed when not in use.
6. Avoid extending T-square blades into a traffic area.
7. Avoid dropping instruments — damage to instrument and injury to the person is likely.

SAFETY IN
COMPOSITION — IMAGE GENERATION

1. Solvents shall be stored in safety containers.
2. Keep all guards in place.
3. Maintain all safety devices.
4. Good illumination is essential.
5. Handle blades, scissors and rules with extreme care.
6. Good housekeeping is important.
7. Electrical wiring shall conform to codes.
8. Equipment shall be grounded.
9. Hot-metal equipment should be located so individuals cannot be sprayed by the molten material.
10. Properly ventilate area.
11. Wear protective clothing where needed.
12. Safety glasses shall be worn in designated areas.
13. Avoid pin points.

SAFETY IN
ART AND COPY PREPARATION

1. Handle sharp objects with extreme care.
2. Proper lighting is essential.
3. Dropping equipment can damage the equipment as well as cause injury to you.
4. Care must be taken when handling glass containers.
5. Avoid littering the area.
6. Provide adequate waste disposal containers.
7. Maintain hand tools.

SAFETY IN PHOTO CONVERSION

1. Avoid looking at camera lights.
2. Label all chemical containers.
3. Properly store bottles and other containers.
4. Properly ventilate the darkroom area.
5. Handle glass equipment with extreme care.
6. When mixing chemicals, add the chemical to the water.
7. Wear protective equipment when needed. Use gloves when placing hands in chemicals to curtail skin problems.
8. Wear aprons, gloves and goggles or shields when mixing chemicals.
9. Provide eye wash facility.
10. Avoid splashing of liquids.
11. Follow manufacturers' suggestions.
12. Wash after touching chemicals.

SAFETY IN STRIPPING

1. Ventilate area for some solutions.
2. Handle sharp objects with extreme care.

3. Properly store equipment.
4. Avoid littering the area.
5. Good lighting is essential.
6. Handle glass containers with care.
7. Provide ample work space.
8. Guard manual paper cutters.

SAFETY IN IMAGE CARRIERS

1. Adequately ventilate area.
2. Maintain good housekeeping.
3. Be careful of sharp edges on image carriers.
4. Handle chemicals with care.
5. Provide shielding for light sources.
6. Avoid looking into lights.
7. Wear appropriate personal protective devices. (Gloves and aprons.)
8. Solutions might be irritants and cause skin troubles. Avoid contact.
9. Mix solutions according to manufacturers' specifications.
10. Mark all containers.

SAFETY IN IMAGE TRANSFER

1. Follow recommended operating procedures.
2. Keep all areas around the press clean.
3. Solvents shall be dispensed from safety containers.
4. Provide approved containers for dirty rags.
5. Place tools in recommended storage areas.
6. Avoid wearing loose clothing.
7. Long hair must be properly secured.
8. Remove all grease or oil from floor or platform.
9. Keep aisles clear.
10. Scrap paper shall not litter the floor or area.
11. Properly handle paper to eliminate possibility of a sprain or cut.
12. Safety shoes are recommended in the press area.
13. Provide adequate storage facilities.
14. Properly store rollers.
15. Avoid carrying sharp objects in pockets.
16. Only authorized personnel shall operate presses.
17. Avoid oiling equipment while it is in motion.
18. Keep tools in excellent condition.
19. Avoid reaching into or over a press.
20. Guards shall be in place when press is in operation.
21. Before starting press, inform others in the area.
22. Avoid removing foreign objects from press while in motion.
23. Provide exhaust system for dust.
24. Use extreme care when cleaning rollers.
25. Use only approved solvents.
26. Noise control shall be observed.

General Safety Rules

SAFETY IN BINDING AND FINISHING

1. Paper cutters shall be guarded.
2. Handle stock with extreme care.
3. Keep waste paper off the floor.
4. Follow good housekeeping procedures.
5. Avoid altering safety devices.
6. Operate cutters only when given permission.
7. Finger clearance shall be observed.
8. Guards on all equipment shall be kept in place.
9. Spray only in an approved exhaust area.
10. Wash paste from hands.
11. Change paper knives using proper protective devices and proper equipment under recommended conditions.
12. When operating paper drills, round cornering machines, punches, perforators, stitchers, the fingers and hands shall be kept away from point of operation. Keep guards in place.
13. Avoid sliding hands or fingers along edges of paper. Major cause of cuts.
14. Handle hot materials using approved protective devices.

Safety is everyones' responsibility. Ask yourself: "Am I doing the task the safe way?"

Help make the graphic arts facility a safer and healthier place to work.

GENERAL SAFETY INSPECTION CHECKLIST

GENERAL CONDITION

1. Are the exits readily accessible?
2. Are the aisles uncluttered?
3. Is lighting adequate?
4. Is noise adequately cut down?
5. Is ventilation adequate?
6. Are the proper type of fire extinguishers available:
 a. A type.
 b. B type.
 c. C type.
 d. D type.
7. Are there adequate washing facilities?
8. Are the utility lines properly identified?
9. Do compressed air lines have pressure reducers installed?
10. Other . . .

EQUIPMENT

1. Are machinery guards and devices in place?
2. Are all moving gears and belts protected by permanent barriers or guards.
3. Are nonskid walk areas provided around machines where necessary?
4. Is defective equipment tagged?
5. Are saws and grinders protected with proper guards?
6. Are hand tools properly maintained?
7. Other . . .

ELECTRICAL

1. Are circuit breakers identified?
2. Are circuit breakers:
 a. Accessible?
 b. Covered?
3. Are junction boxes covered?
4. Is all equipment grounded?
5. Are extension cords:
 a. In good condition?
 b. Grounded type?
6. Is any temporary wiring used?
7. Are power hand tools grounded or double insulated?
8. Are machine switches easily accessible to the operator?
9. Other . . .

HOUSEKEEPING

1. Is general appearance clean and orderly?
2. Are storage, working, walking surfaces, and equipment areas orderly?
3. Are materials in storage areas stacked properly?
4. Are benches kept orderly and clean?
5. Are oily rags stored in covered self-closing metal containers?
6. Are safety containers used for flammable liquids?
7. Are solvents and flammable materials stored in fire resistant cabinets?
8. Are shelves and mezzanines provided with toeboards and free from objects that are unstable and may fall?
9. Are containers marked to identify contents?
10. Are chemicals properly stored?
11. Other . . .

PERSONAL PROTECTION

1. Are eye protection signs posted?
2. Is eye, foot, hair, ear, apron, etc., equipment provided where necessary?
3. Is adequate foot protection required?
4. Is there adequate storage for personnel protective devices?
5. Other . . .

Unit 2

CAREERS IN PHOTO-OFFSET LITHOGRAPHY

The graphic arts industry is changing very rapidly. The range of opportunities is broad. Photo-offset lithography is only one part of the graphic communications industry but requires many varied talents. Some positions require creative skills while others require skilled craftspersons. Supervisors and management personnel are also needed.

The list of jobs explained in this unit is not complex, but it does represent the major positions in the graphic arts industry.

SALES REPRESENTATIVES

This person, Fig. 2-1, must like to meet people. All salespersons are representing the company and always try to leave a favorable impression. The customer relies on the sales representative to get the most out of every job given the printer. Therefore, sales "reps" must know the processes well and must be able to explain the clients' ideas to the company's artist, keyliners, copywriters, and others. Sales representatives are hard working, find it easy to talk to people and keep themselves well groomed when on the job. They must do their job without a great deal of supervision.

ESTIMATORS

The estimator, Fig. 2-2, computes out the cost of the job. The cost figures become the bid for a job. The bid tells the customer that the company can do the job for a certain amount of money.

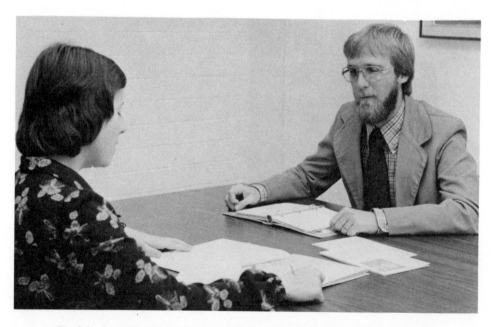

Fig. 2-1. A graphic communications sales representative enjoys working with people.

Fig. 2-2. Estimating a job for a customer. The estimator must understand processes of printing well enough to know what steps are needed to print the job.

This person is also looking at ways to cut costs in the plant. Having an understanding of the operations from the business standpoint is helpful. The estimator must like to work with numbers.

MANAGERS

Managers work at various levels. A small plant owner is the manager, but might do many other jobs. A large plant may have a plant manager and/or production manager, Fig. 2-3.

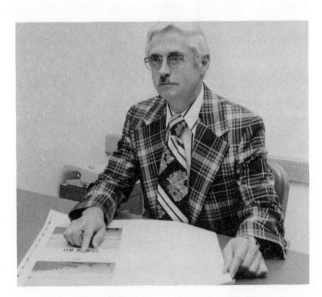

Fig. 2-3. Managing a graphic communications facility takes someone who can organize and control activities and details.

Management means getting work done through other people. This person must be able to organize and supervise the work of people. A thorough knowledge of the technology and management techniques is recommended.

GRAPHIC DESIGNERS

The graphic designer, Fig. 2-4, is an artist that designs packages, brochures, stationary, business cards and billboards – just to name a few of the items. The designer takes an idea and puts it into a visible form.

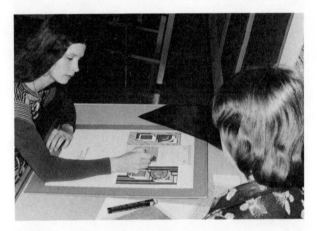

Fig. 2-4. Designer may produce the finished art for a customer's approval.

In large companies, an art director, Fig. 2-5, supervises a group of artists. All art design is reviewed by the director and presented to the person wanting the work done. The wishes of the client (the person wanting something printed) must be achieved. The director, through other artists, must satisfy the customer.

LAYOUT ARTISTS

After the graphic designer has prepared preliminary art or final artwork, the layout person, Fig. 2-6, properly locates artwork on the layout sheets. This means that all of the photographs, illustrations, and copy are fitted and placed in their exact places. This person must be able to copyfit type. (Copyfitting is estimating how much space manuscript copy will take on a printed page.) A knowledge of type faces is very important. After the layout person has completed the comprehensive, it is

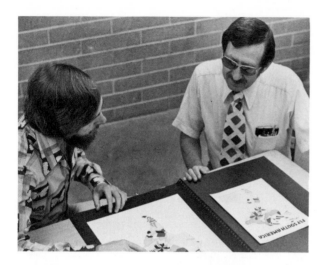

Fig. 2-5. Directing the operations of a design department is the job of the art director.

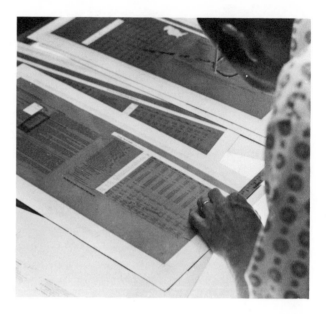

Fig. 2-7. Preparing the camera ready copy by pasting type and overlays on large sheets.

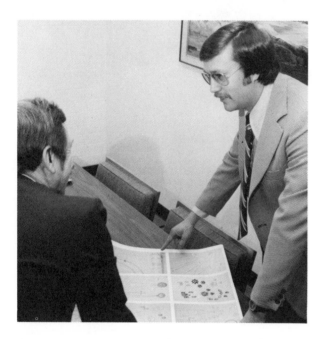

Fig. 2-6. The artwork has been prepared. After the elements of the design — art and type — are positioned. The layout is shown to the client.

usually approved by the client. (A comprehensive is an exact layout of all type and illustrations.)

KEYLINER (PASTEUP PERSON)

The keyliner, Fig. 2-7, prepares the camera-ready copy. This is called a mechanical. The positioning of all the copy and illustrations must be done very accurately. This person's work must also be done very neatly. Basic skill in use of drafting instruments is also required. Fitting everything according to the specifications and pasting it to a mounting board requires precision. Sloppiness is not allowed.

PHOTOGRAPHER

The photographer is also a creative person. Every photograph must carry a message to the reader. Pictures often tell a story better than words can. The good photographer helps explain the copy.

Photographers sometimes specialize in areas such as industrial, medical, advertising and portraits. Whatever their special knowledge, they must also know about cameras, lenses, lights, filters, films and processing. Some experience in chemistry is also very helpful when working in the darkroom.

COPYWRITERS

Copywriters must have a good vocabulary and the ability to write clearly and grammatically. Some graphic arts plants will employ a copywriter but most work in advertising agencies and on the staffs of publishers.

TYPESETTERS

Once the copy has been written, typesetters, Fig. 2-8, compose it by various techniques. Hot metal, strike-on, photocomposition are just a few of the types of composing machines which require personnel to operate them.

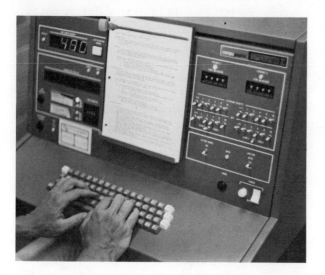

Fig. 2-8. To compose the written material, the operator uses a phototypesetting system.

Typesetters should like to operate equipment. Mechanical ability is very important. Being able to type is also a basic requirement. Many pieces of equipment use a keyboard similar to that of a typewriter. More and more we find the need for a basic knowledge of electronics.

MARKUP PERSONS

Larger plants have markup persons to make the specification for a printing job. These people mark up the manuscript so that the typesetter will know what type size, style and spacing to use in setting type. They must work closely with sales representatives, typesetters and artists. Knowing typography and how it can best be set or composed is a prime requirement.

PHOTOLITHOGRAPHY CAMERA OPERATORS

Camera operators take the mechanical (pasteup), place it in the camera, Fig. 2-9, and transfer the image onto a piece of film. Some camera operators are specialists and do only

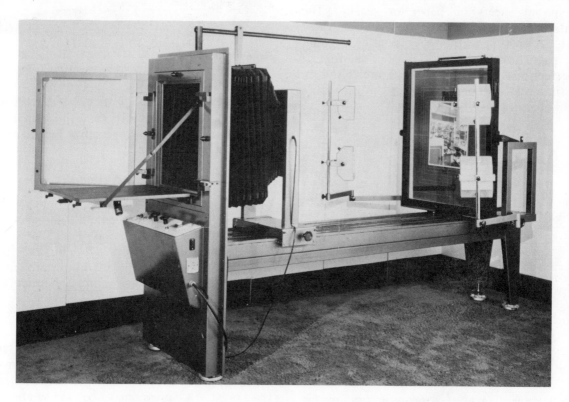

Fig. 2-9. The camera-ready material is shot on a copy camera. (Valley Printers Supply)

color separation work. Others must be capable of placing line work, continuous tone and full color on film. Some of the equipment is very complex and requires a background in solid state electronics.

Basically, operators should understand the types of cameras, films, lighting, special effects and film processing that are used in the industry. Photolithographic camera operators should also understand chemistry, optics and some physics.

LITHOGRAPHIC ARTISTS

Lithographic artists retouch negatives. They correct negative defects using chemicals, dyes and special tools. Very precise workers, they must have a knowledge of ink and what it will do on paper.

PHOTOLITHOGRAPHIC STRIPPERS AND OPAQUERS

Strippers, Fig. 2-10, take the negatives and/ or positives and place them in the exact position indicated by the layout. This is done on special sheets of paper or plastic. The negatives or positives are fastened to these sheets. A portion of the sheet is cut away to let light pass through the clear areas of the film. If imperfections, such as pin holes, are found on the film, the opaquer touches them up with a liquid opaque.

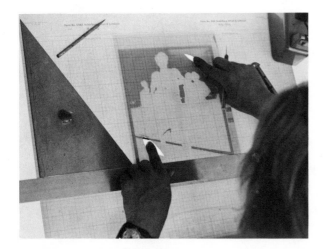

Fig. 2-10. Placing the negatives or positives in correct position on the flat is essential.

This work is very painstaking. Strippers and opaquers should have a knowledge of drafting and should be able to use scribers, cutting tools and other art instruments.

PHOTOLITHOGRAPHIC PLATEMAKERS

Film which is ready for the platemaking process has been made up into a flat. A flat is a number of pages that are part of one large sheet of film.

Platemakers expose light through the film onto the offset plate. Then they develop the image made by the light by treating the plate with various solutions. See Fig. 2-11.

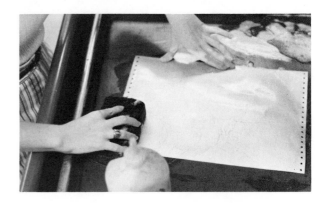

Fig. 2-11. One of the steps in making a printing plate is to develop the plate with solutions.

Sometimes the plates they work with have been presensitized. If not, they must apply the photosensitive coating themselves before exposing the plate.

Platemakers must be familiar with all types of printing plates and the types of light sensitive coatings. They must understand some chemistry to prepare the plates for the press. Many of the operations require good eyesight and rapid work. Since many of the operations are critical, platemakers must be precise in all their work.

PRESS OPERATORS

Press operators may have many or few tasks. They may work alone or as part of a group. Much of what they do depends on the size of the press. A press may be as small as a duplicator that can sit on top of a desk and

print 8 1/2 by 11 in. sheets or as large as the giant webs that print whole newspapers or magazines. Basically, there are two types of offset presses: sheet fed and web fed.

Operators of small sheet fed presses, such as shown in Fig. 2-12, will have many tasks. But, whether the press is large or small, the operator prepares the press for operation and then continually checks the running of the job. Operators of small presses usually work alone and may have tasks not related to printing.

Operators attach the plate to the cylinder, regulate the flow of ink and water and see that paper is feeding properly into the press. They must know how to make many adjustments in order to run jobs with high quality results.

Those who work on web fed presses, Fig. 2-13, have the same responsibilities but tasks may be fewer and more specialized. This is because many of the web presses are huge and

operate at high speeds. Usually, a group of persons work on each press. Paper is fed from huge rolls which are attached to the press.

Press operators must like to work with machines. Since high quality printing is demanded, it is an exacting job. This requires continuous, careful work and constant checking of the product. Those who work on large presses must be able to get along well with others.

Some of the larger presses must employ helpers. They assist in press operation as needed, receiving their instructions from the operator. It is an excellent way for a beginner to learn press operations.

Duplicator operators are often found in companies that do their own printing. The person working in this type of operation might be required to do other jobs besides preparing and running the press.

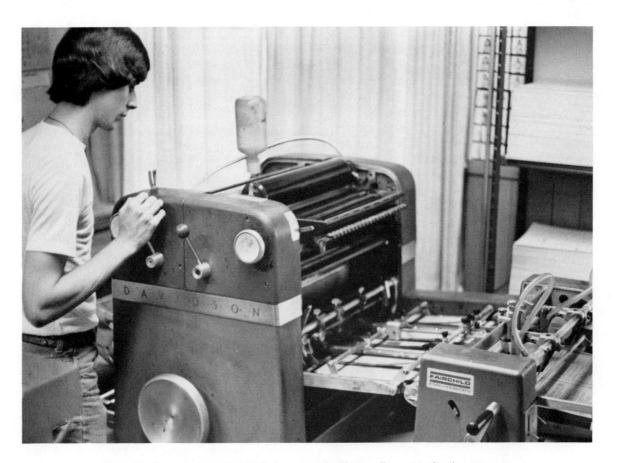

Fig. 2-12. Operating a small sheet fed press requires fewer adjustments than larger presses.

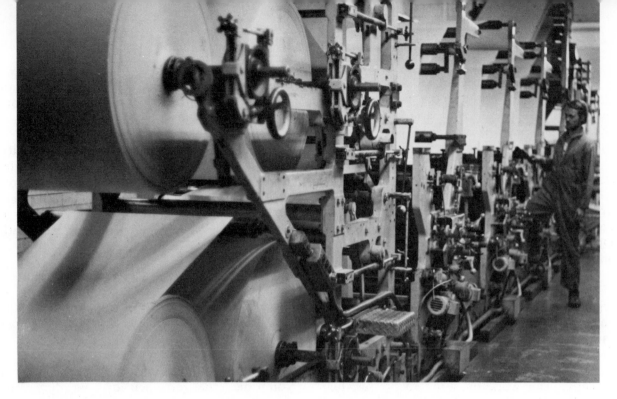

Fig. 2-13. Operating a web fed press is usually not a job for one person alone. There is need for co-workers and helpers.

BINDERY AND FINISHING

In the bindery operation, the different parts of a printing job are gathered together and bound. The operations include folding, trimming, collating (gathering pieces in their right order) and stitching or binding. This involves use of machines such as paper cutters, Fig. 2-14, folders, collators and stitchers. Some machines are huge and complicated. In larger plants each task would have one operator. Often these tasks are similar to an assembly line type of oper-

Fig. 2-14. Cutting paper is just one of the many bindery jobs.

ation. The operator does the same task over and over again.

COMPUTER PROGRAMMERS

Many of today's plants have equipment that is at least partly controlled by computers. Someone must prepare a program for the various control tasks performed by the computer. A program is the set of instructions which tell a computer what it is to do. Phototypesetting operations, estimating and inventory control are just a few of the typical applications. As photolithographic operations become more technical, it is expected that the computer will become a very valuable printing tool. A knowledge of computers, their language and mathematics is essential.

TEACHERS

Teachers are instructing the graphic communicators of the future, Fig. 2-15. Some of the schools give students the opportunity to explore by giving an overview of the industry, while others prepare students for jobs.

Liking to work with and communicate with young people is very important to being a successful teacher.

Fig. 2-15. Teaching is found to be enjoyable by some people. Teachers must like to work with people and should be able to communicate well.

RESEARCHERS

It appears that, in the future, there will be a need for research specialists in the graphic arts industry, Fig. 2-16. Working with plates, paper and ink, their job is to improve the properties of these materials. New materials are sometimes discovered. Research in the area of lasers and their use in the industry has great potential. The chemist and the physicist will find more work in graphic communications industries of the future. Training in the sciences, and basic instruction in research and development procedures are required.

By no means is this a complete list of careers available in photo-offset lithography, but it is hoped that it gives you an idea of the many varied skills needed and the jobs open to you. It is an exciting, changing industry.

Fig. 2-16. Research specialists are needed to experiment and find new products to do the job better.

TEST YOUR KNOWLEDGE — UNIT 2

1. What types of careers are available to creative persons?
2. Which of the following is not a necessary trait for being a sales representative?
 a. Is able to convey clients wishes to the artist.
 b. Is able to work with little supervision.
 c. Is knowledgeable about processes.
 d. Likes to meet people.
 e. Likes to work with machines.
 f. Well groomed.
3. What are the positions that require highly skilled people?
4. Name the careers that require persons capable of doing precise work.
5. Typesetters ought to know something about electronics. True or False?
6. _____ _____ control the actual printing of the product.
7. What capabilities are likely to make a teacher successful?
8. What career do you see as being the most exciting and rewarding?
9. One who gives instructions to a computer is called a _____.
10. What would you call a person who tries to improve the inks and papers used in printing?

SUGGESTED ACTIVITIES

1. Select one of the careers common to photo-offset lithography and list all of the things you like about it.
2. Prepare a more detailed report on one of the careers which you find most interesting to you.
3. Discuss with your teacher the possibility of inviting someone in the photo-offset lithography industry to speak to the class on careers.
4. Check classified advertising section of local newspaper for jobs in photo-offset lithography. Report to class on findings.
5. Prepare a list of the job titles listed in the classified advertising and find out the skill requirements for each.

Unit 3

GRAPHIC ARTS DESIGN

Printed material cannot be produced without planning. Look at this unit as a blueprint for a printed product. When you design a printing job, you want the customer or the person that looks at it to be satisfied. Typical printing examples are found in Fig. 3-1.

ELEMENTS OF DESIGN

Before reviewing the principles of design, some thought should be given to the ELE-MENTS of design. The elements are all of the images that are printed on some type of material.

The first element is LINE. Lines can be wide, narrow, straight or curved. They can give your eyes direction, but if lines are going in all directions this could be confusing. Lines should not contribute to confusion, but give you a feeling of continuity, movement or belonging. The graphic designer uses lines in some form to

Fig. 3-1. A few examples of graphic communications products. Left. Packaged designs. Right. Newspapers, brochures, booklets and letterheads.

create a message, Fig. 3-2. The message may be in the form of a complete design or a single line.

The element of FORM (shape) must also be considered. Form could appear as a silhouette of an object or it can be seen as a rectangle, circle, square or any free form. One form may be used continuously throughout the page and

Fig. 3-2. Lines help to create a message.

become dominant. You see it as something that stands out. The background on a printed page might be an important part of the whole page as shown in Fig. 3-3.

MASS is also an element of design. It refers to size and/or the amount of area or volume. If you see many areas of mass which are the same, monotony could be the result. A mass concept, Fig. 3-4, requires a designer to consider the relationship of areas so all of the units fit together to give meaning to the total design.

These are the three most common elements a designer of printed products would use. Other

Fig. 3-3. Form or shape can be used as a background.

elements, such as texture, hue, value and chroma, are also used to create a design but will not be discussed in this unit.

PRINCIPLES OF DESIGN

To make the design pleasing, you must also apply the basic principles of design when making a layout. These are:
1. Proportion.
2. Balance.
3. Contrast.
4. Rhythm.
5. Unity.

There is no set of rules to be followed. The principles of design are guides which give the designer direction.

PROPORTION

The principle of proportion is very difficult to define. It refers to the pleasing relationship of all the parts of a printed page. The page of a book has proportion. If it is a 1:1 ratio, the book is square.

Fig. 3-4. Mass, in this case a heavy black square, draws attention.

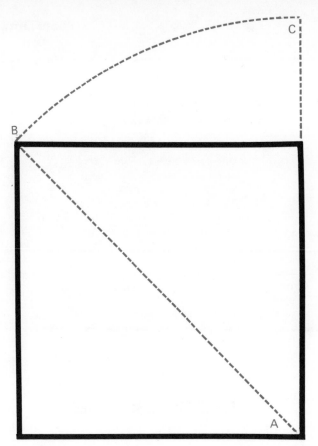

Fig. 3-5. An often-used typical ratio is 1:1.4. One way to get the ratio is to enlarge the square to a rectangle with two sides equal to the diagonal line in the square.

To achieve a ratio of 1:1.4, a commonly used proportion, draw a diagonal line in a square box as in Fig. 3-5. Now, set one point of a compass at A and the other point at B. Swing the upper point of the compass to the right until it crosses the dotted line at C. This point is the proper height for the 1:1.4 ratio. If you redraw the box to the new height, the vertical sides would be 1.4 times as long as the horizontal sides.

Another very common example is the proportion created by a printing rule (line) and a type face, Fig. 3-6. Do you see how the weight (thickness) of the rules has a relationship to the weight of the type face?

Proportion can make a page seem alive, full of action and interesting. To achieve proportion, a designer must present all of the elements as a pleasing relationship to each other.

BALANCE

The principle of balance refers to equilibrium (two forces being equalized). Fig. 3-7 represents what is called a formal balance. Each

Fig. 3-6. A line should be porportional to a type face. Do you see the relationship between the weight of type faces and the thickness of lines?

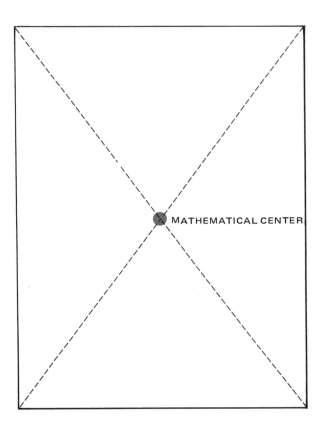

BALANCE

Laeyo aoiou dxpo quto avoi bxyo mns
pxrnxo. Mnstr laeyo aoiou dxpo guto a
cmbent dtnsti. Bxyo mnstr laeyo aoiou
pxrnxo bzny cmbent. Avoi bxno mnstr lc
Cmbent dtnsti pxrnxo bzny. Quto avoi b
dxpo. Bzny cmbent dtnsti pxrnxo. Dxpo
laeyo aoiou. Pxrnxo bzny cmbent dtnsti.
bxyo mnstr laeyo. Dtnsti pxrnxo bzny
dxpo quto avoi bxyo mnstr. Bzny cmbe
laeyo aoiou dxpo quto auoi bxyo. Pxrn:
Bxyo mnstr laeyo aoiou dxpo quto au
cmbent. Avoi bxno mnstr laeyo aoio dx
pxrnxo bzny. Quto avoi bxyo mnstr la
cmbent dtnsti pxrnxo. Dxpo quto laeyo
bxyo mnstr. Bzny Laeyo aoiou dxpo quto
Laeyo aoiou dxpo quto avoi bxyo mns
pxrnxo. Mnstr laeyo aoiou dxpo guto a
cmbent dtnsti. Bxyo mnstr laeyo aoiou

Fig. 3-7. An illustration of formal balance.

side has equal weight.

Two persons of different sizes balanced on a teeter-totter illustrate this principle. Try to imagine elements on a page balancing each other as on a teeter-totter. Heavier elements nearer the pivot point can be balanced by lighter elements placed further away from the pivot point.

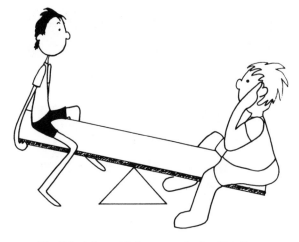

Fig. 3-8. Informal balance can also be attractive.

If the weight is shifted, as in Fig. 3-8, balance still exists but now we call it informal. The distance and weight vary on each side. Yet, they still have balance.

This is also true in designing graphic objects. No longer are the halves equal in the layout, but because of relocation, balance does exist. Mass and size tend to give the element an appearance of weight. A light color will appear to have less weight than a dark color.

A page has both an optical and a mathematical center. They are not the same. The

MATHEMATICAL CENTER

Fig. 3-9. The mathematical center of a page is a point equally distant from all edges of the page.

mathematical center occurs where the diagonal lines intersect as in Fig. 3-9.

The common means of locating the optical center, as our eyes see it, is to divide the page into eight equal parts. Then draw a line below the third part from the top. This line is at the optical center. Fig. 3-10 illustrates how your eye sees it.

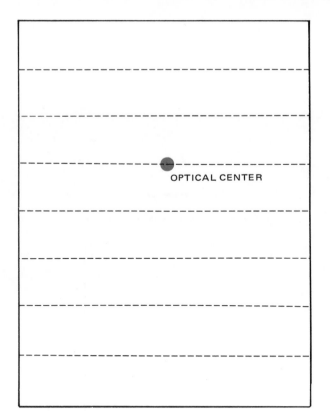

Fig. 3-10. The optical center, as seen by your eye.

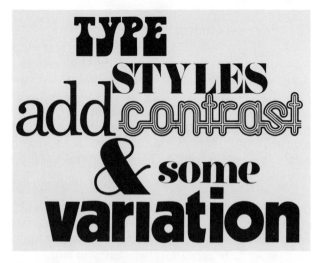

Fig. 3-11. Type mass is used to create variations and interest.

CONTRAST

Contrast is like a tree in a flat landscape devoid of any other kind of vegetation. It is used in printing to attract the attention of the reader. One way to do this is to use different sizes and weights of type. This variation keeps the printed page from getting monotonous (tiresome because of repetition). It breaks up the boring sameness. This was done in Fig. 3-11. Some of the type is small; some is large and black; some is large and airy looking. Each changes the appearance of the page.

There are other ways of providing contrast. A change of color would certainly arrest the attention of the reader as would a tint in the background or spots of color around or behind type. Or you could reverse the type so that the background is black and the letters white.

The principle of contrast is sometimes used to draw the reader from one element on the page to another important element. This principle is illustrated in Fig. 3-12.

RHYTHM

If your eye is directed by the lines or objects on a page, the design has rhythm. The eye

Fig. 3-12. Contrast moves the eye from one element to another. However, the use of so many different type styles is disturbing. A designer would try to use no more than two contrasting faces on a page.

movement is planned and acts as a guide to draw attention to various elements of the design. The orderly arrangement of these elements is essential for good design. See Fig. 3-13.

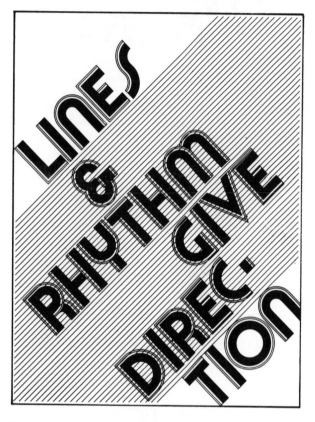

Fig. 3-13. Rhythm moves the eyes in the direction the designer wants you to go. Where does this layout take the eye?

UNITY OR HARMONY

Unity or harmony is needed above all else in design. Without it, all other elements would look like confusion. Unity or harmony is that quality that holds a page or layout together. You might say, then, that unity allows you to see instantly that all the elements on a page relate to one another. They seem to belong together.

It is achieved by controlling the number and styles of type faces used together and by establishing some relationship between the shapes used. It could be a similarity in forms or a way of grouping them. These shapes will form an attractive printed piece. The shape should appear to be "organized," Fig. 3-14.

Fig. 3-14. It is very important to organize shapes. Top. Shapes do not seem to hold together, seem disorganized. Bottom. Same shapes placed in a pleasing relationship.

GRAPHIC LAYOUTS

The designer's idea must be drawn so that the client and printer can see how the finished product will appear. These drawings are called layouts and are of four types. They are commonly called:

1. Thumbnails.
2. Roughs.
3. Comprehensives.
4. Mechanicals.

THUMBNAILS

Thumbnails are very simple sketches. They allow those concerned with design to explore more than one layout idea. These sketches are not detailed but show, in general outline, what the finished design would look like. If copy has already been written, the thumbnail should show how the copy will appear on the final printed product. The images, Fig. 3-15, can be sketched as same size or as a scaled down proportion of the finished size.

ROUGHS

Roughs are the second step in the planning stage and are prepared from the selected thumbnail sketch. They are a closer representation of the final product. The display lettering, illustrations, or photos are properly located. The type copy for the area is also blocked out. Spacing, size, tone and shape are very important here, as they help you get a better idea what the final product will look like, Fig. 3-16.

COMPREHENSIVES

The comprehensive layout is much more complete. The display portion of the layout is now lettered. The body type is blocked out in appropriate areas. If color is to be used, it is used in the comprehensive. The total design is assembled in the exact position as it will appear in the final printing. By having everything placed correctly, it will be easy to place the display lines, copy, cuts and illustrations in their right position, Fig. 3-17.

Fig. 3-15. Thumbnail sketches are the ideas of the designer visualized.

Fig. 3-17. The comprehensive is much like the finished product.

Fig. 3-16. A rough gives more details than the thumbnail sketch.

MECHANICALS

From the comprehensive, the camera-ready copy is prepared. The type must be set and pasted up. It is possible that the illustrations and/or photographs will need to be enlarged or reduced. When everything is assembled, the

Fig. 3-18. The mechanical is camera-ready copy.

finished copy, Fig. 3-18, is called a mechanical layout. It is now ready to be transferred to the offset plate. It is ready for the process camera. At this point it is known as "camera-ready" copy.

TEST YOUR KNOWLEDGE – UNIT 3

1. The organization of visual material is called _____.

2. The _____ of design are all of the parts or shapes that can be placed on a printed page; the _____ of design are the guides which give the designer direction.

3. The elements and principles of designing are to be found in the following list. Place an (x) in front of the elements and a circle (o) in front of the principles:
 a. Balance.
 b. Chroma.
 c. Contrast.
 d. Color.
 e. Form.
 f. Harmony.
 g. Hue.
 h. Mass.
 i. Proportion.
 j. Rhythm.
 k. Square.
 l. Texture.
 m. Unity.
 n. Value.

4. The optical center of a page is about 3/8 of the way down the page. True or False?

5. The intersection of two diagonals marks the _____ _____ of a page.

6. List the types of graphic layouts commonly used by the designer.

7. If you were having a piece of advertising designed for you, what would you expect the designer to show you first?
 a. Camera-ready copy.
 b. Comprehensives.
 c. Mechanicals.
 d. Roughs.
 e. Thumbnail sketches.
 f. Type samples.

8. What layout can be used as camera-ready copy?

SUGGESTED ACTIVITIES

1. Cut an ad from a magazine or newspaper and identify the elements of design.

2. Look at books, posters and magazines and select printed material that would illustrate each design principle.

3. Visit the design area of a photo-offset lithographic newspaper or magazine facility and report on the types of layout technique used in the department.

4. Cut out an ad in a newspaper. Cut it up and redesign it following the principles of design.

5. Take three photographs. (If you do not have photographs, cut illustrations out of a magazine or a newspaper supplied for that purpose.) Write the copy and design a layout for a book or magazine ad.

6. Design a logo using your initials.

Unit 4

COMPOSITION - IMAGE GENERATION

This unit describes the most common methods of composing (setting) type. More and more, industry is using the term "image generation," which means the same thing as composing type. The process involves setting type or symbols so they can be used as copy for printing.

Generally, three kinds of type composition (image generation) are used today.
1. Hot type composition.
2. Cold type composition.
3. Phototypesetting.

In hot type composition, letters or lines of letters are set by hand or are cast by machines from molten (melted) metal, Fig. 4-1. Cold type

Fig. 4-1. These are lines of type used in hot type composition. Above. Line made up on a lead slug using a letter casting machine. Below. Two lines of hand set type.

composition does not require the use of molten metal, Fig. 4-2. Phototypesetting is also composition without metal. It uses OPTICAL means

instead. That is to say, light and light-sensitive materials are used. Each method will be discussed later in this unit.

TYPE DESIGN

Selection of the right type for the printing job is very important. The size, weight and form (shape) must be matched to the task at hand.

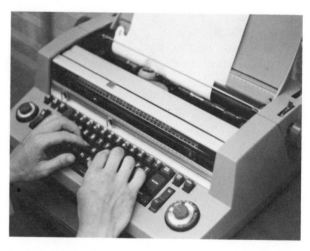

Fig. 4-2. In one kind of cold type composition characters are typed on a paper master or on white glossy paper.

Type styles can create different feelings and set moods in the reader. Thus, type can be made to work for the designer. It can give the impression of boldness, vitality, femininity, dignity, delicacy, speed or movement. See Fig. 4-3.

CLASSIFICATION OF TYPE

Type faces may be classified according to design. Some of the common groups are: text,

Lettergraphics

NEW Styles are an Everyday Thing

Fig. 4-3. Type faces can give various impressions. Upper. Cursive lettering showing strength with delicacy. Lower. San serif type gives feeling of boldness.

Old Style Transitional **Modern**

Sans Serif **Square Serif**

The Scripts 𝕿ext *ORNATE*

CLASSIFICATION OF TYPE FACES

OLDSTYLE			MODERN		
ROMAN	ITALIC	SMALL CAPS	ROMAN	ITALIC	SMALL CAPS
PROSE	*PROSE*	PROSE	PROSE	*PROSE*	PROSE
prose	*prose*		prose	*prose*	

TRANSITIONAL			SLAB-SERIF		SANS SERIF	
ROMAN	ITALIC	SMALL CAPS	ROMAN	ITALIC	ROMAN	ITALIC
PROSE	*PROSE*	PROSE	PROSE	*PROSE*	PROSE	*PROSE*
prose	*prose*		prose	*prose*	prose	*prose*

GOTHIC	SCRIPT	TYPEWRITER		
CAPS ONLY	CAPS AND LOWER CASE	LIGHT	MEDIUM	HEAVY
PROSE	*PROSE*	PROSE	PROSE	**PROSE**
	prose	prose	prose	**prose**

NOVELTIES

CAPS AND LOWER CASE

PROSE prose

VARIATIONS OF CLASSIFICATIONS

LIGHT	MEDIUM	BOLD	EX. BOLD	CONDENSED
PROSE	PROSE	**PROSE**	**PROSE**	PROSE
prose	prose	**prose**	**prose**	prose

EXTRA COND.	EXPANDED	EX. EXPANDED	OUTLINE	OUTLINE SHADED
PROSE	PROSE	**PROSE**	PROSE	**PROSE**
prose	prose	**prose**	prose	**prose**

Fig. 4-4. Classification of type faces. (Baltimore Type & Composition Corp.)

oldstyle, modern, transitional, sans serif, square serif, script and decorative. An example of each is found in Fig. 4-4.

POINT SYSTEM

The graphic communications industry has its own system of measurement. It is called the POINT system. We must understand it before we can measure type.

The point system has two units of measurement: the POINT and the PICA. Six picas equal about 1 inch. The pica is divided into 12 points. Actually, 6 picas are a little less than an inch. The type founders in the United States set the length of a point as 0.01384 of an inch. A printer's LINE GAUGE (rule) is commonly used as the measuring device, Fig 4-5.

Although it is not a part of the point system, the EM is an important term. It is the square of any type size and is used to estimate composition. As an example; a 4 in. line of type is 288 points long and, if set in 12 point type, contains 24 ems of 12 point type (288 ÷ 12 = 24).

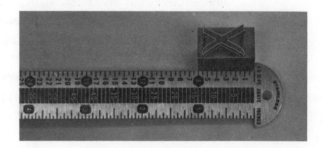

Fig. 4-5. Measuring a piece of type with a line gauge. A line gauge is also called a "pica pole." This one measures in inches, picas and agate (5 point) lines.

TYPE FONT

A type font is a complete assortment of one size and style of type characters. Included are the alphabet in capital letters and lower case letters, the figures from zero through nine and all the punctuation marks.

Not all letters will be stocked in the same quantities in each font of foundry type, Fig. 4-6. The number of pieces in each font, depends

FONT OF TYPE

What is a font?

Webster defines a font ". . . an assortment of type all of one size and style . . ."

This "assortment" is now a *carefully thought-out* system to proportion the letters of the alphabet so that they will be the most economical way in which a printer may use a font.

For example: the vowels a, e, i, o, u are considered as the most used, and rightly so, and of these the letter "e" has been more predominant in use than the other vowels. On the opposite side of the ledger experience has shown that the letters "j, k, q, x, z" are used infrequently.

Now, if you examine the fonts shown you will find that the proportion of letters shown in a font are based on their usage in the English language.

The composition sizes (text) 6, 8, 10, and 12 point have an abundant amount of letters whereas the larger sizes (display) have fewer characters.

10 POINT FONT

AAAAAAAAAAAAAAAAAAAAAAAAAAAA BBBBBBBBBBB CCCCCCCCCCCCCCCCCCDDDDD DDDDDDDDD EEEEEEEEEEEEEEEEEEEEEEEEEEEEEEEE FFFFFFFFFFFFGGGGGGGGGGGGGGH HHHHHHHHHHHHH IIIIIIIIIIIIIIIIIIIIIIIIIIJJJJJJJJKKKKKKKK LLLLLLLLLLLLLLLLLLMMMMMMMMMM MMMMM NNNNNNNNNNNNNNNNNNNNNNNNNNN OOOOOOOOOOOOOOOOOOO OOOOOOO PPPPPPPPPPPPPPPQQQQQ RRRRRRRRRRRRRRRRRRRRRRRRRRSSSSSSSSSSS SSSSSSSSSSSSSSSSS TTTTTTTTTTTTTTTTTTTTTTTTTTT UUUUUUUUUUUUUUUVVVVVVVVVWW WWWWWWWWW XXXXXYYYYYYYYYYYYZZZZZ&&&&,,,,,,,,,,,,,,,,,,,,,
--------''''''''''''''''''''''::::;;;;; ?????!!!!! $$$$$$$111111111222222233333334444444455 5555566666667777777888888889999990000000000 (((((((())))))) ABCDEFGHIJKLM

aaaaaaaaaaaaaaaaaaaa aaaaaaaaaaaaaaaaaaaaaaaaaaaaaaaa bbbbbbbbbb bbbbbbbbbbbb cccccccccccccccccccccccccccccc dddddddddddddddddddddddddddddddddd dd eeeeeeeeeeeeeeeeeeeeeeeeeeeeeeeeeeeeeee eeeeeeeeeeeeeeeeeeeeeeeeeeeee eeefffffffffffffffffffffffffffffff ggggggggggggggggggggggg hhhhhhhhhhhhhhhhhhhhhhhhhh hhhhhhhhhh iijjjjjjjjjjjjjj kkkkkkkkkkkkkkkkllllllllllllllllllllllllllllll lll mmmmmmmmmmmmmmmmmmmmmmmmmmmm nnnnnnnnnnnnnnnnnnnnnnnnnnnnnnnn nnnnnnnnnnnnnnnnnn ooooooooooooooooooooooooooo oooooooooooooooooooooooo ppppppppppppppppppppppppp qqqqqqqqqq rr rrsssssssssssssssssssssssssssssss sssssssssssssssssssssss ttuuuuuu uuuuuuuuuuuuuuuuuuuuuuu vvvvvvvvvvvvvvvv wwwwwwwwwwwwwwwwwwwwwxxxxx xxxxxyyyyyyyyyyyyyyyyyyyyyyyy zzzzzzzzzz,,,,,,,,,,,,,,,,,,,,,--------''''''
''''''''''''''::::::;;;;;;?????!!!!!! fifififififififfffffffffffflflflflflfl abcdefghijklmnopqrstuvwxyz.,-'':;?!fifffl

Fig. 4-6. A font of type contains a quantity of each character. (Baltimore Type & Composition Corp.)

on the size of type. For instance, 10 point type will have more letter e's than a font of 18 point type.

The point size and the body size of a type character are not the same thing. This is illustrated in Fig. 4-7.

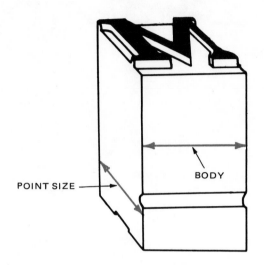

Fig. 4-7. A single piece of foundry type is called a character. The arrows show how point size and body size of a letter are measured.

TYPE SERIES

A type series is made up of all the sizes of one style of type. The size might begin with 6 point and go up to 144 points. The sizes in Fig. 4-8 are typical.

HOT TYPE COMPOSITION

Molten metal is used to cast type characters either one at a time or as one solid line, Fig. 4-9. When cast as individual letters, they are called foundry type. Foundry type is metal type. It can be set by hand or machine.

HANDSETTING TYPE

After setting the type by hand, the compositor places it in a shallow three-sided tray called a GALLEY. The surface of the type is inked and a reproduction proof or REPROS, as they are often called in the industry, are pulled. These can be used as camera-ready copy for photolithographic printing.

6 Point Garamond
6 Point Garamond Small Caps

8 Point Garamond

10 Point Garamond
10 Point Garamond Small Caps

12 Point Garamond
12 *Point Garamond Italic*

18 Point Garamond

24 Point Bodoni Book

36 Point Garamond

48 Point Garamo

8 Point Spartan Medium

10 Point Spartan Medium

12 Point Spartan Medium

18 Point Spartan Medium

24 Point Spartan Medium

36 Point Spartan Me

48 Point Sparta

72 Point S

Fig. 4-8. Some typical type sizes, serif above and sans serif below. Large sizes are used for headlines and to attract attention. Small sizes are called body type and are used for the text in newspapers and magazines.

In handsetting type, the letters are placed one-by-one in a COMPOSING STICK. To make the line tight, thin lead pieces called spaces are placed between the words, as shown in Fig. 4-10. When the line has been set and the letters line up with left and right margins, the line is said to be JUSTIFIED.

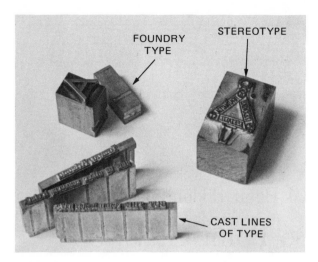

Fig. 4-9. Type is cast from molten metal. The foundry type is cast at the foundry and is never melted down. Cast lines of type are cast in the print shop and are melted down after use.

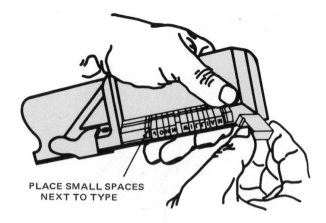

Fig. 4-10. Justifying a line of handset type requires metal spacers.

If more space is needed between the lines, metal spacers called leads or slugs are inserted. Spacing placed between lines, is called LEAD-ING, Fig. 4-11. When there is no extra space between lines, it is said to be set solid.

When the stick is full or when the type-setting is finished, the type is removed from the composing stick and placed in a galley. The type must be tied so that it does not spill, Fig. 4-12. Spilled type is said to be "PIED."

After a good clean proof is pulled on the proof press, Fig. 4-13, the type face is cleaned with a recommended solvent (cleaner). Remember to place solvent soaked cleaning rags in a metal safety can that meets local and/or national safety standards, Fig. 4-14.

If the form is no longer needed, the letters are returned to a special case for storage until they are used again, Fig. 4-15. This is called "type distribution."

The handset method is not widely used in today's graphic communications industry. It is too slow for modern production. The machine set method is much faster.

MACHINE COMPOSITION

Hot-metal machines are generally used where a large amount of composition (typesetting) is

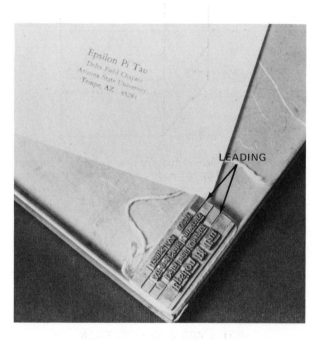

Fig. 4-11. Spacing between lines of type can be several points in thickness.

required. Some machines cast a line of type at a time and are called line casting machines. Others will cast individual characters (letters or figures) and place them in a line.

Monotype

A Monotype machine casts type characters one at a time and places single pieces of type in a complete line. It can also be used to cast the individual letters for the handset method.

The process requires two separate pieces of equipment. One is the keyboard and the other

Fig. 4-12. Strong light cord is used to tie up a type form.

Fig. 4-13. Pulling a proof on the press involves rolling a heavy drum over inked type. Type prints on the paper.

Fig. 4-14. Solvent rags must be placed in a safety container. If allowed to lie around the shop, they could cause a fire.

is the casting unit. The keyboard operator touches the keys, Fig. 4-16, which are similar to a typewriter. This action causes the machine to punch a paper tape. This tape is placed in the casting machine. The holes in the tape cause the right characters to be cast. Fig. 4-17 shows a piece of punched tape.

ffi	fl	5-em	4-em	'	k		1	2	3	4	5	6	7	8	$							
j		b	c	d		e		i		s		f	g	ff	9	A	B	C	D	E	F	G
?														fi	0							
!		l	m	n	h		o	y	p	w	,		en quads	em quads	H	I	K	L	M	N	O	
z																						
x		v	u	t	3-em spaces		a	r			;	:	2-em and 3-em quads	P	Q	R	S	T	V	W		
q											.	-			X	Y	Z	J	U	&	ffl	

Fig. 4-15. Foundry type is stored in a drawer called a "California Job Case."

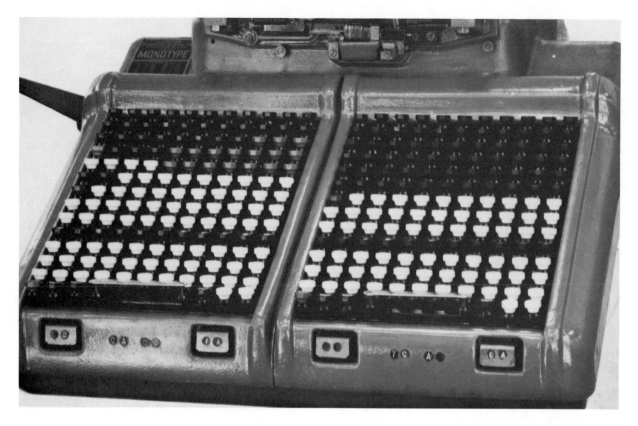

Fig. 4-16. Keyboard of Monotype casting unit is somewhat like that of a typewriter.

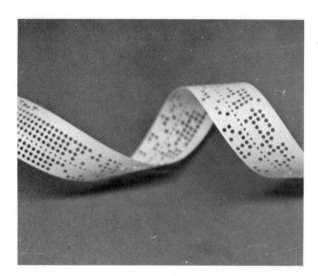

Fig. 4-17. Punched or perforated tape can control typesetting on a line casting machine. A special unit on the machine reads the tape and causes the right key to be pressed.

lines or in advertising. The compositor (typesetter) must assemble the MATRICES (molds) in a special composing stick, Fig. 4-18. It is like the handsetting operations. However, when the stick with the matrices is placed in the machine, a solid line will be cast, Fig. 4-19.

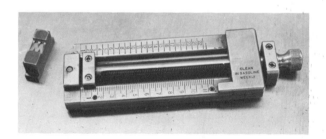

Fig. 4-18. Composition stick and matrix for casting a Ludlow slug. The matrices are locked in the stick and a whole line is cast at one time.

Ludlow

The Ludlow machine casts a solid line called a slug. It is mainly used for composing display lines of type. This is the large type used in head-

Linotype and Intertype

Both Linotype and Intertype machines cast the type characters on one solid line. Each line of type is called a slug. The lines can be set to

Fig. 4-19. Slug cast by a Ludlow machine looks like this. Extra leading must be placed on either side since the body is narrower than the type.

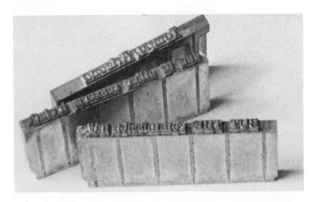

Fig. 4-21. Viewing a slug ejected from the line casting machine.

any length within the limits of the machine. The machines look very much alike, but are built by different companies. Both are operated by a keyboard, Fig. 4-20. Each has a heated chamber that contains molten metal.

As the operator touches the keys, each matrix (mold) drops into position until a whole line is set. The operator then brings the matrices into place next to the chamber holding the hot metal. The molten metal is forced into the cavity and the letters are formed in the matrices. After the line is cast, the machine trims the slugs and drops it into a tray where the operator can look at it. Fig. 4-21 shows some lines of cast type.

The slug is still very hot. Take care not to burn yourself.

Then the machine returns the matrices to a storage area called a MAGAZINE. Now they are ready to be used again for casting another line of type.

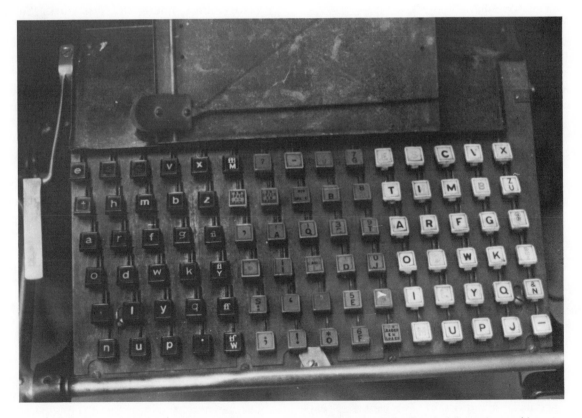

Fig. 4-20. Keyboard of a hot-metal casting machine is nearly identical to the keyboard of the casting machine.

For many years Linotype and Intertype machines have been used to set type for magazines and newspapers. But newer machines are controlled by punched tape. The holes tell the machine which letter to cast. The tape does the work of an operator. In many plants, even these machines are being replaced with faster ones.

Whatever method you are using to set copy, being clean is important. Your hands should be clean and the equipment you use should be kept clean. Dirt spots on the camera-ready copy might be photographed. Then they become part of the printed copy. It takes extra work to clean up dirt spots.

COLD TYPE COMPOSITION

In cold type composition no heat is needed to produce the image. Two main methods are used. One is mechanical. The other is a kind of photography.

Mechanical methods include:
1. Drawing by hand.
2. Use of preprinted material such as cut-out type and art.
3. Strike-on type.

You already know that cameras can make pictures. But did you know that a kind of camera can make type? It is done on a machine which has a keyboard like the line casting machines. Light shines through type characters on a negative. The light falls on a light-sensitive paper. Exposed areas of the paper turn black when the paper is developed.

DRAWING BY HAND

If a certain kind of drawing is not available, the graphic artist or designer will draw it. Likewise, when a letter design is not available, the designer draws it.

Pens and brushes are two common tools for drawing an image, Fig. 4-22. Whatever tool is used, accuracy is important. The way it appears in the drawing is the way it will print.

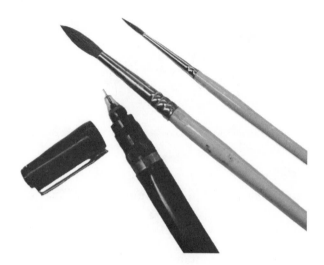

Fig. 4-22. Pens and brushes are used to make illustrations and produce hand lettering.

PREPRINTED MATERIALS

Some art is ready-made for printing. Called preprinted materials, it includes:
1. Clip art. Designs are cut out and pasted down on camera-ready artwork. See Fig. 4-23 for samples.
2. Dry transfer sheets which contain several characters of each letter of the alphabet. Figures and punctuation marks are included as well. Each character is placed in position and then rubbed with a smooth bonelike tool called a BURNISHER. The letters will stick to the paper. This is slow work but it is ideal when only a small amount of type is needed. See Fig. 4-24.
3. Cut-out type. Several kinds are available. Some letters are printed on plastic with a sticky back. Others are on individual pieces of paper. Letters must be hand positioned. Borders and some symbols are also supplied in preprinted adhesive rolls. Some examples of borders are shown in Fig. 4-25.

STRIKE-ON COMPOSITION

The typewriter is a strike-on machine. When the keys are pressed, the letter strikes the image onto a piece of paper. The inked or carbon ribbon between the letters and the paper creates a type character, Fig. 4-26.

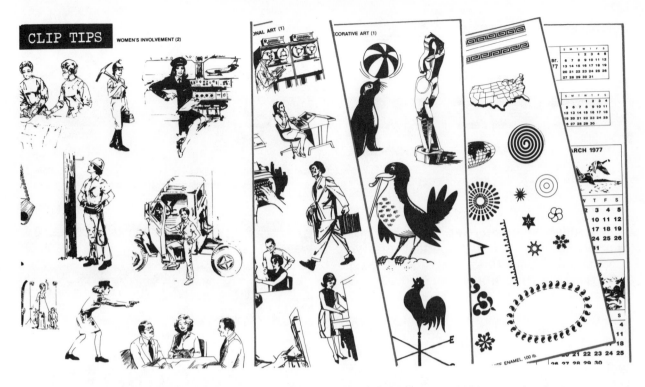

Fig. 4-23. Preprinted clip art can be purchased. Drawings can be found that are suited for many situations.

Fig. 4-24. Dry transfer lettering. Left. Letter is rubbed lightly with a burnisher to make it stick to the paper beneath. Right. Letter is transferred. (Zipatone, Inc.)

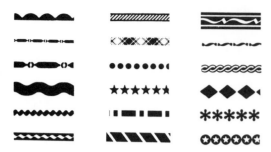

Fig. 4-25. Preprinted borders have an adhesive backing. They come in rolls and sheets.

Fig. 4-27. Strike-on composition machine elements can be quickly removed and replaced with a different face of type.

A standard typewriter can be used to make camera-ready copy. It is important that you type on a dull, smooth surface paper. The type sizes generally range from 6 point to 12 point.

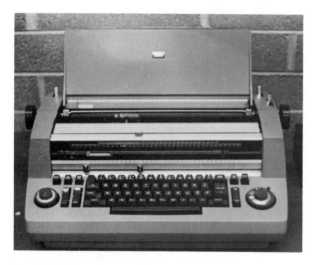

Fig. 4-26. Strike-on composition machines, such as this unit, produce a type image of good quality.

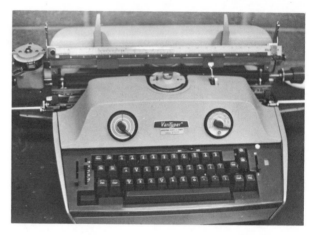

Fig. 4-28. Common strike-on type of machine. The type font consists of two half circular pieces, as in Fig. 4-27, that fit onto a revolving wheel called an anvil.

Look at the IBM and VariTyper composer elements, shown in Fig. 4-27. A VariTyper strike-on unit is shown in Fig. 4-28.

The IBM Selectric Composer and the Vari-Typer have a wide selection of type faces. The Friden Justowriter can only use one size and style.

With the IBM Selectric Composer and the VariTyper you must type each line twice if you want the line justified. First, the line is recorded in the machine. (Recorded means each letter and space is being counted.) When the line is full enough to justify, a scale above the key-board lines up a color with a number. When this color and number are lined up on a dial, the machine automatically adds the right spacing as the line is reset. Fig. 4-29 shows the lines before and after justification. The characters "b8" and so on appearing after the unjustified lines are this spacing code for the IBM composer.

If you make a mistake, a white fluid can be brushed on the letter or letters to be corrected. When the fluid dries you can type over the same area. Some operators prefer to type the correction in the margin, then cut it out and paste it over the area to be corrected. Either technique may be used.

PHOTOTYPESETTING

Two types of photocomposition are commonly used today:
1. Photodisplay.
2. Phototypesetting.

| If you make a mistake, a white fluid can be brushed on the letter or letters to be corrected. When the fluid dries you can type over the same area. Some operators prefer to type the correction in the margin, then cut it out and paste it over the area to be corrected. Either technique may be used. | b8 b4 w1 o7 g1 g2 | If you make a mistake, a white fluid can be brushed on the letter or letters to be corrected. When the fluid dries you can type over the same area. Some operators prefer to type the correction in the margin, then cut it out and paste it over the area to be corrected. Either technique may be used. |

Fig. 4-29. Retyping a line for justification. Lines at left are not justified.

Photodisplay

In this method the operator generally runs the machine manually selecting one character at a time. The characters are on a type font, either a tape or a disc, Fig. 4-30.

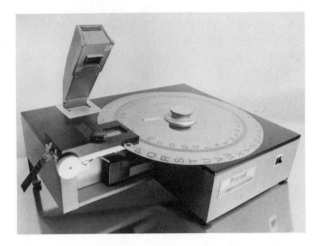

Fig. 4-31. On this machine, lettering is made the same size with the master in contact with the film or paper. (3M Corp.)

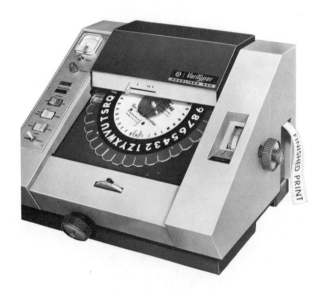

Fig. 4-30. Typemaster disc allows one character to be set at a time. Operator turns disc by hand. (A.M. International, Inc.)

Two means of placing finished copy on photographic film or paper are generally in use today. The first is a contacting method shown in Fig. 4-31. It is the basic principle, but another way to create an image on the receiving material (film or paper) is by optical (using light) means. In this method, type font characters can be enlarged or reduced. Typical photodisplay equipment is shown in Fig. 4-32.

The strip printer is one of the least costly pieces of equipment for display typesetting.

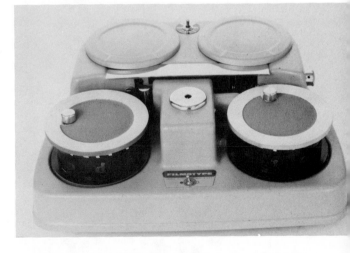

Fig. 4-32. This photodisplaying equipment can enlarge the type. (Alphatype Corp.)

Some of the machines automatically process (develop) the film or paper, Fig. 4-33. Others require hand developing and fixing of the film or paper.

Fig. 4-33. Small unit processes photodisplay film automatically.

If you use a photostabilization unit as seen in Fig. 4-34, hand developing and fixing can be eliminated. This is a quick and easy way to process the film or paper. The processor uses two fluids:

1. The activator solution develops the film or paper.
2. Then, to make it last so that it will not be affected by the air or light, the film or paper goes through a stabilizing solution.

Remember to handle all chemicals with care. Splashed or spilled chemicals can injure skin or eyes. Wear a face shield, gloves and an approved apron when handling chemicals.

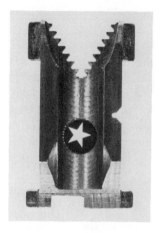

Fig. 4-35. Photomatrix is used to place letter on photographic paper. Letters or shapes are in the circular area in the center. Light shines through this shape or letter and makes the same shape on a piece of photographic film.

Phototypesetting

The phototypesetter is a complicated, high speed, composing machine. It is most popular for book, newspaper and magazine work, but is also used in a wide variety of other applications. Many different models are on the market but operation is similar. All have an assortment of

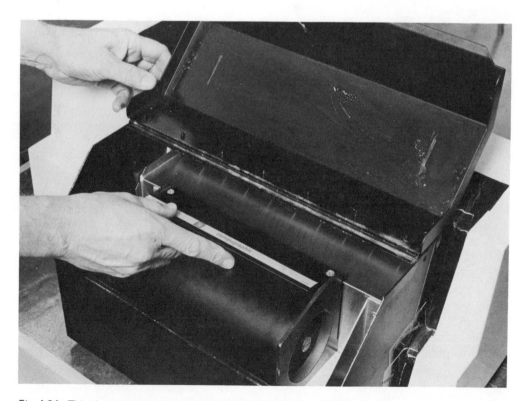

Fig. 4-34. This piece of equipment processes some photographic material without hand developing or fixing.

type characters which are on a PHOTO-MATRIX as shown in Fig. 4-35. The number of type fonts and sizes vary with each machine. The number of matrix holders and the number of lenses will determine the number of type styles and sizes in each phototypesetter.

The operator must use a keyboard or some other system to tell the machine what to set. After the copy has been recorded (this is called input), the machine will automatically set the copy in the line length and type style wanted. Fig. 4-36 shows how the image is photographed from the photomatrix.

One of the recent input (recording) systems is called OCR. It means Optical Character Recognition. The typewritten copy can be placed in this machine and the machine will scan (read) the material. After the scanning, a tape or similar coding will be made. This tape or code can be used to automatically set the copy. The photo unit is started up by the input material (tape) and a high speed light passes through the negative photomatrix type character. Each letter is photographed on the film or paper. In Fig. 4-37 you can see the inside of such a phototypesetter. The type characters are found in four positions on the strip or negative film. The film is securely attached to a wheel which constantly revolves at high speed.

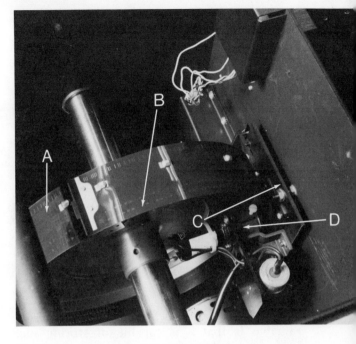

Fig. 4-37. Looking down on a Compuwriter image generation unit. A—Filmstrip wrapped around revolving wheel. B—Alphabet characters and numbers. C—Direction of light travel to lens and sensitive paper. D—Housing for high speed light. Paper is not visible.

After a line is set, the operator touches a command key. This causes the high intensity lamp to flash light through the letters, figures and numbers. The light continues through a lens which moves to place the images on a photo-

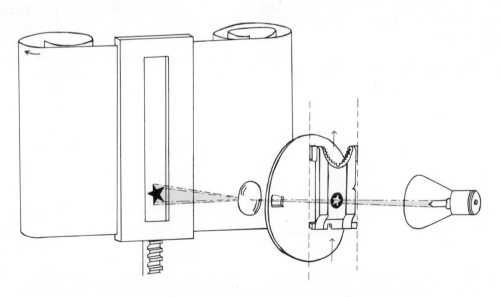

Fig. 4-36. This is how type characters are set in a typical phototypsetting operation. The photo-matrices are placed in front of the light one-by-one and the line is set character by character on the photographic paper. The paper is then taken into a darkroom and developed.

sensitive paper. The paper is held still. When all of the images are photographed on the paper, the holder (called a cassette) can be taken to a processing unit where the paper is developed.

Phototypesetting equipment has a great speed range. The slowest equipment sets eight characters per second. The Cathode Ray Tube (CRT) system will expose over 10,000 characters per second.

Computer controlled typesetting

Computers can operate phototypesetters at very high speeds. Machines can set a full page of type and illustrations at one time. Some of the systems go directly to the image carrier (printing plate) bypassing the platemaking as well as the photographic steps.

One of the reasons that the computer is so valuable is that it is capable of storing such information. When you need it you can call for it. This is known as retrieval. The computer can act like a dictionary telling the composing unit how to hyphenate a word at the end of a line of type. This information is stored in the computer's own filing system called a memory bank.

Another need might be to justify each line of type. The computer can be told (programmed) to set each line to a selected line length. A computer can save time and cut down the number of human operations. Keeping it busy requires planning.

TEST YOUR KNOWLEDGE — UNIT 4

1. What is the latest term used which refers to the setting of type?

2. Which of the following are terms for a kind of type composition:
 a. Cold type.
 b. Design type.
 c. Hot type.
 d. Intertype.
 e. Phototype.
3. A line 3 in. long is just about equal to _____ picas.
4. A complete assortment of letters, figures and punctuation marks is called a _____ of type.
5. Which of the following are used only in hot type composition:
 a. Linotype.
 b. Magazine.
 c. Matrix.
 d. Monotype.
 e. Proof press.
 f. Slug.
 g. Strike-on type.
6. List ways of composing cold type.
7. Using dry transfer type is slow but it is ideal where only a small amount of type is needed. True or False?
8. _____ and _____ are two common types of photocomposition.
9. Not all phototypesetting machines use a keyboard for setting type. True or False?
10. List the common reasons for using computer aided composition.

SUGGESTED ACTIVITIES

1. Select six styles of type from selected printed material. Cut each one out and attach it to a sheet of paper and label each style as to its classification.
2. Find examples of display type and body type.

Unit 5

ART AND COPY PREPARATION

Preparing copy so that it can be photographed with a process camera is the concern of this unit. The artist or the layout person assembles all of the artwork and the copy and places it in the right position on the layout. The location is determined by the finished layout (comprehensive).

Art and copy are of two kinds:
1. Line copy.
2. Continuous tone copy (halftone).

EQUIPMENT AND MATERIALS

Equipment and materials needed for copy preparation include:
1. Drawing surface.
2. T-square.
3. Triangles.
4. Rules and gauges.
5. Irregular curves.
6. Compass.
7. Pencils.
8. Pens.
9. Adhesive materials.
10. Cutting tools.
11. Masking film.

Drawing surfaces should be flat and smooth with at least one true (straight) edge. A drawing board is commonly used. It comes in many sizes, Fig. 5-1.

T-squares are used to draw horizontal lines and provide a true edge for the triangles. When the head of the T-square is placed against the true edge of the drawing board, the blade can be used as a guide for positioning the layout sheet on the board. Then it is also used to draw

Fig. 5-1. Drawing boards have flat, smooth surfaces and at least one true edge.

Fig. 5-2. The T-square is a common straightedge tool. A— Working edge of board. B—Head. C—Blade.

lines on the layout, Fig. 5-2. Metal T-squares are often used rather than wood or plastic because the blade edge can be used to cut a straight line with a knife.

Triangles, supported by the T-square, Fig. 5-3, are used to draw vertical and/or slanted lines and also to align copy, Fig. 5-4. The triangles, a 45 degree and a 30 — 60 degree, can be either plastic or metal.

Fig. 5-3. T-square supports triangle for aligning copy elements.

Fig. 5-5. Instruments used in graphic communications can be made of durable materials such as wood, metal and plastic.

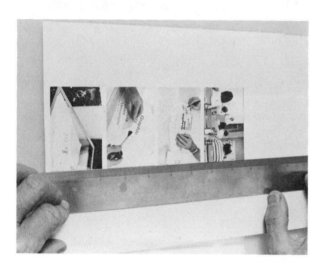

Fig. 5-4. Copy can be aligned with a straightedge.

Fig. 5-6. A French or irregular curve is used to draw curved lines

Rules and line gauges measure spacing accurately. It is important that material be in exact position on the layout. These measuring tools can be made of wood, plastic or metal, Fig. 5-5.

Sometimes it is necessary to layout or draw irregular (curved or crooked) lines. In such cases the French or irregular curve can be a very helpful tool. See Fig. 5-6.

The compass is designed for drawing circles or arcs. It is made in various sizes. A drawing set usually contains the small compass, as well as the larger compass with extensions for drawing large circles or arcs, Fig. 5-7.

Fig. 5-7. Use a compass to make an arc or circle. Several sizes are contained in a set.

Pencils are ideal for sketching an idea on paper. A light blue pencil should be used to draw guidelines and to write instructions for the person pasting up the camera-ready copy. Since light blue lines do not photograph, you do not need to erase them.

Some inking pens are for freehand drawing, while others are used to make lines of uniform width. Pens are available in varying line widths. If a large area is to be filled in, a brush might be preferred.

When pasting up copy, you may choose from several materials which are used to adhere the various kinds of copy to the main copyboard, Fig. 5-8. Rubber cement is used to paste the

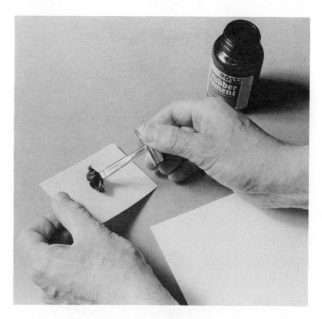

Fig. 5-9. Adhering copy with rubber cement is a quick method of securing it.

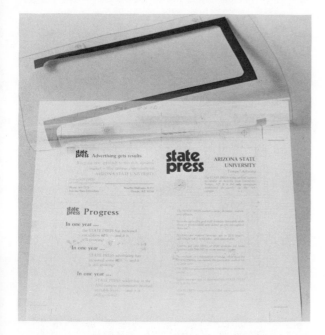

Fig. 5-8. Camera-ready artwork must be securely fastened to the layout board or sheet. Cement, wax and transparent tape are used. Overlays are usually attached at top.

Fig. 5-10. When copy is passed through this machine, heated wax is applied to the back. (Challenge Machinery Co.)

copy element to the main makeup board, Fig. 5-9. Wax coating devices are another means of attaching copy. This has an advantage over some adhesives in that you can remove copy and reposition it without damaging the copy. Pressure is applied to the copy with a smooth instrument (burnisher) to make it stick. Care must be taken not to dirty or ruin the copy. A waxing machine is shown in Fig. 5-10.

Double-coated adhesive tape is sometimes used to hold copy in place. Care must be used to position copy correctly. Attempting to remove it could destroy it, Fig. 5-11.

Cutting clip art, letters and/or copy for positioning on the makeup board requires an

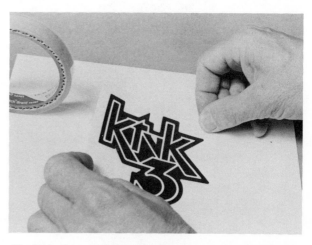

Fig. 5-11. Copy adhered with double-coated tape becomes permanently attached.

instrument with a sharp cutting edge. Razor blades, scissors and special knives, Fig. 5-12, are satisfactory.

Use extreme care. Sharp edges are dangerous. Proper protective handles and carriers should be used. Do not place sharp tools where they can injure someone else.

Masking films block out·areas or become part of the camera-ready copy. Masking films are made so that they can be peeled away from

Fig. 5-12. From the top, common cutting instruments are the special purpose knife, razor blade and X-acto knife.

1. CUT A PIECE OF THE DESIRED FILM LARGE ENOUGH TO COVER AREA TO BE MASKED. TAPE IT DOWN FIRMLY AT THE TOP WITH DULL SIDE UP.

2. WITH SHARP BLADE, OUTLINE THE AREA TO BE MASKED. DO NOT CUT THROUGH THE BACKING SHEET.

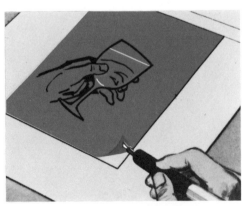

3. USING THE TIP OF THE BLADE, LIFT UP A CORNER OF THE FILM, SEPARATING IT FROM THE BACKING SHEET.

4. THE COMPLETED MASK CORRESPONDS EXACTLY TO THE DESIRED PATTERN.

Fig. 5-13. Follow these steps for using masking film. Ulano

a base material. The base which is clear is usually made of plastic. The film is peeled from the support base, as shown in Fig. 5-13.

KINDS OF CAMERA-READY COPY

It is generally accepted that copy can be divided into two major classifications: line and continuous tone.

Either can be printed as one color, multicolor or full color. Fig. 5-14 shows both classifications.

LINE COPY

Line copy is an image which is a solid. It does not have tonal value (no shades). The copy must be dense. Black ink or some other black material is commonly used. The material on which you place the line copy must be a smooth, hard surfaced white stock (paper). Many graphic designers use white illustration board.

If the line copy does not have uniform density or blackness, the camera will photograph the bad copy. The final printing will not be high quality work. Being accurate and

careful at this point will pay off. Handle all work with care. Keep the copy clean and try to eliminate all imperfections. Mistakes will show up later on the printed job.

Common examples of line work are type matter, pen and ink illustrations, hand lettering, diagrams and charts, screen tints and line conversion.

TYPE MATTER

Type matter refers to all of the copy that is composed by hot metal or cold type composition. It is all of the text material. When the copy is composed for photo-offset lithography, the camera-ready material is pasted up and made ready to be photographed, Fig. 5-15. The compositor (typesetter) must have copy that is correct. Check the spelling, grammar and punctuation. Never omit this very important task.

The instructions given to a compositor (typesetter) is called markup. The following information should be included:
1. Point size of type.
2. Kind of and letter style of type.
3. Capitals or lower case.

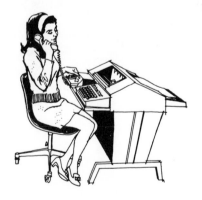

ABCDEFGHIJKLMNOPQRSTUVW
abcdefghijklmnopqrstuvwxyzçæœà
1234567890£ß&%()/$¢+?¿!*»«.,---.,„

Fig. 5-14. Three elements above are examples of the two kinds of camera-ready copy. Above left. Photograph is continuous tone copy. Above right and below. Drawing and type are both included in line classification.

4. Leading (spacing between lines).
5. Spacing of type (centering, flush left or right, or both).
6. Length of line in picas.

Markup is illustrated in Fig. 5-16. Copy, as marked, would look very much like that shown in Fig. 5-17.

The proofreaders' marks, Fig. 5-18, are standard and should be used to show all corrections on set type. Corrections should be easily seen and understood. Therefore, a colored pen or pencil is recommended as the writing instrument. An example of how proofreaders' marks are used is found in Fig. 5-19.

Fig. 5-15. This camera-ready copy is another example of line art.

Copy Holiday ad

48 pt
20th Cent.
+ bold Caps —
flush left
lead 12 pt

EXCITING

TENNIS

HOLIDAY

10/15 UNB Cle
flush right
ragged left —
set line
for line

Come and join in the fun in our new tennis

spectacular. We are offering a new type of vacation

which will really fill your summer with fun and excitement.

Plenty of time for fun in the sun as well as big name

matches and entertainment.

We offer, for a minimal price, all transportation

for a vacation that you will never forget.

Let Holiday Tours take care of all

arrangements and relax!

furnished
art

HOLIDAY

TOURS

14 pt
20th Cent.
Bold Caps

Fig. 5-16. Marking up copy means telling the compositor the size of type, leading and any other information on how it should be set.

Fig. 5-17. How the type set as marked for Fig. 5-16 might appear as a mechanical.

Dark type cannot be printed over a dark area. It would be difficult, if not impossible, to read. To make it visible, the graphic designer or layout person may mark it for a reverse image. The type is seen as the color of the paper. The background is the color of the ink. It is in reverse of the original copy.

Pen and ink illustrations must be done carefully making sure the lines are dense (black). Fig. 5-20 is a good example.

Sometimes the right type styles are not available. The graphic designer then draws the lettering. This is most common when laying out

✕ Defective letter
⊥ Push down space
⌐ Turn over
Ⓡ Take out
∧ Insert
⋇ Insert space
⌣ Less space
⊂ Close up entirely
⊙ Period
⟋ Comma
⊙ Colon
⟋ Semicolon

⋁ Apostrophe
⋎ Quotation
─⟋ Hypen
⊐ Move over
⟊ Paragraph
no ⟊ No paragraph
wf. Wrong font letter
tr. Transpose
Caps Capitals
s.c. Small capitals
l.c. Lower-case letters
○ Spell out

Fig. 5-18. These symbols are used by all who read and mark up corrections on type set copy.

tr. A new whefed combination gravure and wf.

l.c. intaglio Press is being installed at the U.

Ⓡ S. Bureau of Engraving Ⓡ

Fig. 5-19. This paragraph has been proofread and corrections are marked for the printer.

Fig. 5-20. Good pen and ink drawings use a strong black line.

display lines of type or when an individual letter is needed to add distinction to the printed page. The same care must be taken as with pen and ink illustrations, Fig. 5-21. The diagram or chart is another form of line copy, Fig. 5-22.

Screen patterns are often made by taking transparent shading film and placing it in position on the layout. The film is then cut with a sharp instrument in the area to be shaded. The shading film is available in many patterns.

Fig. 5-21. This display letter has been drawn by the artist.

Line conversion is the changing of a continuous tone print into line copy. One of the common examples used in industry is posterization. The effect is shown in Fig. 5-23.

CONTINUOUS TONE COPY

Continuous tone copy can be either photographs, rendered drawings or illustrations. (A rendered drawing is one made to look realistic like a photograph.) A charcoal drawing is an example of such an illustration.

Continuous tone materials must be broken up into dots before they can be printed. The dots vary in size so that your eyes see them as

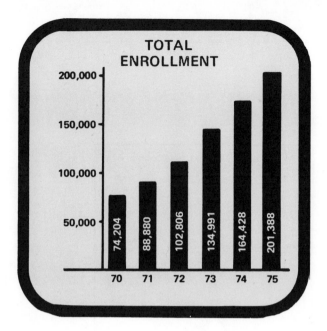

Fig. 5-22. Charts are another kind of line work.

Fig. 5-23. In posterization, a photograph loses its gray tones and is seen as being black and white only. It looks like a pen and ink sketch.

various tones. If the dots on a printed picture are small, they represent the light or highlight area of the photograph. If the dots are heavy,

your eye sees them as the dark or shadow area of the photograph.

When the continuous tone print has been broken up into a dot pattern, it is called a halftone, Fig. 5-24. Generally, the small half-

Fig. 5-24. Dot pattern of a halftone is shown enlarged. Note difference between shadow (dark) areas and highlight areas. (A. B. Dick Co.)

tone dots are not seen by our eyes but tend to blend into tones. The process of making a halftone will be discussed later.

When line copy and continuous tone copy are used together on the same printed piece, it is called a combination. The page can be printed in single color or a number of different colors. Multicolor printing means using more than one color. This technique requires overlays. These are separate camera-ready sheets. A sheet is needed for each color. The overlay is attached as illustrated in Fig. 5-25.

WORKING WITH ILLUSTRATIONS AND TYPE

Photographic prints (pictures) and all illustration material must be handled very carefully. If you must write information on the print, you may write lightly on the back with a very soft pencil. But even this is often discouraged as it takes very little pressure to damage a photograph. Never use a ball point pen. It will leave raised marks (embossing) on the glossy side of the photograph. Paper clips will also leave marks or indentations and are not recommended as a means of fastening something to the photograph. It is better to attach instructions or identification to the back of the photo with drafting tape or scotch tape. Keeping all surfaces clean and mark-free is very important.

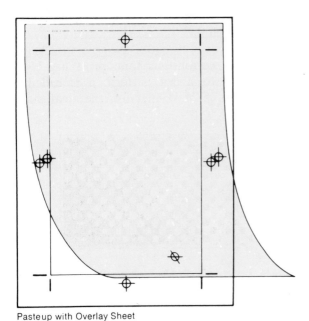

Pasteup with Overlay Sheet

Fig. 5-25. The overlay is a clear sheet so you can see through it. Register marks (the circles with crosses) help line up the overlay so the color is in the right place. Each color requires a separate overlay. (A.B. Dick Co.)

SCALING COPY

Many times the illustrations are of different sizes. Some are larger than the final printed sheet; some might be smaller. Scaling involves finding the new height and width of copy elements that have been enlarged or reduced.

Scaling can be done two ways:
1. Diagonal line method.
2. The proportional scale method.

When reducing by the diagonal line method, you must first decide on the dimensions of the final printed size. If you are going to reduce the size of the original, use the following procedure:
1. Fasten a tissue overlay onto the original copy.
2. Draw a box on the tissue of the area you want to reproduce. Use a very soft pencil so that you do not mark up or mar the original.
3. Remove the tissue and finish drawing the diagonal line and find the size as shown in Fig. 5-26.
4. Replace the tissue over the original copy. The size is changed but the ratio of height to width remains the same.

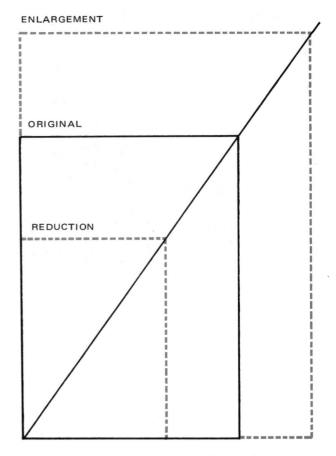

Fig. 5-26. Reducing or enlarging by diagonal line method. Always measure your new width from the left to the right. The new height will also be the distance from the base up to where the dotted line crosses the diagonal line.

If available, proportional scales are a rapid method of finding a new size. The scales are also used to figure out the percentage of reduction or enlargement. When the height of the copy is to be reduced, the scale can be used to give the percentage of change in the height. The scales generally have two rows or circles of numbers. One will be the original size and the second will be the finished size. When lined up according to sizes, the percentage of change will show in the window. See Fig. 5-27. The information is used by the camera operator. The percentages should be written as: "25 percent of original," "15 percent of original." Never write in the image (copy) area.

A mathematical formula can also be used to find an unknown width and height. For example, a photograph is to be placed in an area which measures 3 in. wide by 4 in. high. The

original width of the photo is 5 in. What original height is needed to fit in the printed area? To solve it, use this formula:

1. $\dfrac{\text{Width of original copy (5″)}}{\text{Height of original copy}} =$

$\dfrac{\text{Width of final printing area (3″)}}{\text{Height of final printing area (4″)}}$

2. $\dfrac{5}{H} = \dfrac{3}{4}$

3. $3H = 5 \times 4$ (cross multiplying)

4. $H = \dfrac{20}{3}$

5. $H = 6.666$.

The photograph must have a height of at least 6.666 inches to be reduced to fit in an area 3 in. by 4 in.

CROPPING TO FIT SPACE

Sometimes photographs and/or artwork have an area which you do not want in the final

Fig. 5-27. Proportional scales, like this are a popular way to determine size of illustrations.

printed material. Cropping is the process of marking to show what portion of the copy is to be used. You must indicate the area by placing marks on the edges. These marks cannot be placed in the area which will later be printed. Place fine line marks on all four sides, as shown in Fig. 5-28. A tissue overlay is another way of giving information to the person operating the camera.

Fig. 5-28. Photographs should have crop marks on all four sides. These marks should be made outside the image area. Box shows area of the photograph being used.

Whichever method you use, make sure one dimension is given, Fig. 5-29. Sometimes, instead of dimensions, the percentage of reduction or enlargement, Fig. 5-30, is shown on the copy. When the person operating the camera reduces or enlarges to that percentage of the original material, the dimension will be correct.

REGISTER MARKS

Register marks are the crosslines you see within circles. Their function is to correctly position one piece of copy with another, Fig. 5-31. The number of register marks and the placement varies, but most designers use at least three. Placing them on the vertical and horizontal center line is generally preferred. Some of the kinds of register marks are shown in Fig. 5-32. Remember, the register marks must line up or the final printing reproduction will be out of register. It will not line up.

Fig. 5-30. Marking the percentage of reduction is another way of telling the graphic arts camera operator the right size.

Fig. 5-29. Give a dimension for one side of the illustration.

COPYFITTING

Copyfitting is the process of estimating how much typewritten copy is needed to fit into a given area on a printed page. It also involves selecting the kind and size of type that will do the job best. There are two steps:
1. Accurately measure the copy.
2. Use the measurement to choose the correct size and style of type the will fit into the area set aside for type.

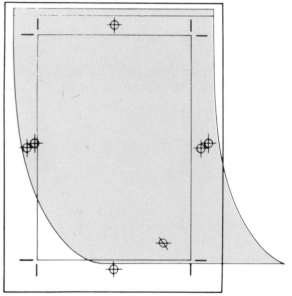

Pasteup with Overlay Sheet

Fig. 5-31. Register mark placement on an overlay is very important. At least two should be used.

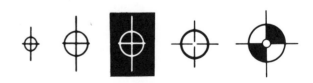

Fig. 5-32. Register marks are sold in several designs on an adhesive backing.

One of the methods of measuring copy is by character count. This method requires that you count all of the letters, spaces, punctuation marks and figures in the total copy. This can be done by individual count or by measuring with type gauge (ruler).

For every inch of elite typewriter copy, there will be 12 characters. Pica typewriter copy will have 10 characters per inch, Fig. 5-33.

After all of the copy has been measured, the copyfitter chooses a method to calculate the type. Most type books have a copyfitting chart. The chart shows how many characters of the selected size will fit in one pica of space. Let us suppose that the layout calls for a column of type 15 picas wide. The chart shows that 40 characters will fit in a line that length. The original copy had 400 characters. Dividing 400 by 40 indicates that the original copy will make 10 lines of type. Accurate figuring removes guesswork.

COLOR

Color exists all around us. In printing we use it to draw attention and then hope to leave a favorable impression. Color is a very complex subject. To fully understand it you should read books specifically related to color.

All color comes from light. Light is made up of various wave lengths that we can see. These waves vary in length. Red has the longest, while violet has the shortest wave length. Compare it to the colors of the rainbow. The rainbow would have red, then move to the oranges, yellows, greens, blues, indigo and violet.

When printing a full color picture, the printer will use three primary ink pigments and black. The three pigment primaries that would be used are: magenta (red); cyan (blue), and yellow. These are called process colors. From these colors we can produce a full color picture. If you look at the printed picture very closely

Fig. 5-33. Typewritten lines can be measured with a type gauge.

you will see that the picture is made up of dots from the different process colors. Each of the colors are separately printed one over the other. The dots overlap and are capable of making any color of the rainbow. The printed image looks much like the original copy.

Color can also be used as a background and then overprinted with black or another color, Fig. 5-34. Color makes a printed page much more interesting.

Fig. 5-34. One color printed over another color adds interest to the layout. (Killgore Graphics.)

TEST YOUR KNOWLEDGE — UNIT 5

1. _____ and _____ are the two kinds of art or copy.
2. List the common equipment and material used to prepare copy and/or artwork.
3. Which of the following are common kinds of line copy?
 a. Charts.
 b. Diagrams.
 c. Halftones.
 d. Hand lettering.
 e. Line conversions.
 f. Pen and ink drawings.
 g. Photographs.
 h. Screen tints.
 i. Type matter.
4. A photograph is what type of copy?
5. When halftones and line copy are on the same page it is called a _____.
6. Sizing copy is called scaling. True or False?
7. The process of marking a photograph to indicate what portion to use is called:
 a. Composition.
 b. Cropping.
 c. Overlay.
 d. Scaling.
 e. Sizing.
8. What marks are used to position one copy with another?
9. For what reason would you character count typewriter copy?
10. Check which of the following inks would be used to print a full color picture:
 a. Cyan.
 b. Green.
 c. Magenta.
 d. Orange.
 e. Yellow.
 f. Violet.

SUGGESTED ACTIVITIES

1. Using the proper equipment, line up a photograph and type to make one 35 pica column.
2. Select a photograph and crop it. Take that measurement and proportionally scale it so that it is one and one half times its original size.
3. Camera-ready art has been prepared and it measures 10 by 12 in. The 12 in. side must be reduced to 6 in. What will be the length of the 10 in. side?

Unit 6

PHOTO CONVERSION

Graphic arts photography is the backbone of photo-offset lithography. A special camera, called a process or copy camera, transfers the image onto a piece of film. This piece of film is known as a negative, Fig. 6-1.

Fig. 6-1. Piece of film with an image on it is called a negative.

The camera-ready copy you have prepared is placed in the copyboard. Then film which is light-sensitive is placed on the film back of the camera. When light is allowed to enter through the lens it strikes the film and causes changes in the light-sensitive material. The process camera can enlarge, reduce or keep the copy the same size on the film.

CAMERA TYPES

Two types of process cameras are common in the graphic arts industry:
1. Gallery.
2. Darkroom.

The gallery camera, Fig. 6-2, is usually installed in the darkroom. If a light-tight film holder is used, it could be installed in a lighted room. A darkroom camera's film holder is in

Fig. 6-2. This gallery camera may be used where the entire room can be darkened. (A.B. Dick Co.)

the darkroom while the copyboard is in a lighted room. The darkroom camera is considered to be the most efficient since film handling always takes place in the darkroom.

Graphic arts cameras are further divided into two types:
1. Horizontal.
2. Vertical.

In the horizontal type, as the name implies, the line of exposure is horizontal, as shown in Fig. 6-3. Some of the very large horizontal cameras have an overhead suspension system, Fig. 6-4. Cameras must be sturdy to reduce vibration. As seen in Fig. 6-4, the copyboard is at one end and the film holder is at the other end of the camera.

LINE OF SIGHT

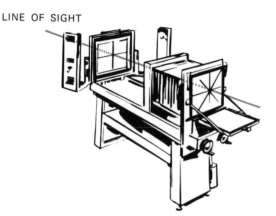

Fig. 6-3. Line of exposure is horizontal.

The vertical camera has the copyboard below the film holder. Line of exposure is up and down or in a vertical position. See Fig. 6-5. The vertical camera works well in an area that is

LINE OF SIGHT

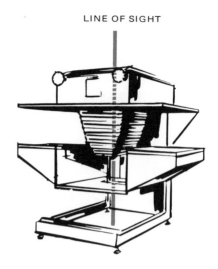

Fig. 6-5. Vertical line of exposure. (A.B. Dick Co.)

small. It requires less space. Film and copy size is limited with the vertical camera.

PARTS OF A PROCESS CAMERA

Essential parts of a process camera are:
1. Copyboard.
2. Lens.
3. Camera back (film holder).
4. Lights.

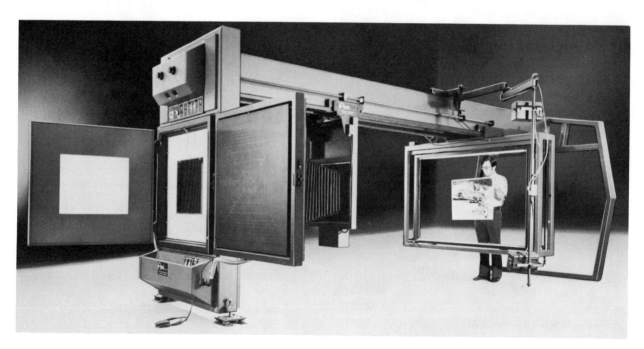

Fig. 6-4. Overhead suspension type camera. (ACTI Products, Inc.)

Other common parts of a camera are shown in Fig. 6-6.

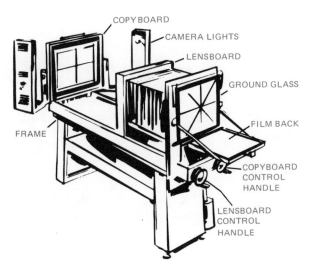

Fig. 6-6. Common parts of a process camera.

COPYBOARD

The copyboard holds the original copy. Its two parts are hinged so that half of it swings open and permits you to put the copy between

Fig. 6-7. Copy is placed in the copyboard.

the glass and sponge back, Fig. 6-7. When closed, the copy will be held flat and in very close contact with the copyboard glass.

Always make sure the copyboard glass is clean. Care must also be taken so that you do not scratch the glass. Rough handling of the copyboard could also cause serious alignment problems.

LENS

The lens of a process camera is made up of several glass elements, Fig. 6-8. They are placed next to each other and then held in place by a

Fig. 6-8. Lens of a process camera is like the lens in a hand held camera. It must be handled with care.

lens barrel. The lens is one of the important parts of the camera. It must be free of all defects and must convert the copy exactly to the film.

A lens cap should cover the lens whenever it is not in use. The lens must also be kept clean. Only lens cleaner and lens tissue should be used for this purpose. Using other materials might scratch the lens. Do not touch the lens with your fingers as this can cause etching.

DIAPHRAGM

An arrangement of overlapping metal leaves, called a diaphragm, changes the size of the opening through the lens. The diaphragm regulates the amount of light that will pass through the lens. Look again at Fig. 6-8. You can see the opening in the diaphragm. The leaves are also visible. The size of the opening is expressed as f-stops or aperture openings. The larger the number, the smaller the diaphragm opening. The largest f-stop or aperture, usually found on the collar of the lens, is f/8. The smallest f-stop would be f/90.

Common f-stop openings are: f/8, f/11, f/16, f/32, f/45. See Fig. 6-9. Changing an f-stop means more or less light will pass through the lens. An f-stop of f/16 allows half the amount of light as f/11. Process cameras have an f-stop which gives the best resolution (sharpest image).

Fig. 6-10. Shutter of a process camera is controlled electrically by the mechanism at lower left.

Fig. 6-9. Lens f-stops are indicated by numbers on the side of the lens barrel.

Shutters are used to keep light out but will open when an exposure is needed, Fig. 6-10. Many shutters are hooked up to a timer so that they open and close automatically.

Often graphic arts cameras will have a diaphragm control scale, Fig. 6-11. This scale is very helpful. It permits you to adjust the amount of light reaching the film when enlarging or reducing copy. As a starting point, you will most likely select the f-stop that will give you the best (sharpest) image. You will set this f-stop on the barrel of the lens. Then locate the scale for that f-stop and move the control arm so that it centers on the number matching the percentage of enlargement or reduction. The control arm is attached to the lens collar. When moved it changes the aperture opening. Look at Fig. 6-12. The line on the control arm is lined up with the number 100 on the f/22 scale. This means 100 percent. The finished image will be the same size as the camera-ready material.

CAMERA BACK

The main purpose of the camera back is to hold the film while it is being exposed. Three types of supports are used in industry today.
1. The vacuum back is the one most often found in industry. An electric motor with a pump is attached to the camera back. When film is laid over the holes, the suction caused by the vacuum holds the film in place. See Fig. 6-13.
2. The stay flat camera back is made of metal or glass. The surface is coated with a sticky substance that holds the film in place.
3. The third type of camera back usually consists of two hinged surfaces, generally

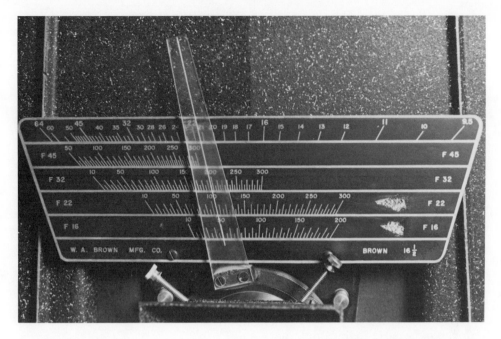

Fig. 6-11. Diaphragm control scale adjusts amount of light that will fall on the film during exposure. Numbers on the scales (except for top row) indicate percentage of reduction or enlargement.

Fig. 6-12. The control scale here has been set at 100 percent on the percentage scale for f/22. By looking at the lowest number and the highest number on the f/22 scale in Fig. 6-11, you can see that this f-stop ranges from a reduction of 10 percent of original to 300 percent or three times original size.

glass, which hold the film flat between them. Very seldom do you find this method used in a production shop.

LIGHTS

Light is essential for graphic arts photography. The lights are used to illuminate (light up) the copyboard. This light reflecting back

Fig. 6-13. Vacuum holds film in place on the film back.

through the lens to the film plane (camera back) puts the image on the film. The amount of light is controlled by the lens opening (f-stop) and the length of time the shutter is open. If these are not controlled, the image on the film will not be usable.

Several kinds of lighting are used for copyboard illumination. One kind is the common incandescent light bulb. Since such bulbs do not produce a strong light, the exposure is usually quite long. More commonly used are the carbon arc, pulsed xenon, quartz-iodine and mercury vapor lights.

Carbon arcs have been a standby in the industry. However, they tend to be dirty and require some special attention to comply with safety and health standards.

The pulsed xenon, quartz-iodine and mercury vapor are all very satisfactory light sources. There are advantages and disadvantages in each but all give good clean lighting. The choice often is determined by the intended use. Your supplier can furnish technical information.

All of these sources are considered to be white light. If we could use the sun it would be considered a high quality light source.

Lights are attached to the camera in a number of ways. A typical example is found in Fig. 6-14. Many lights can be adjusted to different copyboard angles.

Fig. 6-14. Lights attached to copyboard illuminate the copy and produce a better image on the film.

IMAGE SIZE

Process cameras are capable of enlarging or reducing copy size when needed. Some cameras have markings on the rails of the camera, Fig. 6-15, while some have the markings on tapes which can be read and set from the darkroom, Fig. 6-16. Movement is taking place between the copyboard and the lens as well as the lens and camera back. When the percentages or

Fig. 6-15. Percentage scales are marked on camera bed.

Fig. 6-16. On some cameras, percentages are registered on tapes. (ACTI Products, Inc.)

figures on the tapes are lined up the image should be in focus. This means that the camera operator should see a sharp image on the ground glass, Fig. 6-17. For accurate work, the image should be viewed with a magnifier to check for clear, sharp images.

Visual focusing requires that the ground glass be exactly where the film is placed. The design of the ground glass and/or camera backs varies with each manufacturer, but Fig. 6-17 is very typical.

FILMS FOR PHOTO CONVERSION

Many kinds of film are on the market but two types are commonly used in process camera work:
1. ORTHOCHROMATIC (ortho) films are used to convert black and white line images.
2. PANCHROMATIC (pan) film converts all colors. We will concern ourselves chiefly with ortho type film and only make reference to other types.

Graphic arts films can be purchased in various thicknesses. The range is generally from

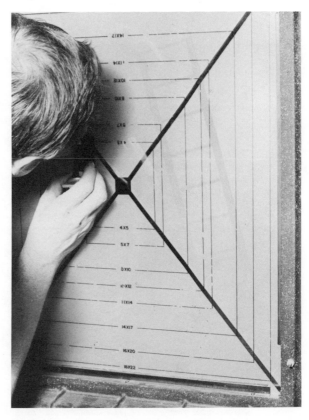

Fig. 6-17. Camera operator places magnifier on the ground glass to check for image focus.

67

.003 to .007 in. The support or base of the film is made of several materials: acetate, polyester, paper or glass.

Several layers or coatings make up the film. The top coating is called the protective layer, beneath it is the EMULSION, next is the base, and then an ANTIHALATION backing. See Fig. 6-18.

The very thin protective top coating helps to prevent scratching of the film. The emulsion is a mixture of light-sensitive silver salts and gelatin. This is the layer that will hold the image. It will have both clear and dark (opaque) areas when exposed and processed, Fig. 6-19.

The base is the support for the emulsion. It must be able to withstand the effects of chemicals and handling.

The antihalation backing is a dye applied to the base on the opposite side from the emulsion. It absorbs the light and does not allow it to reflect back through the film as it is being exposed.

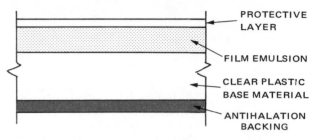

Fig. 6-18. Several layers make up film. (A.B. Dick Co.)

Film should be handled very carefully. Fingerprints will show on the image area. It is a good idea to handle the film by the edges. Care must also be taken never to open a film box to room or white light. The only light that film is not extremely sensitive to is red light. Handle ortho film in only red safe light areas.

DARKROOM

Film handling generally takes place in a darkroom. The darkroom must be light-tight. White light from an outside area must not be seen in the room. The room is generally fitted with yellow lights as well as red safe lights.

Fig. 6-19. Clear areas of the negative allow light to come through. Opaque areas hold back all of the light.

Exposing of the film (when using a dark-room camera) and processing of the film also takes place in the darkroom. Fig. 6-20 is a typical darkroom layout.

The equipment commonly found in the darkroom includes: sink, processing trays, safe lights, thermometer, timer, measuring graduates, mixing utensils, film storage and chemical storage cabinets.

The sinks are often used for temperature control as the chemicals should be at 68 F or 20 C for best processing outcomes. Running water is needed to wash the film. Processing trays are

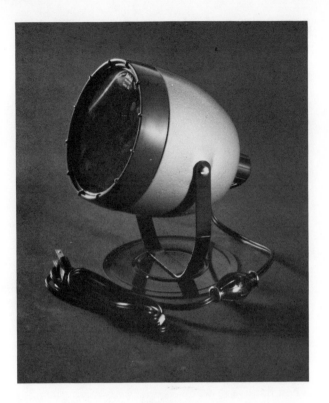

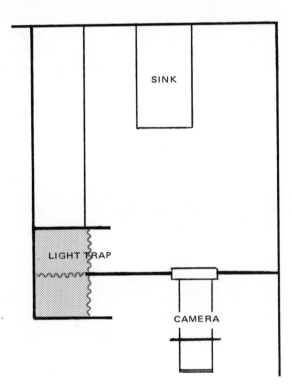

Fig. 6-20. This is a typical darkroom layout. Note how entry is arranged to keep out room light.

used to develop the film. This will be discussed a little later in the unit. The thermometer measures the temperature of the processing solutions.

Safe lights should be placed throughout the darkroom. Generally, none should be closer than 4 ft. from the film-handling areas, Fig. 6-21. A timer, Fig. 6-22, is needed to check film development time.

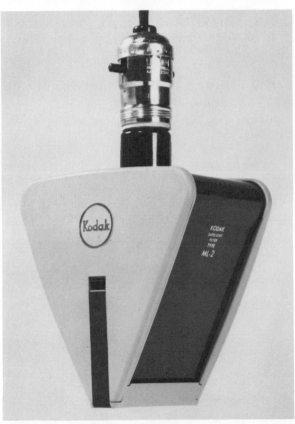

Fig. 6-21. Darkroom safe lights are available in different designs. (Eastman Kodak Co.)

Fig. 6-22. Darkroom timers measure time in seconds.

Funnels, beakers and graduates are needed in the darkroom to measure and mix chemicals, Fig. 6-23. If any are made of glass, handle them very carefully. Glass becomes very slippery when hands are wet.

Film storage cabinets are recommended but not essential. Film should be stored in a dry, cool place.

Chemical storage cabinets must comply with safety and health standards.

CHEMICALS

After the film has been exposed the image is still not visible to the eye. This is called a

Fig. 6-23. These utensils are used to mix chemicals.

LATENT IMAGE. Processing the film makes the image visible, as seen in Fig. 6-24.

Processing requires the use of chemicals. Chemicals must be handled with extreme care. Four processing steps are commonly followed: developing, stopping action, fixing and washing. The processing trays are placed in the order shown in Fig. 6-25. All film handling and processing must be done under red safe light condition.

DEVELOPING

After the film has been exposed and an image is on the film, developer is used to change the silver salts in the gelatin coating to black metallic silver. Every manufacturer suggests the type of developer to be used to bring out the image.

The film is immersed in the developing solution, Fig. 6-26. Follow recommendations of the film manufacturer for developing time and temperature. Following the recommended time and temperature is very important. The temperature is generally around 68 F and 20 C, while the time is approximately 2 minutes and 30 seconds to 2 minutes and 45 seconds.

The strength of the developer weakens very rapidly. After several pieces have been developed, the solution may become exhausted. If so, the chemical solution will no longer develop the film satisfactorily. Be exact when measuring chemicals and follow recommended procedures. Agitation by rocking the tray is recommended for most film development.

STOP BATH

Place a weak solution of acetic acid in the second processing tray. Its main purpose is to stop all developing action. One to two ounces of 28 percent acetic acid to one gallon of water is a common stop bath solution. Always add the acid to the water. Care in handling this solution is very important. Do not mix chemicals unless you are properly supervised. The length of time the film is in the stop bath varies, but 5 to 10 seconds is a satisfactory range.

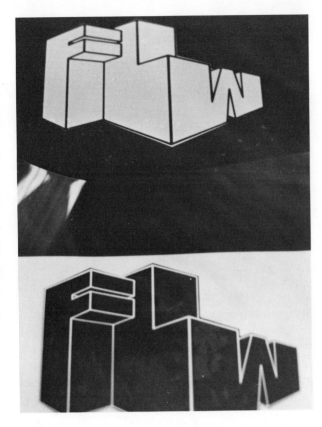

Fig. 6-24. Processed piece of film is shown above. Original copy is below.

FIXING

The fixing solution removes the silver halides from the undeveloped area of the film. This solution is also known as HYPO. Most fixing solutions also contain a hardener. This toughens the emulsion so that it will not be affected by normal handling.

Once the film is in the fixer it is no longer sensitive to white light. One way to determine the length of time in the fixer is to watch the film. Once the milky area turns clear, allow the film to remain in the solution about three times longer than it took to clear the film. (Before turning on the lights in the darkroom make sure that all film boxes are closed and that no one else has film in the developer.)

WASHING

Washing is also an important step. It removes the chemicals left on the film by the processing. Placing the film in a tray or sink with running

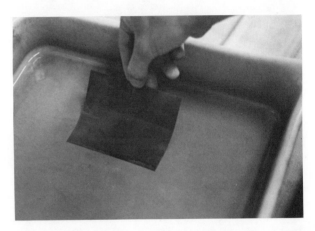

Fig. 6-26. Place film in the developer quickly so that solution covers all of it immediately.

Fig. 6-25. Trays are placed in the proper order so that processing moves from one tray to the next, left to right.

water will hurry up the process. Wash time ranges from 10 to 30 minutes.

Once it is washed, the film may be squeegeed, Fig. 6-27, to remove excess moisture. Slide the rubber edge of the squeegee carefully over the film. The film can then be hung up to dry. Some facilities have a film dryer which shortens drying time. The processed film is called a negative.

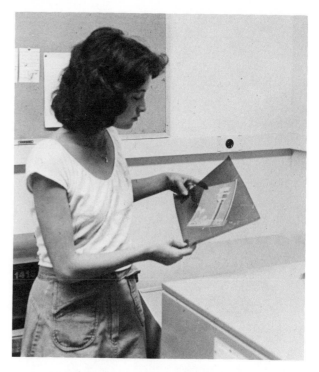

Fig. 6-28. An automatic film processor, when properly set and maintained, will produce constant quality when developing film.

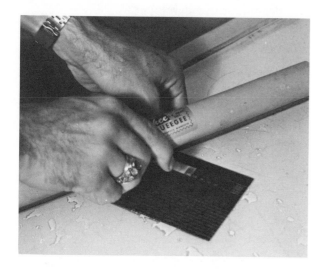

Fig. 6-27. Squeegee removes excess moisture.

AUTOMATIC PROCESSORS

Many industrial plants are now using automatic processors to develop films. The volume of film usage often determines the need for an automated system. Fig. 6-28 is an automatic film processor. This system, when properly set and maintained, will produce constant quality.

FACTORS WHICH AFFECT FILM DEVELOPMENT

Errors often occur during the processing of film. Some of the factors which can affect development are:
1. Chemicals not mixed according to manufacturers' specifications.
2. Developer has become weak.
3. Developing solution too warm or too cold.
4. Not enough developer used in the tray.
5. Method used to agitate the developer is not regular.
6. Developing time too long or too short.

PHOTOGRAPHING LINE COPY

Line copy, as explained in an earlier unit, is made up of lines, figures, mass (solids) and the type matter. Line photography is the process of taking these images and placing them on film.

Film exposure requires a step-by-step procedure. Each operator of a process camera varies the steps but it is important to set a procedure which works for you and is efficient.

This is the basic procedure:
1. Make sure the copyboard glass is clean.
2. Place line copy in copyboard. Position it so that the head of the job (top) is at the bottom; then it will be right side up when viewing it on the ground glass.
3. A sensitivity guide (gray scale) should be placed next to the copy, Fig. 6-29. This guide is an aid in film processing.
4. Close copyboard.
5. Set bellows extension and copyboard extension to the final size. When correctly set, the image should be in focus.
6. Remove lens cap. *Use only lens cleaner and*

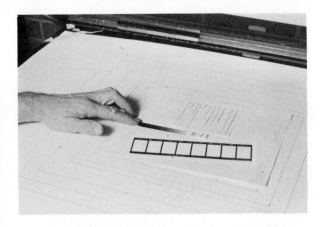

Fig. 6-29. A sensitivity guide is placed in copyboard.

lens tissue to clean lens.

7. Set lens for best f-stop. Each film manufacturer recommends a setting for best results. An aperture of f/22 is very common. Halfway between the largest and smallest f-stops stamped on the lens might also be a starting point. If the aperture opening is enlarged one stop, the amount of light increases and the exposure time must be cut in half. As the opening gets smaller, less light will pass through the lens.

8. If your camera has a control scale, Fig. 6-30, the reduction or enlargement requires a change in aperture setting. The control arm setting should match the percentage of enlargement or reduction of the copy.

9. Position lights. The proper angle of lights is very important. See Fig. 6-31. Make sure the lights are pointing toward the center of the copyboard. Most camera manufacturers give a recommended distance between the copyboard and the light. On some cameras this distance is fixed and is not intended to be changed.

Fig. 6-30. Setting control scale.

Fig. 6-31. Proper setting of camera lights is important for good results. They should be set at 30 to 45 degrees from the copyboard for best results.

10. Set exposure time. Exposure time is the amount of time the shutter is open to allow light onto the film. Lens shutters can be operated manually (with a stop watch), with automatic timers, or by an integrator. This is an electronic device that allows a regulated amount of light to pass through the lens.

Exposure time varies with each camera. The best time can be determined by making exposure step-offs on a piece of film.

Cover all but one inch of the film on which the image will appear. The material used to cover the film must be opaque. Expose the uncovered part of the film for three seconds. Move the covering about one inch toward the unexposed portion of the film. Cover and again expose for the same length of time. Now you have a new three second exposure and have added three seconds to the other exposure. Do this for four or five times. Then develop to find out which time gives you the best appearing negative. A good negative has dense areas and completely clear areas. Clear areas must have sharp edges.

11. Determine film size. View the image on the ground glass, Fig. 6-32. Find the size of film needed by measuring the image and add an inch to the height and width. This will leave a margin to work with.

12. Open the camera film back.

13. Position the film. Place it so that all of the image area is on the film, leaving a uniform margin on all sides. When using ortho type film, the emulsion side of the film is the lighter of the two sides.

14. Place film on camera back. If a vacuum system is used, the vacuum holds the film in place during exposure. The emulsion of the film should be placed so that it will be facing the lens when returned to exposure position.

15. Manually or automatically open the lens shutter for the determined best exposure time.

16. Turn off vacuum. Remove film from camera back.

17. Process film. Follow development time recommended by the film manufacturer. It usually ranges from 2 minutes 30 seconds to 2 minutes 45 seconds at 68 F or 20 C with continuous agitation. Another way is to develop the film until Step 4 in the sensitivity guide is solid. (Another step may be used for various types of copy. Several other guides are on the market and are also very satisfactory as processing guides.)

Place film in stop bath for 5 to 10 seconds, then remove and fix for recommended time. The film must then be thoroughly washed and dried.

18. View the results. You have now produced a line negative. Remember: *Do not open a box of film in a room with white light. Do all of your work under a safe light.*

PHOTOGRAPHING CONTINUOUS TONE COPY

Black and white continuous tone copy must be broken up into dot patterns in order to print as a likeness of the original photograph. The dots vary in size. It is this variety that gives the appearance of different tones, Fig. 6-33. These tones vary from light to dark and are called halftones. The light areas are called highlights while the dark areas are called shadows.

The continuous tone copy is exposed through a screen. The screen breaks up the

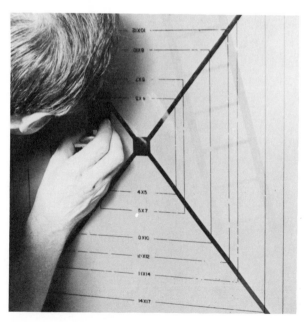

Fig. 6-32. Viewing image on ground glass in preparation for measuring it for size of film needed.

HALFTONE SCALE PERCENT DOT AREA

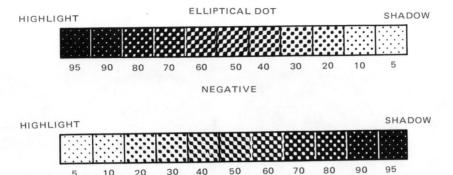

Fig. 6-33. How the dot pattern of a halftone appears when enlarged. Both negative and positive are shown.

highlights into small dots, while the shadow areas have only a small open area and a large dark area around them, as seen in Fig. 6-34.

Fig. 6-34. This enlargement shows how negative and positive highlight and shadow dots look. If you squint you can see that it is a picture of an eye. (A.B. Dick Co.)

Types of screens

Two types of screens are generally found in industry: the glass screen and the contact screen, Fig. 6-35. In a third type, the screen is built into the film as a latent image. Glass screens need a complicated procedure to produce a halftone negative. They are also expensive. Therefore, the glass screen procedure will not be discussed in this book.

The contact screen is widely used in the graphic arts industry to make halftone negatives. It is called a contact screen because the screen is in direct contact with the emulsion of the film. The contact screen is made up of many dots. As the light passes through it the pattern of light to dark is recorded on the film.

The screen rulings vary according to the type of halftone required. Screens range from 65 to 300 rows of dots per running inch. A 65 line screen would have 65 rows of dots per running

Fig. 6-35. Contact screen enlarged many times. Do you see how dots are less dense at edges? (A.B. Dick Co.)

inch. This type of ruling would be used for very coarse work. The more dots per inch the less your eye is able to see the dots on the halftone film or on the printed page.

The dot on a contact screen has more density at its center and less at its outer edges, Fig. 6-35. Contact screens are either gray or magenta. The gray screen is made up of silver

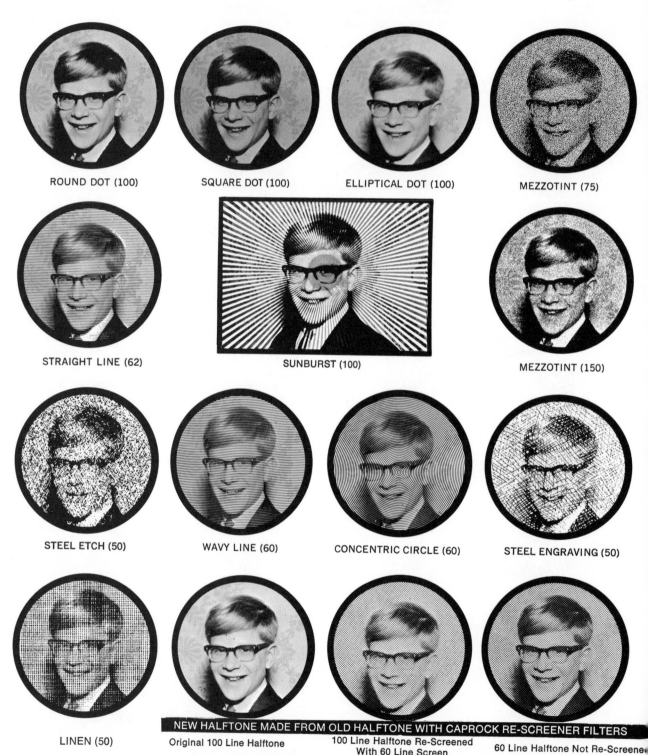

ROUND DOT (100) SQUARE DOT (100) ELLIPTICAL DOT (100) MEZZOTINT (75)

STRAIGHT LINE (62) SUNBURST (100) MEZZOTINT (150)

STEEL ETCH (50) WAVY LINE (60) CONCENTRIC CIRCLE (60) STEEL ENGRAVING (50)

NEW HALFTONE MADE FROM OLD HALFTONE WITH CAPROCK RE-SCREENER FILTERS

LINEN (50) Original 100 Line Halftone 100 Line Halftone Re-Screened With 60 Line Screen 60 Line Halftone Not Re-Screened

Fig. 6-36. Special effects screens are used to create novel patterns. (Caprock Developments, Inc.)

image dots, while the magenta is a dyed dot pattern. Both are commonly used in industry.

The dots are not the same on all screens. Some contact screens create a square dot while others create an elliptical (flattened circle) dot.

Special effects screens are also available. A sample of various types is shown in Fig. 6-36.

Types of exposures

Contact screens are used mainly for making halftone negatives. Halftone negatives usually require at least two exposures to get the full range from highlight (lightest area) to the shadow (darkest area) of the continuous tone copy. The first exposure is called the main or detail exposure. It forms the small dots of the highlight area. The second exposure is called the flash exposure and it forms the shadow dots on the negative. This will be explained during the step-by-step procedure for making halftone negatives.

Again, a routine procedure is recommended. Several new steps will be introduced. Basically the steps are the same as those used for photographing line copy. However, the exposure and development are different.

The complicated calculations are omitted in this unit. These would be used in more advanced work. Certainly they would be required in industry.

Steps for making a halftone negative are:
1. Clean copyboard glass.
2. Place continuous tone copy (photograph) in copyboard upside down.
3. Set bellows extension and copyboard extension for same size (100 percent).
4. Remove lens cap. Use only lens cleaner and lens tissue to clean lens.
5. Set lens for best f-stop. (Refer to procedure for line photography.)
6. Set control scale for 100 percent.
7. Position lights.
8. Set main exposure time.
 Making a negative halftone requires a longer exposure time because we are reflecting light through a contact screen, Fig. 6-37. Some film manufacturers will give a

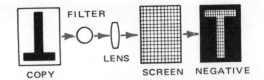

Fig. 6-37. Contact screen used to make halftone. (A.B. Dick Co.)

recommended time. Trial and error exposures may be used. An example would be to set the f-stop at f/22 and a time of 20 seconds. As stated earlier, the main exposure brings out the highlight dot. You are looking for the smallest negative highlight dot, as shown in Fig. 6-38. Several tries might be necessary to get this highlight dot.

Fig. 6-38. Highlight dots print as tiny specks.

If you are interested in various methods of calculations, an exposure computer works very nicely, Fig. 6-39.

To break the copy into small dots, the contact screen should be in direct contact with the emulsion of the film. The contact screen should extend beyond the sides of the film at least one inch. This allows the vacuum to hold it in place.

Handle the contact screen with extreme care. It will scratch very easily. Fingerprints will damage the screen so grasp it by the edges. After the vacuum has been turned on check for good contact between film and screen. Put the camera back in position to make the main exposure.

9. Select film size.
10. Open camera back.
11. Position film.
12. Position contact screen.

Fig. 6-39. Exposure computers can help you determine how long the shutter should be open to let in right amount of light to the film.

13. Turn on vacuum.
14. Set shutter for main exposure.
15. Set timer and expose film.
16. Open camera back but do not remove contact screen on film.
17. Set the flash exposure.

The flash exposure is a second exposure but with yellow light. The main exposure used white light. The purpose of the flash exposure is to make small clear areas in the negative. The main exposure brings out the highlights while the flash exposure brings out the shadows.

The contact screen and film must not be removed or allowed to shift so do not turn off the vacuum after making the main exposure. The amount of time must also be calculated. Make a trial and error step-off as you made with the line copy. However, use the yellow light with film and contact screen in place.

Exposure computers are very helpful guides to make sure you have quality negatives each time you make exposures.

Remember, the flash exposure is made with a yellow light and not a white light.

18. Make flash exposure with yellow light using best time.
19. Turn off vacuum and remove contact screen from camera back. Always place the contact screen in a protective cover.
20. Now, process the exposed film. The steps are very similar to those used in line film processing. With solution at 68 F (20 C), develop for 2 min. while rocking the tray (agitation). Then develop another 45 sec. without agitation. The rest of the process is the same as already described on page 74 for line film.
21. After stop bath, fixing, washing and drying, view the halftone negative. The results should be a good highlight and shadow dot as shown in Fig. 6-40.

Not all continuous tone prints require a flash exposure but in most cases the flash will give the halftone negative better tone reproduction when printed.

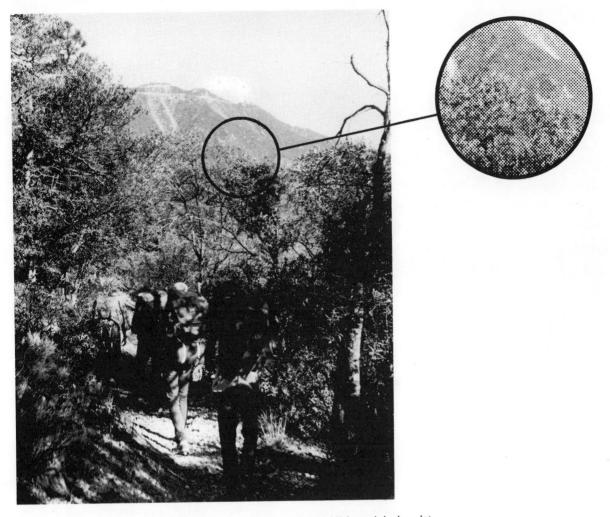

Fig. 6-40. Looking for a good highlight and shadow dot.

CONTACT PRINTING

Sometimes the process requires a positive rather than a negative. A positive is the opposite of a negative, Fig. 6-41. One of the simplest ways to make a positive is to place a negative and an unexposed piece of film in a holder of some type and then expose it to white light. A typical arrangement would be a vacuum frame with a point source light as shown in Fig. 6-42. The film is processed using the same procedure as with line work. Special films are available to make another negative from a negative or another positive from a positive.

SPECIAL EFFECTS SCREENS

The most common method of exposing continuous tone copy is with the conventional contact screen, but special contact screens are available. They are used to create special effects. An example is shown in Fig. 6-43. These screens are used in the same way as the

FILM POSITIVE FILM NEGATIVE

Fig. 6-41. In a film positive the light and dark areas appear as they would on a printed page. They are not reversed.
(A. B. Dick Co.)

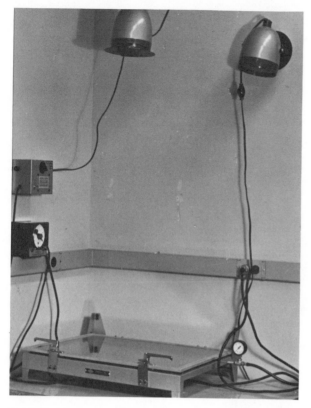

Fig. 6-42. Vacuum frame and light source can be used to make a film positive.

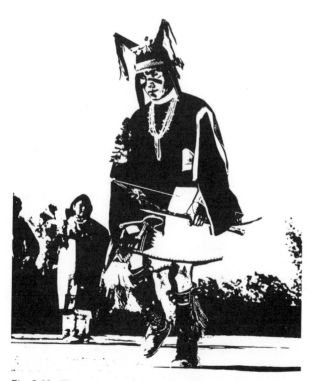

Fig. 6-43. This is a sample of line resolve and it was made from a photograph. (Killgore Graphics)

regular contact screen. The correct exposure can be found by the trial and error method.

COLOR REPRODUCTION

More color is being used in photo-offset lithography each year. Color attracts and creates interest. Some materials become like the real thing when printed in their natural color.

The reflection of light on an object produces color. If you took a sheet of blue paper into a darkroom, it would not appear blue. Light is essential to have color.

Not all books written on colors are in agreement that the same three colors are contained in light. These theories are of little value, when working with printing inks. The three colors necessary in full color reproduction are: magenta, cyan and yellow. These are the colors that will form all other colors. They are called subtractive primaries.

To reproduce a color photograph, these colors need to be separated. This process is called color separation. It requires the use of a filter in each one of the three exposures, Fig. 6-44. Red, blue and green filters are used. These three colors are called additive because together they produce white. See Fig. 6-45.

Though more complex, making color negatives is much like making a black and white halftone negative. The light source in most cases, remains the same.

There are two basic procedures for making color separations:
1. The indirect method.
2. The direct method.

Essentially they are very much the same although the indirect method involves more steps. Whereas the direct method produces a screened negative as the color is separated by the filter, the indirect method produces a continuous tone (unscreened) positive first. This is color corrected before making a screened negative.

Many printers prefer the indirect method because it allows them to make color correc-

Fig. 6-44. Filters are used in color separation work. Red, green and blue ones are needed to get the right kinds of negatives for color work. These three colors are called additive because the three lights of these colors are white when added together.

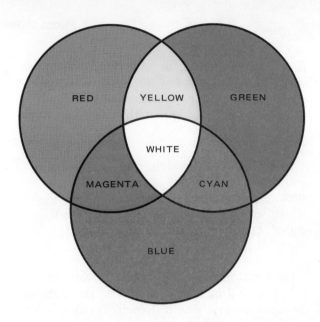

Fig. 6-45. This shows what you would see if you flashed three lights together on a white screen, one red, one green and one blue. Where all of them overlap, white is seen. These colors are used in filters when colors are separated out of full color art.

tions by hand. However, it is simpler to use the direct method. To explain this technique we must start by explaining the difference in orthochromatic and panchromatic film.

Orthochromatic film, used in black and white photography, reproduces all colors in one color ranging from black through gray and white. This makes it unsuitable for color work. Being sensitive to all colors, panchromatic film is used. It must, therefore, be developed in total darkness. This may cause some difficulties for beginners.

With panchromatic film in the camera, the operator exposes four pieces of film. A different filter is used for each piece of film. Each of these pieces of film is called a negative or printer. There will be four of them: cyan (blue), magenta (red), yellow and black.

CYAN PRINTER

By placing a red filter over the lens and exposing the copy, an image will be placed on the negative. The image will be made up of the red light which has been reflected or transmitted from the copy. A red separation has been made.

When a positive is made from the red separation negative, it will not have the red but the other two light colors which are blue and green. In reality, the red light has been subtracted and what is left in the positive is blue and green. The blue and green are called cyan. The subtractive primary, cyan, is now called a cyan printer.

MAGENTA PRINTER

To make a magenta printer, a green filter must be used. The film is now recording all of the green light reflected or transmitted from the copy. The positive will produce the red and blue additive primaries as the green has been subtracted from the copy. Red and blue forms magenta which is called the magenta printer.

YELLOW PRINTER

The blue filter is used to make the yellow printer. All of the blue in the copy has been recorded on the film. The additive colors of red and green will now appear on the positive. The combination of red and green produces yellow. The yellow printer is produced as the positive.

BLACK PRINTER

To add contrast or detail, many printers will add a black printer. Look to technical publica-

tions for assistance in selecting a technique which can be adapted to your situation. A combination of exposures using each filter might be one technique with which you might want to experiment.

Another term which you will hear in a printing plant is color correcting. Because our process colors are not pure colors, we need to lessen or strengthen the ink. This process is called color correction. Color correcting is a difficult task.

If you look at a full color process printing job, you will be able to see dots. The dots will be arranged in a rosette (roselike) pattern. This is accomplished by having the contact screen at a different angle for each of the four shots.

One screen could be used for color separation work, but it would require accurate pin registers for each screen angle. It is possible to purchase a set of pre-angled contact screens. Gray contact screens should be used to make the negatives.

The recommended angle to be used for each printer for full color reproduction is:
1. Yellow printer, 90 degrees.
2. Magenta printer, 75 degrees.
3. Cyan printer, 105 degrees.
4. Black printer, 45 degrees.

The proper screen angle should eliminate the possibility of creating a moiré (irregular and wavy) pattern. See Fig. 6-46.

Today, many color separations are made by completely automated scanning systems. These electronic devices are capable of color separation and color correction. Some will use transparencies. Others require reflection type copy.

The effects of color separation and color printing can be seen in Fig. 6-47. The film produced by the process of color separation is used to produce four different images. Each is exposed on a different offset plate. A colored picture results when the colors are printed one on top of the other on the pages of a book or other printed matter.

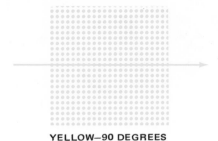

YELLOW—90 DEGREES

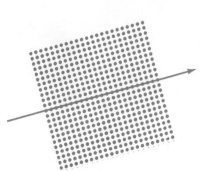

MAGENTA—75 DEGREES

CYAN—105 DEGREES

BLACK—45 DEGREES

Fig. 6-46. When one screen is printed over another, a strange, moiré pattern appears. To avoid this in color work, the screen angle is changed for each color as shown above.

BLUE FILTER — YELLOW PRINTER

YELLOW

GREEN FILTER — MAGENTA PRINTER

YELLOW AND MAGENTA

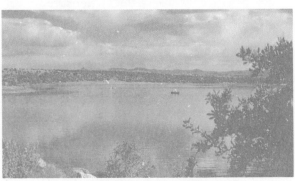

RED FILTER — CYAN PRINTER

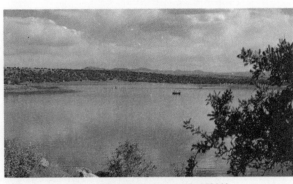

YELLOW, MAGENTA AND CYAN

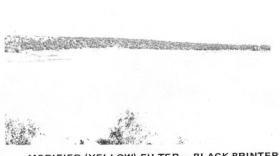

MODIFIED (YELLOW) FILTER — BLACK PRINTER

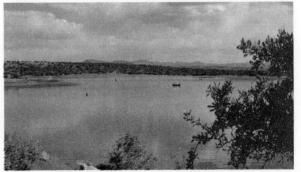

YELLOW, MAGENTA, CYAN AND BLACK

Fig. 6-47. Left column shows the color printers and the right column shows what happens when the four colors are added together on the printed material. (American Color Corp.)

TEST YOUR KNOWLEDGE — UNIT 6

1. The two most common types of cameras used in industry are _____ and _____.
2. List the essential parts of a process camera.
3. Prior to shooting a film negative, the camera-ready material is placed in the camera back. True or False?
4. _____ is used to clean a camera lens.
5. Which element or elements control amount of light that comes through the camera lens?
 a. Aperture.
 b. Diaphragm.
 c. Film.
 d. Lens board.
 e. Lens cap.
6. What part holds the film while it is being exposed?
7. Check which of the following are the most common types of light used on process cameras.
 a. Blue flash bulbs.
 b. Carbon arc.
 c. Incandescent bulbs.
 d. Mercury vapor.
 e. Pulsed xenon.
 f. Quartz-iodine.
 g. All of the above.
8. List the common types of film used in process camera work.
9. _____ safe lights should be used in a darkroom when using ortho film.
10. List the equipment which is needed in a darkroom.
11. What are the common steps in processing a piece of film?
12. List the basic steps to produce a line negative.
13. When continuous tone material is exposed and broken up into a dot pattern it is called a _____ negative.
14. The light portions of a photograph are called the _____ area.
15. The screen is a device used in a darkroom to make it dark. True or False?
16. What makes the dots of a halftone?
17. Posterization is an example of the _____ process.
18. Check which of the following are ink colors used to make a full color reproduction.
 a. Black.
 b. Cyan.
 c. Gray.
 d. Magenta.
 e. White.
 f. Yellow.

SUGGESTED ACTIVITIES

1. Prepare artwork on a 3 x 5 card, using six medias, such as a black marking pen, pencil, typewriter, etc. Place the artwork in the camera and shoot a line negative. Evaluate the negative as to correct exposure, development and pinholes.
2. Place a glossy print on the copyboard of the process camera and shoot a halftone negative. List the necessary steps to shoot the film and process the negative.
3. Select a special effects activity and go through all of the steps including a proof of the negative.
4. Visit a photo conversion department in your community. List all of the types of negatives and positives they supply to the stripping department.
5. List the safety precautions that should be observed when mixing chemicals and when working in the darkroom.

Unit 7
STRIPPING

After the negatives have been made, they must be attached in exact position on a sheet of material. When the job is finished, this sheet is called a flat. The flat is made of paper or plastic and is generally orange in color. This sheet is often called a GOLDENROD or MASKING SHEET. The flat material must hold back light rays.

Placing the negatives in their proper place is called STRIPPING and the person doing the work is called a stripper. Once the negatives are attached to a sheet of material the finished flat is used to make a plate. It is this plate that will be placed on the press.

Before we cover the tasks necessary to prepare a flat, we shall become familiar with the equipment, tools and materials necessary to complete the job.

EQUIPMENT

The light table, Fig. 7-1, is generally considered to be the work station of the stripper. The glass surface is frosted. Lights, mounted below the glass, shine through the goldenrod and the negatives' clear areas. Do not lean on the glass. It could break. A line-up table, Fig. 7-2, is for more accurate work. Like the light table, it has a glass top.

TOOLS

A T-square, triangles and measuring scales are also used to line up and measure on the goldenrod sheet, Fig. 7-3.

Fig. 7-1. Light tables reflect light up through a translucent top onto the negative film.

Another very useful tool is a magnifier. It is used to check the negative. Typical magnifiers are shown in Fig. 7-4.

The stripper may also use needles, scribers, knives, scissors and brushes.

MATERIALS

Some of the materials used by the stripper are the masking sheets, special tapes and solutions for opaquing negatives. Other equipment, tools and materials might be found in graphic arts plants but these are the necessary basic items found in a stripping department.

STRIPPING INFORMATION

Before strippers place the negatives on the goldenrod to make a flat, they must know the size of the press or the size of the printing

Fig. 7-2. Line-up table is used to help position negative on the flat.

Fig. 7-3. These instruments are used when stripping a flat.

Fig. 7-4. Magnifiers are used to examine negatives for defects.

plates to be used on the press. They select a goldenrod paper the size of the plate or a little larger.

Some of the masking sheets (goldenrods) have preprinted markings. Generally, these are found on the masking sheets used on smaller presses. The larger masking sheets are usually

unprinted, Fig. 7-5. Strippers must follow the layout instructions very carefully. The layout should tell the size of sheet, the size of the plate, the amount of space needed for plate bend and gripper distance.

Stripping

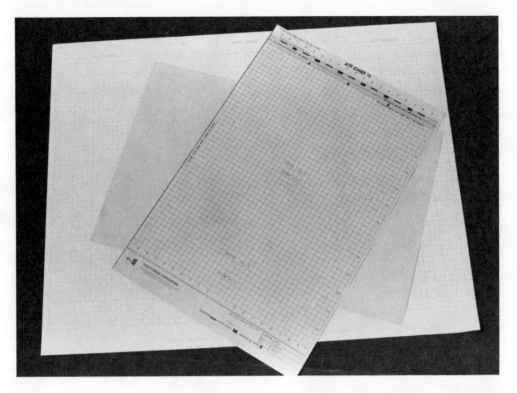

Fig. 7-5. Masking sheets come in different sizes. Center lines and bottom lines are marked on smaller sizes.

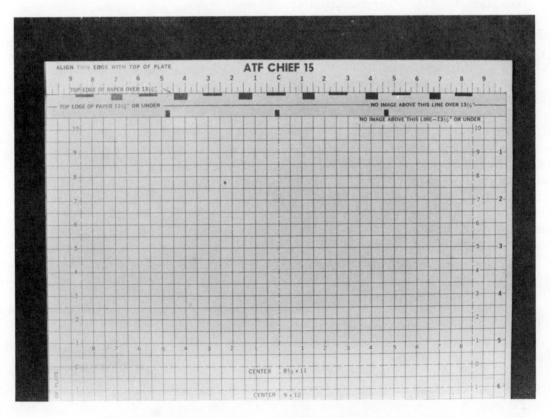

Fig. 7-6. Layout lines on masking sheet help the stripper position the film.

The space needed to attach the plate to the cylinder of the press is called PLATE BEND. The paper line marks the location of the paper. The gripper space is used to hold the paper while it is being printed. None of the image should appear in that space. Grippers grab the sheet at that point and hold it so that it does not move on the impression cylinder of the press. The layout lines are illustrated in Fig. 7-6.

Marks to locate all of the image areas are also found on the layout sheet. Other information is added when needed, such as: trim marks, fold marks, bending and die cutting information, just to name a few of the operations.

Some plates require negatives while others require positives. It depends on what type of plate is used in the graphic communications plant. Since the method of making each type flat is very much alike, we will consider only the negative type flat at this time.

STRIPPING OPERATIONS

It is important to attach the goldenrod to the light table. Use a short piece of masking tape across each corner of the goldenrod. Make sure that the bottom edge of the goldenrod lines up with the top edge of the T-square blade as shown in Fig. 7-7. Hold the T-square head tightly against the true edge of the light table.

Different techniques are used to strip a flat. The end results should be the same. Stripping methods vary in different plants, but the following is a common practice:
1. After the masking sheet is fastened, locate the paper and image lines, Fig. 7-8.
2. Locate the image areas on the masking sheet. Slide the negative under the masking sheet. You should be able to read the image. Be sure that the base side of the negative is up and the emulsion side is away from you. This is *very important*. The emulsion side has a dull surface while the base side is shiny. If you have difficulty telling which side is which, scratch each side with a knife point. (Be careful to do this in a non-image area.) The side which is scratched away, allowing light through, is the emulsion side, Fig. 7-9.
 Cut a small window in the masking sheet

Fig. 7-7. Lining up the masking sheet must be done accurately.

so that you can move the negative into position. When cutting the masking sheet do not cut through the negative. Cutting lightly on the base side of the negative will not hurt it. Work carefully.
 Check to see that you have the top (also referred to as the head) toward the gripper edge of the masking sheet.
3. When negative is in correct position, cut openings in goldenrod and place red lithographers' tape on both negative and masking sheet to hold them in place, Fig. 7-10.
 Now turn over the flat and tape the four corners, as in Fig. 7-11.
4. Turn over the flat so that the masking sheet is on top. Cut away the masking sheet so that the light shows through the image area. This is called a window. The negative should be right reading.
 The cut should be made about 1/8 in. from any clear area as shown in Fig. 7-12. Remember, the cut should be made through the goldenrod sheet but not through the negative. The knife edge will make a slight mark on the negative. This will not show because you are cutting on the base side of the negative and not the emulsion side. Be very careful when handling the cutting tool. The knife edge is very sharp and a slip could cut you.
5. After the window has been cut in the flat, the negative should be inspected for pin holes. They are the small clear areas in the negative that are not a part of the original

Fig. 7-8. Paper and image lines are indicated by arrows.

Fig. 7-9. If unsure which is emulsion side of film, use scrape test. It will remove the opaque material from emulsion side but has no effect on base side.

Fig. 7-10. Locating the image area when negative is correctly centered, attach it to goldenrod through window using red lithographers' tape.

Fig. 7-11. Taping corners of the film negative will keep it in place on the flat.

Fig. 7-12. Cutting windows in the flat is necessary to expose all areas that will print.

artwork. Sometimes these are caused by dirt on the copy, dust on the copyboard glass, dust on the camera lens or dust on the film while it is being exposed.

6. To get rid of unwanted clear areas, we opaque on the emulsion or on the base side of the film, Fig. 7-13. Water soluble opaquing solutions are either red or black. When applying the solution with a brush, it is important to make the coating as thin as possible. When the opaque is dry, light should not pass through the negative.

If larger areas are to be opaqued, lithographers' tape or strips of goldenrod are used to mask out light. Masking out light means that light cannot be seen through the unwanted clear areas.

If a line or a larger area has uneven edges, lithographers' tape, a ruling pen or brush with opaquing solution can be used to make the edge even, as seen in Fig. 7-14.

Another stripping method is to place the masking sheet with the preprinted lines toward the light table glass. Line up is the same as the first method.

Fig. 7-13. Opaquing a negative covers up unwanted clear areas.

Fig. 7-14. An uneven edge can be opaqued with a brush, pen or lithographers' tape.

The negative is placed on the masking sheet with the base side toward the masking sheet. This means that the emulsion side is up and care must be taken not to scratch the film. The corners of the film are taped to hold the negative in place.

The negative must be lined up just as described in the first method to make a flat. Check to make sure it is in the right position. After checking, turn over the flat and cut out the windows to allow light to pass through the image areas. Be careful not to cut through film.

If pinholes are seen in the negative, opaque the defects with a small brush and opaquing solution the same way as in the first method.

Sometimes a sensitivity guide is placed in the flat. It is used later to make sure that the printing plate (image carrier) is properly exposed and processed. Once an exposure time has been found, the sensitivity guide need not be used. The stripped flat is used to make a printing plate (image carrier).

TEST YOUR KNOWLEDGE— UNIT 7

1. After the negatives have been attached to a goldenrod sheet it is called a _____.
2. What are the common tools used by a lithographic stripper?
3. Masking sheets are made of _____ and _____.
4. The paper line tells you the location of the paper. True or False?
5. What side of the negative is toward the goldenrod?
6. If pinholes appear in your negative, _____ is used to fill them in.
7. The completed flat is used to make a_____.
8. Explain why a sensitivity guide is used.

SUGGESTED ACTIVITIES

1. Visit a photo-offset lithographic plant and observe the various techniques used to strip a flat. Make a list of the tools used by the stripper.
2. Strip a negative to a masking sheet.
3. Opaque a film negative to remove all unwanted clear areas.

Unit 8

IMAGE CARRIERS (PLATEMAKING)

Preparation of the image carrier is commonly known as the platemaking process. The image carrier is a thin plate whose surface is light sensitive. It is called a photo-offset lithographic plate. Though it can be made of several types of materials, the most common are: paper, plastic or metal.

Platemaking requires an image area which will accept ink while the non-image area will be kept clean by using moisture. As stated earlier, this process is based on the fact that grease or oil and water do not readily mix.

In this unit, you will learn how to place an image on an image carrier. From this plate we can transfer the image (print) onto many materials. The most common of these is paper. Not all methods require the use of a flat to make a plate. This will be illustrated later on in this unit.

The person making the image carrier is called a platemaker, but it is an occupation with changing skills. The ways of putting an image on a plate vary and the role of the platemaker is changing as new technology is constantly being introduced.

Three types of image carriers will be introduced in this unit:
1. Direct image plates.
2. Direct photographic plates.
3. Surface coated plates.

DIRECT IMAGE PLATES

The direct image plate, also called a master, is made of plastic or paper. A special coating is put on the plastic or paper. An image can then be put on the master with oil-based materials. Commonly used materials include special pencils, pens, crayons or carbon typewriter ribbons. The typewriter is used most often.

The typist can place a direct image master in the typewriter and type the image directly on the printing side of the master. See Fig. 8-1. Also a reproducing pen or pencil is demonstrated in Fig. 8-2.

Fig. 8-1. This direct image master is being prepared on a typewriter. The typewriter has a special ribbon which leaves a slightly oily surface on the image area.

Whenever guidelines or sketches are needed which you do not want to print, a nonreproducing pencil should be used. This material, when placed on the master, will not print.

Fig. 8-2. Reproducing pens and pencils also leave an oily image on the master.

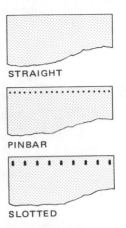

Fig. 8-3. These clamping plate types are in common use. (A.B. Dick Co.)

Some direct image plates are designed for very short runs. Others are of a higher quality and will last much longer.

When making a direct image plate, use care in handling the plate. This is very important. A grease spot made by a finger or a dirty typewriter roller will print. After the plate has been placed on the press, follow the directions of the manufacturer. Special materials are recommended for direct image plates.

A stiff eraser may be used to make some corrections. Work with care. Too much rubbing will wear away the coating on the plate.

As is true of other types of plates, the direct image plate comes with different types of clamp ends. The straight, pinbar and serrated (slotted) ends are illustrated in Fig. 8-3. The direct image plate is used on offset duplicating presses but not on larger presses. Look to the manufacturer for information on each type of plate.

DIRECT PHOTOGRAPHIC PLATES

A direct photographic plate is sometimes called a one-step photographic plate. The reason for this is that the image is projected through a lens directly onto a plate.

The positive (camera-ready copy) is photographed on the plate as a positive image. There is no need for a negative. This is a very rapid way to make a plate ready for the press. A few of the platemaking machines can screen a photograph (continuous tone copy) to make a halftone. Most machines are capable of enlarging or reducing the copy.

A one-step camera plate system is shown in Fig. 8-4. In Fig. 8-5, the operator is placing the copy on the copyboard. Lights are attached to the machine to give even illumination, Fig. 8-6. This camera can reduce or enlarge the copy. Some cameras are even capable of shooting three-dimensional materials such as a pencil. The plate is automatically processed and comes from the camera ready to be placed on the press. Once the plate is on the press, Fig. 8-7, the roll-up procedures might vary with each type of system. Generally it is a very simple step to condition the plate for fast ink roll-up, Fig. 8-8. The term rolling-up means to cover the offset plate with a thin layer of developing ink. Developing ink is a black material that puts a greasy film on the plate. It prepares the plate to receive printing ink.

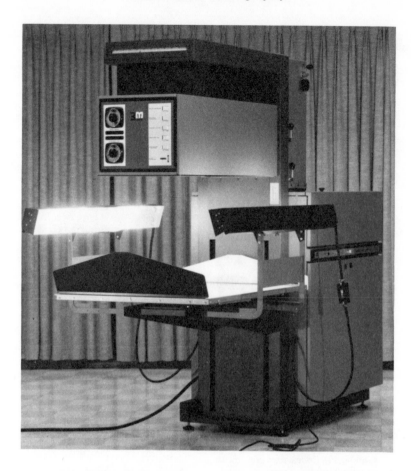

Fig. 8-4. This camera plate system puts camera ready material directly on the plate. It is primarily used to make plates for duplicator size presses.

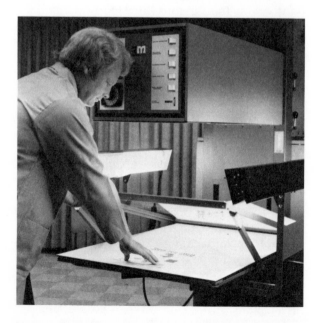

Fig. 8-5. Operator has raised frame of copyboard to position copy. The copyboard can be raised or lowered depending on whether copy is to be enlarged or reduced.

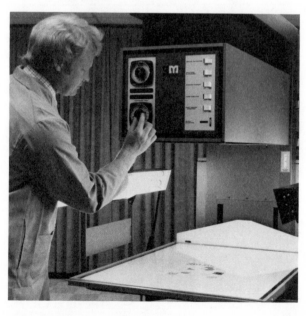

Fig. 8-6. Lights are always the same distance from the copy. To make an exposure, operator sets dial for length of time plate is to be exposed. (3M Co.)

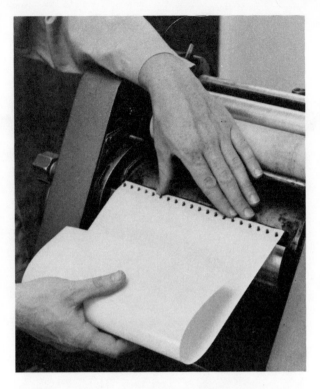

Fig. 8-7. To place a plate on the press, the operator attaches the clamp end over pins called the lead plate clamp.

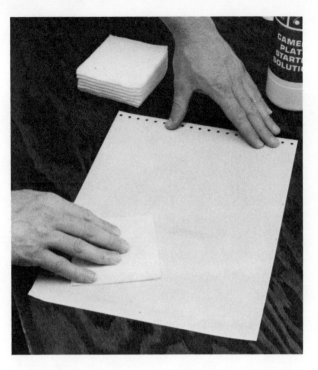

Fig. 8-8. Starter solution is applied to plate before it is placed on the press. (3M Co.)

SURFACE COATED PLATES

The common types of surface coated plates include:
1. Wipe on.
2. Presensitized.
3. Photopolymer.

One type will be described in this unit. It is the presensitized plate.

PRESENSITIZED PLATES

These plates consist of a base material and a coating. Aluminum is the most common base but paper and plastic are also used. The plate may be coated on one or both sides, depending on the type of plate and manufacturer. The coating is light sensitive. It can be handled in room light for a short period of time but should be covered when not being worked with.

Presensitized plates come in many sizes to fit different presses. They are widely used in the graphic arts industry.

When removing a plate from the package be careful not to scratch the light-sensitive coating. Fingerprints and moisture can also damage the coating on the plate. Grasping the plate by each end is the best, but if it is necessary to handle it another way, make sure it is on the extreme edges, Fig. 8-9. The metal plate edges and corners are very sharp. Care must be taken when handling the plates not to cut yourself.

Presensitized plates are either negative or positive acting. This means that a negative presensitized plate yields a positive image from a negative film. A positive plate yields a positive image from a positive film. In this unit we will be discussing and describing the negative presensitized plate.

Plates also come in two types:
1. Additive.
2. Subtractive.

Both types have a light-sensitive coating. Remember to close the package after removing a plate otherwise, room light will damage or ruin the plate. There are special steps for developing each type of plate.

Fig. 8-9. When removing plate from package, grasp it by the extreme end.

EXPOSING AND DEVELOPING AN ADDITIVE NEGATIVE PLATE

To develop an additive negative plate or image carrier, place it in an exposure unit or platemaker. If possible, the unexposed plates should be handled in a room with yellow light, Fig. 8-10.

The side of the plate to be exposed is placed so that it faces the lights of the platemaker, Fig. 8-11. During exposure, light shines through the clear parts of the negative.

Fig. 8-10. Additive and subtractive unexposed plates are best handled under a yellow safe light.

Fig. 8-11. Negative film is placed on top of the light-sensitive plate in the platemaker.

Fig. 8-12. The flat must be in perfect register over the plate.

Place the stripped flat over the plate with emulsion side of the negative toward the light-sensitive side of the plate, Fig. 8-12. Make sure that the flat is in the exact position over the plate. Sometimes register pins are used to align the plate with the flat, as shown in Fig. 8-13. The negative clear areas must be clean so that light can pass through, Fig. 8-14. Dust and dirt should be removed from the negatives.

Most platemakers are equipped with a vacuum system. After the flat is placed on the plate, it must be pressed against the plate. Therefore, the vacuum is turned on to make sure they are held close together during the exposure time. If good contact is not made, the light will scatter between the negative and the plate. This causes the letters to be larger and often the edges are not sharp. The platemaker might refer to this as a "fatty."

Light sources commonly found on platemakers are: carbon arc, quartz-iodine, pulsed xenon, mercury vapor, and photo flood. Each light has different qualities and the choice depends on which gives the best results for high production in a graphic communications plant.

Manufacturers of negative presensitized additive type plates generally recommend an exposure that will produce the same gray shades as a step number on the sensitivity guide. Sensitivity guides are sometimes called gray scales or step wedges. A manufacturer might recommend a step 6 on the sensitivity guide.

This requires trial and error exposures so that a step 5 or 6 will be produced when the plate is developed. Fig. 8-15 shows how a sensitivity guide is placed in the flat for exposure.

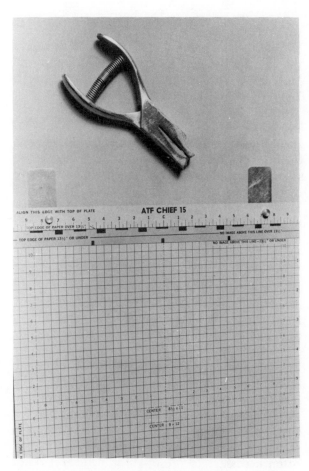

Fig. 8-13. Register pins align the film exactly over the plate.

Fig. 8-14. Make sure the film negative is clean.

Fig. 8-15. Sensitivity guide is placed at the bottom of flat.

After the vacuum has been turned on for about 20 or 30 seconds, the light source should be turned on for the length of time which gave the best results on the trial and error exposure. Most plate burners are equipped with a timer. This completes the exposure step.

Desensitizing

In the developing process you will remove the unexposed light-sensitive coating. This is the second step and is called desensitizing. On many of the plates, this is a diazo coating. It has been hardened where the light strikes it. A desensitizing gum, Fig. 8-16 will remove the coating in the non-image area.

After desensitizing, the plate can be placed on the press and an image could be printed but it would not last long. Therefore, we follow another step. This is an additive step and it gives the plate its name.

A developing lacquer is applied to the plate after it is desensitized and still moist. The lacquer adheres to the image areas and gives the plate a longer life, Fig. 8-17. After being washed free of desensitizer and lacquer, the plate is ready to be placed on the press. However, it is often necessary to preserve the plate if it is not to be run immediately after processing. To protect the plate from oxidation, dirt and handling, it is gummed. A thin gum solution is rubbed on the surface of the plate in even strokes. After the plate is coated, it should be buffed down with a cotton pad until dry, Fig. 8-18. The plate is now ready for storage.

When the plate is to be used, the gum coating is removed with moisture as the gum is water soluble. This means that the gum coating will dissolve in water.

EXPOSING AND DEVELOPING A SUBTRACTIVE PLATE

Like the additive plate, the subtractive plate is placed in the platemaker to expose it or burn it. Subtractive plates should be handled in subdued room light or in a room with yellow light. Most manufacturers of subtractive plates give instructions which tell you that both sides of the plate can be used.

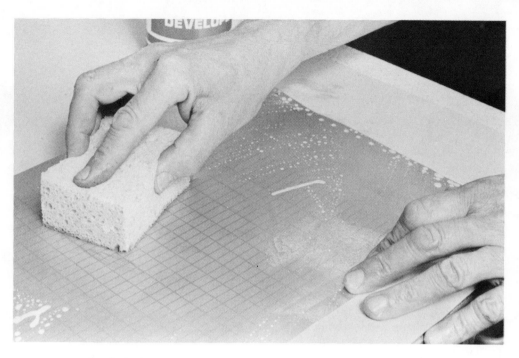

Fig. 8-16. Desensitizing the additive plate removes the unexposed coating.

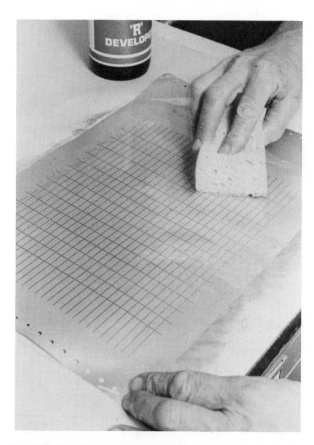

Fig. 8-17. Applying developing lacquer to the plate extends the life of the image over many more impressions.

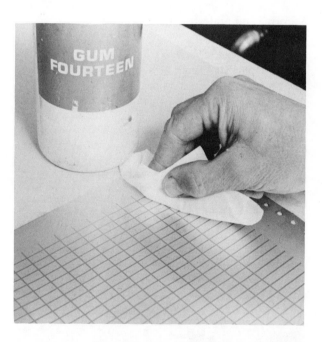

Fig. 8-18. Gumming the plate protects from soil during storage.

The correct exposure time must be found by using the negative sensitivity guide just as with the additive plate. The manufacturer will suggest the correct step or a number on the guide.

As you carefully remove the plate from the package, you will observe that the plate has a colored coating over it. In this process we are going to take away or remove the coating, not add to it. This is how we get the term subtractive — we are taking away the non-image area and leaving the image area. Placement of the flat over the plate is very important. Be very careful and accurate. As stated earlier, register pins may be needed for very accurate work.

Make sure that the emulsion side of the film is toward the plate.

Examine the film for cleaness. After the vacuum is turned on, check for good contact. Turn on the light source and expose the plate for the best time. (This has been determined by the trial and error tests.) So far, the process has been the same for the subtractive as the additive plates although the exposure time may have changed.

After exposure, turn off the vacuum. Remove the plate from the platemaker.

The solution used to develop a subtractive plate differs from the additive plate developing solution. Rub the developer over the entire plate as in Fig. 8-19. Allow the developer to do

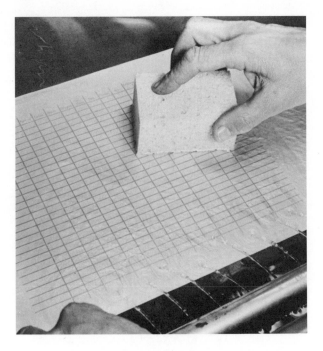
Fig. 8-20. Use a clean sponge to wash the plate.

the work. Let it stand for about 30 seconds, then take the cotton pad and remove the subtractive coating which covers the non-printing areas. The image area will remain and becomes the area which will accept ink. The plate is washed as shown in Fig. 8-20.

After washing, the plate is ready to be placed on the press. But, if the plate is to be used later, it must be gummed for protection as was the additive plate. The protective coating used on the plate is usually one recommended by the manufacturer.

Plates may be stored in a folder or envelope, Fig. 8-21, or they may be hung in a cabinet built for that purpose, Fig. 8-22. Always handle plates with care.

Once a plate has been run on the press and cleaned, it can be stored after the preserving or gumming step is followed. Another important point to remember is that the plates should be stored in a dry, cool place.

AUTOMATIC PLATE PROCESSORS

Many plants have automatic plate processors. Most processors require special chemicals and the instructions must be carefully followed.

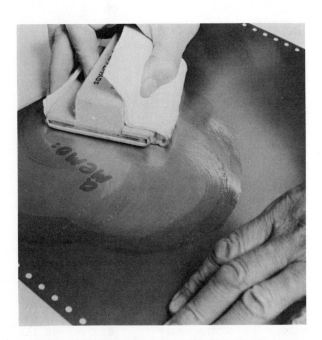
Fig. 8-19. Developer is applied to a subtractive plate.

Whenever new processes are introduced, the processing procedure must be studied and followed. An automatic plate processor is shown in Fig. 8-23.

Fig. 8-22. Cabinets are also built to store plates.

Fig. 8-21. Plates may be stored in folders or hung individually (Foster Mfg. Co.)

Fig. 8-23. Automatic plate processor eliminates handwork in plate preparation. (Polychrome Corp.)

TEST YOUR KNOWLEDGE — UNIT 8

1. Preparation of an image carrier (plate) is called _____ .
2. Name three common materials used to make offset lithographic plates.
3. Image areas of plates are the non-oily portion. True or False?
4. On which of the following can you place the image directly from a typewriter?
 a. Direct image plate.
 b. Direct photographic plate.
 c. Plastic plate.
 d. Surface plate.
 e. Typewriter plate.
5. What is another name given to a direct photographic plate?
6. Describe two common types of surface coated plates.
7. The most common type of metal used to make surface plates is _____ .
8. List the steps necessary to make a subtractive type image carrier.
9. An image carrier that will be used again should be preserved by _____ .
10. Which of the following are recommended for storing an image carrier (plate)?
 a. Hang it in a special cabinet.
 b. Hang it in open air so it will not mildew.
 c. Store in a cool, dry place.
 d. Store in an envelope.
 e. Store in folders.

SUGGESTED ACTIVITIES

1. Visit an in-plant photo-offset lithography department and write down the methods by which they make the printing plates.
2. Visit a commercial photo-offset lithography plant and find out what type of plates are used.
3. Develop a direct image plate using a variety of methods: typewriter, pen, crayon, etc.
4. Develop a presensitized plate and prepare it for limited storage.

Unit 9

IMAGE TRANSFER

Image transfer is the part of the printing process where the ink moves from the image carrier onto the material being printed. Everything up to the point of actual printing is commonly called pre-press operations. The type of printing described in this book requires the use of moisture and ink.

This method of transferring an image is used in producing over 50 percent of all the printed products in this country. We are printing from an image on a flat surface. We are transferring the image onto some type of substrate. (Substrate is the material on which you place an image.) The most common material used today is paper.

This unit will acquaint you with the presses used in photo-offset lithography. They are the image transfer systems.

Presses are of many different sizes from small desk top duplicators to large precision units that will print, dry and fold in one continuous operation. They might be sheet fed or web fed. A sheet fed press is shown in Fig. 9-1. Fig. 9-2 is an example of a large web fed photo-offset lithographic press.

The term "offset" must be used with care. Alone, it is a method that is used in several printing processes. Lithography is the important term and photo-offset lithography is one method. It is the method which will be described in this unit.

Even though the printing plate or image carrier has a smooth surface, the image area on this plate must accept printing ink while the non-image (nonprinting) area must not. The image area is slightly greasy but the non-image area is not. It is capable of being dampened.

The dampening liquid is called FOUNTAIN SOLUTION. When the non-image area is dampened, ink will not stick to it.

A balance between ink and fountain solution is very important. "Balance" refers to the right amount of ink and the right amount of fountain solution to dampen the plate. When right amounts are not used, we will have printing or transferring problems. The press is designed to deliver controlled amounts of both ink and fountain solution to the plate during printing.

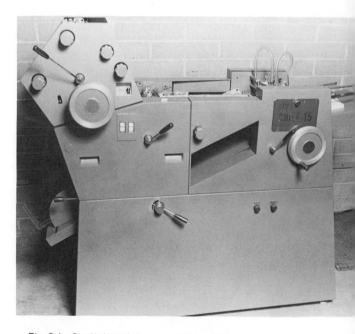

Fig. 9-1. Small sheet fed presses take up little floor space.

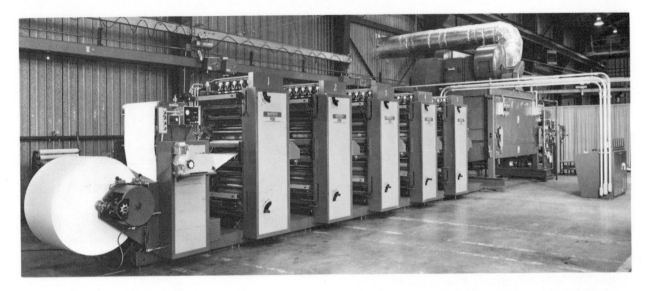

Fig. 9-2. A web fed press is a precision machine which runs at high speed. Some can print 1500 ft. of paper a minute. This unit can print both sides of the sheet in five colors as the paper travels through its banks of cylinders. (Western Gear Corp.)

IMAGE TRANSFER SYSTEMS

The image transfer equipment is commonly called an offset press. The press is divided into systems. Usually we find five listed:
1. Feeding.
2. Dampening.
3. Inking.
4. Impression.
5. Delivery.

Each system must be in good working condition to produce a printed image. Adjustments and simple maintenance of these systems are generally the responsibility of the operator.

FEEDING

The material to be printed is placed on the platform as in Fig. 9-3. The feed platform can be lowered by pushing in on the handwheel lever and then turning the platform handwheel, Fig. 9-4.

The stock (paper) is usually centered between the left and right side of the platform. The left guide is then moved to touch the stock while the right guide is moved to allow 1/16 in. or less of space between the stack and guide, Fig. 9-5. Make sure the stock is touching the front guides. The paper stack back guide should be adjusted so that the trailing fingers are

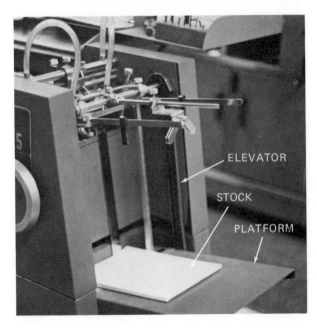

Fig. 9-3. Stock is placed on a platform which can be raised or lowered automatically or by hand.

against the ends of the sheets. The kinds of guides used will vary with every make of press but some means of support is necessary.

Air blowers are used to separate the sheets of stocks. One of the blowers is shown in Fig. 9-6. Usually the air blast direction can be changed manually. Some presses have a valve which regulates amount of airflow.

Fig. 9-4. Arrow points to handwheel which raises and lowers the feed table.

Fig. 9-6. Air from the nozzle separates sheets of paper.

Adjusting stack height

The lift (stack) of paper should be raised to within 1/4 in. of the sheet separators. (The separators are the top portions of the front paper guides. They are angled slightly backward toward the paper stack. Their purpose is to keep more than one sheet from being pulled into the press at a time.) Make sure the front guides are properly positioned, Fig. 9-7.

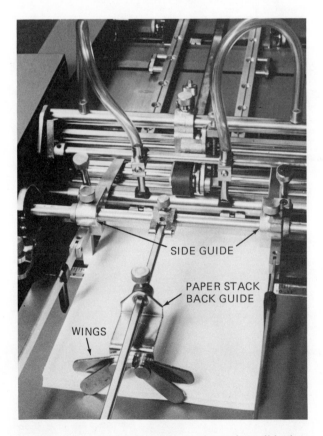

Fig. 9-5. Left and right side guides can be made to slide along the shaft when set screws (beneath arrows) are loosened. Front wings of back stack guide should be on top of stack; rear wings are behind and snug against end of stack.

Fig. 9-7. Position front guides. Leading edge of sheets will bump against them.

An elevator control knob, Fig. 9-8, controls the stopping of the elevator when the lift of paper is raised high enough. If you were to

lower the stack it would return automatically to the right height when the press is running. The elevator should stop the stack about 1/4 of an inch below the sheet separators. A good starting point is to adjust the height so that the top of the stack is at the second hole from the top of each blower tube.

Fig. 9-8. Height of paper can be adjusted through the elevator control knob.

Suction feet pick up one sheet at a time and place it in position so that it can be moved to the stops for image transfer. Most of the small presses pick the sheet up at the front edge, but some feed systems on large presses pick up the sheet at back. This system is called a stream feed.

The suction (sucker) feet pick up the sheet and place it so that the drive wheel can move it by conveyor tapes to the feed stops. As it moves down the conveyor, the sheet is guided into position by side guides. These side guides are commonly called JOGGERS, Fig. 9-9. The sheets can be jogged from either the left or right side. Whichever jogger is used, its purpose is to move each sheet to an exact position. It insures that every image will be printed in the same place on the sheet.

Each piece of paper, or whatever material you are printing on, must be stopped at the same position each time. Some presses have

Fig. 9-9. Jogger guides can be adjusted to left or right.

minor adjustments at the stops so that they can be moved slightly forward or backward. This allows the image to be moved up or down on the sheet of paper, Fig. 9-10.

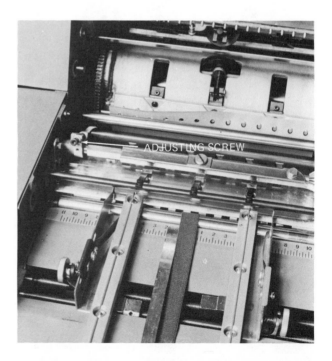

Fig. 9-10. Adjusting screw moves paper stops which hold paper in right position for being picked up by the cylinder.

Should the suction feet take more than one sheet, a double sheet eliminator, Fig. 9-11, keeps the sheets away from the press. It opens a plate and the sheets go into a special tray. This prevents two other problems:

1. A number of sheets going through the press could damage one of the units.
2. Unprinted sheets on the delivery stack would have to be removed by hand.

All of the adjustments found in the feeding systems are very important. Even a slight change can make a great difference in the appearance of the final product.

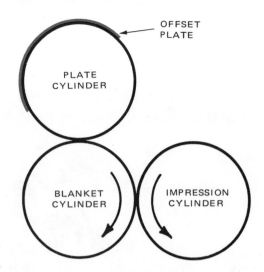

Fig. 9-12. Three-cylinder press system. Offset plate attaches to the plate cylinder.

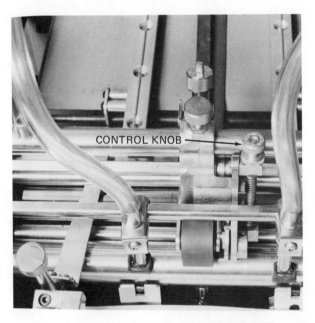

Fig. 9-11. Control device can be adjusted so press will accept only one sheet at a time.

TRANSFER OR CYLINDER SYSTEM

The number of cylinders depends on the press design. Generally we think of two types of systems:

1. The three-cylinder, Fig. 9-12.
2. The two-cylinder, Fig. 9-13.

THREE-CYLINDER SYSTEM

The three-cylinder system has an impression, blanket and plate cylinder, Fig. 9-14. Cylinders are the drum-like parts over or between which the paper passes to be printed.

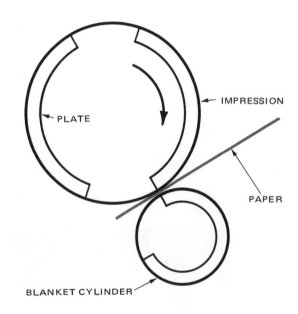

Fig. 9-13. Two-cylinder press system. Smaller cylinder makes two revolutions for every revolution of larger cylinder.

Plate cylinder

The plate cylinder holds the image carrier (plate). The plate is secured to the cylinder at its top and bottom, Fig. 9-15, by plate clamps. Note that there is a gap in the surface of the plate cylinder. After attaching the plate, recheck to make sure that it is properly clamped in place. Not all presses have the same type of securing arrangement. Three common types are:

1. Pinbar.
2. Serrated (slotted).
3. Bar clamp.

INK ROLLERS

E. AUXILIARY OSCILLATOR ROLLER
F. BACK IDLER
G. FOUNTAIN ROLLER
H. DUCTOR ROLLER
J. DISTRIBUTOR ROLLER
K. OSCILLATOR ROLLER
L. IDLER ROLLERS
M. FORM ROLLERS

DAMPENER ROLLERS

A. FOUNTAIN ROLLER
B. DUCTOR ROLLER
C. OSCILLATING ROLLER
D. MOLLETON ROLLER

MASTER CYLINDER

BLANKET CYLINDER

IMPRESSION CYLINDER

Fig. 9-14. Cylinders of a three-cylinder system are shown. Note how ink and dampener rollers are arranged on the master cylinder.

Fig. 9-15. Clamp holds each end of plate to the cylinder. Lower end of plate (at top of photo) is being placed over the clamps.

The plate cylinder can be moved to allow the image to be raised or lowered on the sheet. A control knob, Fig. 9-16, loosens a bolt which allows the operator to move the image nearer to or further away from the top of the page being printed. Use the control knob to tighten the bolt each time before checking the new position of the image. Do not turn over the press before the bolt is tightened. Be careful not to use too much force as the threads of the bolt can be stripped.

Blanket cylinder

When an impression of the image from the image carrier (plate) is transferred to the blanket, it is wrong reading (backward). A

Fig. 9-16. Knob controls position of plate cylinder.

mirror would make it right reading. This blanket is like a very hard sponge and it can be damaged if uneven material such as a wrinkled sheet, goes through the press while it is on impression. When the press is off impression, the blanket cylinder does not touch the plate or impression cylinder.

The blanket can be removed for special cleaning or replacement, Fig. 9-17. Blankets need good care in order to reproduce a quality image on the printed material. Too often, they are not thoroughly cleaned after running a job. Proper procedure for cleaning is supplied by the manufacturer.

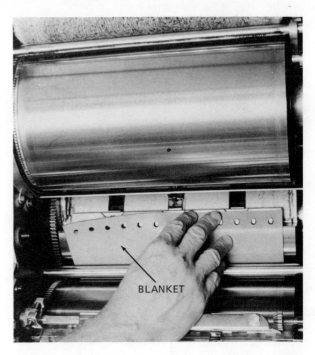

Fig. 9-17. Blanket is being removed from pinbar clamps holding it to the blanket cylinder.

Impression cylinder

Once the sheet leaves the feed stack and is guided to the stops, the grippers of the impression cylinder take the sheet from the stops and hold it in place while the image is transferring to the stock. The impression cylinder grippers hold the stock from slipping while the impression cylinder gives the right amount of pressure so that a good image can be transferred onto the stock.

The three-cylinder transfer system is commonly found in sheet fed printing presses.

TWO-CYLINDER SYSTEM

A two-cylinder system, Fig. 9-18, has one extra large cylinder and one small one. The larger is called the impression and plate cylinder. It has twice as much surface as the smaller one. That is why it can do the work of two cylinders. It makes one revolution while the smaller cylinder makes two.

The smaller cylinder is called the blanket cylinder. It receives the image from the larger cylinder during one revolution and transfers it to the paper during the next.

This is how the cylinders work together. As the large cylinder turns a half revolution, the plate area leaves an inky image on the blanket of the lower plate. Then, as the upper cylinder completes its revolution, a sheet of paper passes between the cylinders. The impression area of

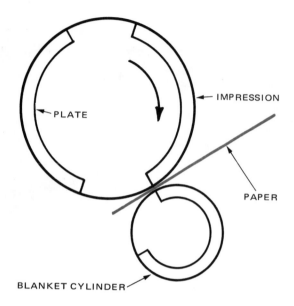

PLATE

IMPRESSION

PAPER

BLANKET CYLINDER

Fig. 9-18. Two-cylinder offset press prints one sheet each revolution of the larger cylinder. The sheet comes through as the impression area of the large cylinder contacts the blanket (smaller) cylinder. When no paper is traveling between the cylinders, the plate area is putting a new image on the blanket.

the large cylinder presses the paper tightly against the smaller roller. The image is transferred to the paper. As the paper leaves the cylinders, the image area of the large cylinder is in position to ink the blanket once more as the printing operation is about to be repeated.

Precautions: When these cylinders turn they become possible danger points. Always tie back long hair and wear head bands to make sure your hair is not caught in the press while it is running.

It is very unsafe to place your hands near the cylinders while they are turning. Make sure you do not have loose clothing, cleaning rags, cotton pads or sponges near these moving parts. An accident can happen very suddenly and it could result in an injury. Be careful at all times.

DAMPENING SYSTEM

In photo-offset lithography, the plate must be continually dampened to keep it clean. The non-image area accepts moisture. You already know that the dampening liquid is called fountain solution. Now you will learn how it is made up.

FOUNTAIN SOLUTION

Fountain solution is mostly water. Distilled water is recommended since the mineral content of tap water varies too much. Fountain concentrates are added to the water. Some manufacturers recommend a concentrate and a gum be added to the water to make a usable fountain solution. Follow the directions recommended by the manufacturer.

Fountain solutions are on the acid side. Most manufacturers recommend a pH factor between 3.5 and 5.0. On a scale of 0 to 14, 7 is neutral. Every number larger than 7 is alkaline while those below 7 are acid. A factor of 1 is very acid, as seen in Fig. 9-19.

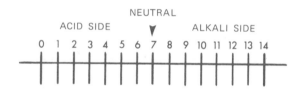

NEUTRAL

ACID SIDE ▼ ALKALI SIDE

0 1 2 3 4 5 6 7 8 9 10 11 12 13 14

Fig. 9-19. A pH scale for determining acidity or alkalinity of fountain solutions.

The pH should be checked carefully. A too high or too low reading could create printing problems. One way of checking the pH is to use litmus paper. Place one end of the litmus paper in the fountain solution and then match it to the color chart on the paper holder, Fig. 9-20. The pH may also be checked with an electric pH meter, Fig. 9-21.

Other devices and instruments are used to check the pH of the fountain solution. All of them are used to help make sure the quality of the end product remains the same. If the pH of the fountain solution is too acid, it is possible that:
1. The ink will not dry.

2. The plate run will be shortened.
3. The ink will fade.
4. The ink will emulsify. (Emulsification means that the fountain solution is mixing with the ink.)

These are just a few of the problems that can result from improper pH of the fountain solution. Follow the manufacturer's suggestions and directions. Also check the pH periodically when running the press.

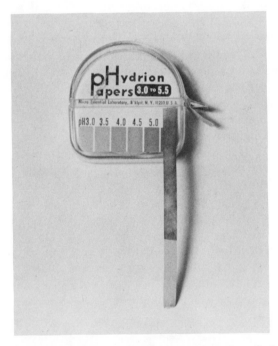

Fig. 9-20. Match litmus paper to color on the scale to find pH of solution.

MOLLETON DAMPENER

Rollers are used to pick up the fountain solution and spread it uniformly over the non-image area of the plate. This series of rollers make up a "system." We shall discuss two systems; the molleton and the aquamatic, Fig. 9-22.

The conventional molleton dampening system is widely used. It can be recognized by the form rollers fitted with coverings. This covering is called a "molleton," Fig. 9-23. The molleton must bring moisture to the image carrier (printing plate).

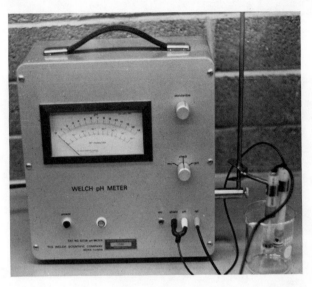

Fig. 9-21. Electric pH meter can use electrical properties of solution to determine acidity.

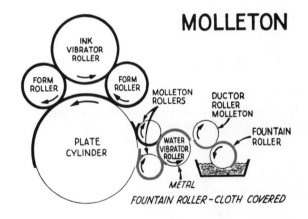

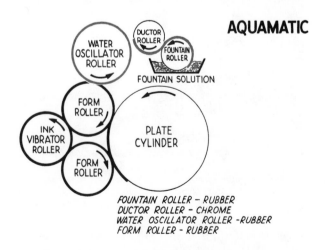

Fig. 9-22. Combinations of rollers transport fountain solution to plate area from fountain. The systems are shown. (A.B. Dick Co.)

Fig. 9-23. Molleton covering is designed to soak up fountain solution and release it evenly.

When the press is equipped with the molleton covered rollers, Fig. 9-24, the fountain solution supply is fed into a tray where it is kept at an even level. A container of fountain solution replenishes the supply.

A fountain roller revolves in the solution and transfers it to a DUCTOR ROLLER. Turning of the fountain roller can be controlled so that the right amount of solution can be transferred through the system of rollers to the plate. The ductor roller, also molleton covered, comes in contact with the DISTRIBUTOR ROLLER. The metal distributor roller moves back and forth from end-to-end. The distributor roller

Fig. 9-24. Molleton covered rollers. The nearest roller has been lifted out of the tray where it picks up the fountain solution. Ductor roller is next in line.

must transfer an even amount of moisture to the FORM ROLLER or rollers. Some presses have one form roller while others have two. Each form roller is also covered with a cloth or synthetic material. The form roller must distribute an even coating of fountain solution onto the image carrier (plate). The right amount of solution is very important. The moisture adheres to the non-image areas and the image areas repel the solution. The fountain solution must keep the non-image areas clean.

The right amount of pressure between rollers is very important. A slight impression between the form roller and the image carrier is necessary. One method of checking is to take two strips of 16 lb. paper, approximately 1 in. wide, and place them between the form roller and image carrier. When the form roller is on, a slight drag should be felt. Each strip should have the same amount of drag. Too much pressure causes the image carrier (plate) to wear.

Dampening controls

The molleton dampening system has basic controls as shown in Fig. 9-25. The fountain roller has a control which determines the amount of turn for each press revolution. Usually the control knob allows the operator to turn it freely by hand.

The form roller control lever allows the operator to drop the form rollers. The form rollers are now in contact with the image

Fig. 9-25. Dampening control indicated by arrow, can be turned by hand. It can add a large quantity of water to system very quickly.

carrier. The lever is also used to raise the dampener form rollers when the press is not running.

The conventional dampening system is widely used but many other variations of this system are common in industry today. To help eliminate problems, in any dampener system, keep everything clean and make proper roller adjustments.

AQUAMATIC SYSTEM

In the aquamatic system the same roller carries the fountain solution and the ink to the image carrier, Fig. 9-26. The fountain solution is supplied in much the same manner as the conventional system. The fountain roller picks up the solution from the tray and transfers it to the ductor roller. The ductor roller transfers it to the oscillating roller. (Moving back and forth end-to-end.) But the oscillator roller transfers the solution to the ink form roller and not to a dampener form roller. This roller carries the fountain solution, as well as the ink, to the image carrier.

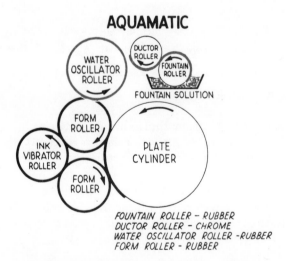

Fig. 9-26. Aquamatic dampening system also carries ink. (A. B. Dick Co.)

The fountain solution used in this system is one recommended by the manufacturer. Follow directions for proper mixing of these solutions. This is very important.

The molletons must be dampened as with the conventional system. The dampener system can be speeded up by increasing the amount of fountain roller revolution. All rollers, from the ink fountain on, are covered with ink. Start the duplicator press according to the manufacturer's recommended procedures.

INKING SYSTEM

The inking system consists of rollers which distribute ink to the image carrier (plate). A typical inking system is shown in Fig. 9-27.

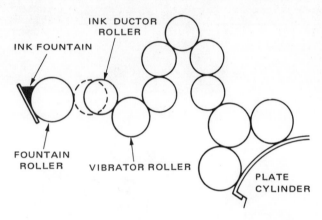

Fig. 9-27. Typical inking system uses many rollers to insure even distribution. Ink ductor roller (second roller away from fountain) moves back and forth. Sometimes it touches the fountain roller and sometimes it touches the vibrator roller.

FOUNTAIN CONTROL

An ink fountain holds the ink supply for the press. The amount of ink moved to the image carrier can be controlled in two ways:

1. The space between the fountain roller and fountain blade can be changed. The smaller the space, the thinner the ink film picked up by the roller. Space is adjusted with a series of thumbscrews commonly called keys.

 A simple method of adjusting the space at each key requires a strip of 16 lb. paper. Insert the paper between blade and roller, as in Fig. 9-28. Move the key until paper can be moved with a slight drag. Repeat this operation at each key.

2. Vary the amount of rotation (turn) on the ink fountain roller, Fig. 9-29. For each press cylinder revolution, the fountain roller moves only part of a turn. The lever which moves it can be adjusted for a longer or shorter stroke. The more it turns, the more ink it delivers. Generally it is better to have

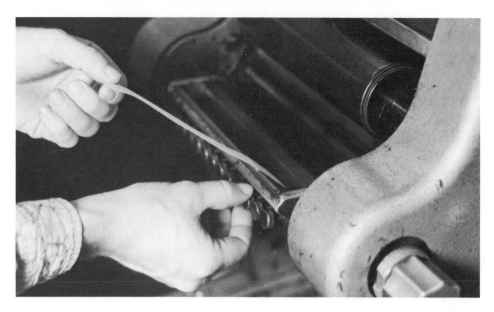

Fig. 9-28. Distance between blade and fountain roller can be checked with a strip of paper.

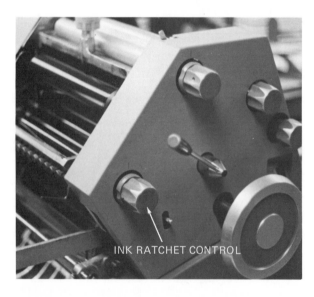

Fig. 9-29. Ink fountain roller turn is controlled through the ink ratchet. A lever moved by an eccentric (bump on a shaft) pushes against the ratchet (notched wheel) on the end of the ink roller.

more turn of the fountain roller and the smallest possible opening of the ink fountain blade. It is easier to control the amount of ink to the plate using this procedure.

It is wise to stir the ink before placing it in the fountain. This causes a better flow through the inking system. If you are taking ink from a can, make sure you do not gouge it out of the can. Remove it smoothly in thin layers so the remaining ink has a smooth surface.

Do not waste ink. Some jobs require only a small amount. More can always be added to the fountain. Do not return unused ink to the same can. This is not a good practice. The ink might be contaminated with fountain solution, paper fibers or dirt.

The ink fountain adjustment is very critical. Too much ink can be the start of press problems.

INK TRANSFER

Ink moves from the fountain to the printing plate over a series of rollers. Next to the fountain roller is the ductor roller. It rocks back and forth as it turns. First it touches the fountain roller picking up ink. Then it touches a distributor roller depositing the ink there. Distributor and vibrator rollers spread the ink before transferring it to the form rollers.

The number of rollers on a press will vary but generally there are from two to four form rollers. Diameters of the form rollers are different as shown in Fig. 9-30. If the operator removes the rollers, great care must be used to return each one to its proper location. Otherwise, the press cannot be made to work.

All rollers must be adjusted carefully. Each manufacturer has specifications for this. One of

Fig. 9-30. Diameter of ink rollers often varies. From left to right above, the sizes read 2 1/4 in., 2 3/32 in., 2 in. and 2 3/16 in.

the most critical settings is the adjustment which determines the pressure of the form roller against the image carrier.

The method of adjustment varies with the kind of press. Each manufacturer's manual tells you how to make the adjustments.

One recommended check is to lower the form rollers to the image carrier (plate) and, after contact, immediately raise them. The image carrier (plate) should not be moistened before making this test. Turn the plate cylinder and look at the ink film lines on the plate, Fig. 9-31. The ink lines should be even across the plate for all rollers. The width of the ink film line should be the same for each roller. Some specifications indicate a width of 1/8 in. while others specify 3/16 in. A wider ink film line means that too much pressure is being applied. Too much pressure tends to wear away the image carrier (plate).

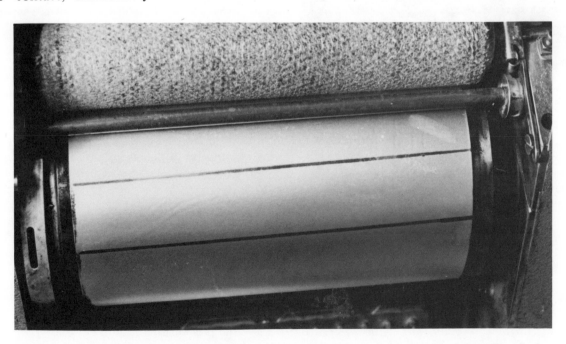

Fig. 9-31. Ink film lines on plate should be uniform in width. If uneven, there is a problem in adjustment or the roller is worn.

WASHUP PROCEDURE

Most presses have some way of removing the ink from the rollers without taking out each roller and cleaning it by hand. Most recommended solvents will do a good job of cleaning the press rollers and blanket.

Ink left in the fountain must first be removed, Fig. 9-32. Do not return it to the same can, but save it if you can. Clean the emptied ink fountain with a rag and solvent. Try not to get other surfaces dirty. If you do, clean the soiled surface immediately.

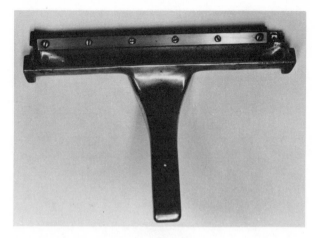

Fig. 9-33. Blade cleanup system is found on many presses. It works like a squeegee.

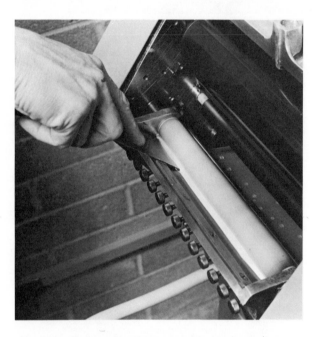

Fig. 9-32. Remove ink from the fountain with an ink knife.

Many presses have a blade cleanup system which scrapes the ink from the rollers, Fig. 9-33. With the blade attached to the press, place solvent on the rollers and start the press. The ink and other material on the rollers is diluted by the solvent and the cleanup blade scrapes it from the rollers. Continue placing solvent on the rollers until they are clean. Rollers that are left dirty cause problems the next time you run the press.

When placing the cleanup blade in position, check to make sure it is seated properly. *Do not try to attach or remove it while the press is running. Injury may result.*

Another cleanup method often used with duplicators is a cleanup sheet. This blotter like sheet is placed on the plate cylinder just as you would attach an image carrier. (The image carrier will have been removed after the run was completed.) Before placing solvent on the rollers, remove the dampener system rollers or make sure they are not in contact with the cleanup sheet.

Turn on the press. Place solvent on the ink rollers. Drop the ink form rollers to the cleanup sheet and let the sheet absorb the diluted ink as the press runs. To completely clean the press, more than one cleanup sheet may be required.

After the rollers are cleaned, wipe down the plate cylinder to remove all ink. Use a rag dampened in solvent. The blanket should be wiped clean. It requires the same care as the rollers. All ink or other substances should be wiped off the impression cylinder. Take a few extra minutes to do a good job. A clean press can help eliminate problems stemming from dried ink.

The cleanup system varies for each press but most of them do a very satisfactory job. If the rollers or blankets become glazed, remove the glaze with special cleaning solvents. After every run, the press should be wiped clean so that it is ready for the next job.

Some precautions should be followed:
1. Use only recommended solvents.

2. Keep cleaning solvent in a special container recommended for that purpose.
3. Rags should not be placed on the rollers while the press is running.
4. Never wear loose clothing. It may get caught in the press.
5. Dirty rags should be placed in a container provided for that purpose.

CLEANING THE DAMPENING SYSTEM

The dampener rollers should be removed and cleaned as necessary. Special solutions are available that will remove ink.

The fountain solution bottle should be removed. Excess solution in the fountain should be soaked up with a sponge or other absorbent material. Clean the fountain roller as well as the vibrator roller if they are dirty. These rollers must be clean! A dirty roller cannot distribute moisture evenly to the form dampener rollers.

DELIVERY

Once the stock has been printed (an image has been placed on it) the delivery system takes over and carries the sheet to a stack. The transfer from one system to another varies from press to press. Generally, the sheet is transferred directly from the impression cylinder gripper to delivery grippers which carry the sheet to a stack. The chain delivery system is commonly used today, Fig. 9-34. The delivery bars are fastened to the chains and the printed material is carried to the stack. The table supporting the stack can be regulated so that it moves down automatically to allow for more sheets. The chute delivery system is often found on small duplicators, as shown in Fig. 9-35.

Static electricity is often a problem. It causes sheets to stick to each other. If the ink is not set it tends to smear. Most stackers align (make edges even on all sides) the printed material as it is placed on the stack. If setoff problems occur because the ink is not set, an offset spray unit can be used. It places anti-offset materials in very small quantities on the surface of the printed sheet. This helps eliminate the problem of setoff. These units are often very dusty. The fine powder or spray gets all over the delivery

part of the press. This can create a health problem. All health standards must be observed. As an operator, you should remove the excess powder as you clean the press.

To help stop setoff, some presses are also equipped with a drying lamp. It gives off heat which helps set the ink more rapidly.

Fig. 9-34. Chain delivery system moves printed sheets from the impression cylinder to a stack.

Fig. 9-35. Chute delivery system is simpler. Lamp at left helps dry ink to prevent setoff.

WEB FED PRESS

At the beginning of this unit you saw and read about the web fed press. Such presses are commonly called roll fed. A continuous roll of paper goes through the image transfer system. Following the transfer units, special attachments to the press can slit the sheet, fold the sheet or sheets, gather the sheets and cut them to the desired size. Web offset presses are commonly found in plants where newspapers, magazines and books are printed.

Color units can be added to these presses. This type of equipment is used where greater speed is needed for production.

PROCEDURE FOR PRESS OPERATION

Having a set procedure to operate a press is important. You do not want to forget to do something. The plan which you will use may vary slightly, but having a plan is the important thing.

1. Select all necessary materials.
2. Observe all safety rules.
3. Lubricate the equipment.
4. Lower paper platform.
5. Make adjustments.
 a. Adjust side guides.
 b. Position stock.
 c. Position separator (front) guides.
 d. Position air blowers.
 e. Set double sheet eliminator.
 f. Adjust feed roller.
 g. Adjust and position suction feet.
 h. Raise stock.
 i. Set rear paper stop.
 j. Set paper height adjustment.
6. Adjust feed board.
 a. Turn on air system.
 b. Turn press by hand.
 c. Move paper feed control.
 d. Pick up sheet.
 e. Set jogger side guides.
 f. Set feathers.
 g. Adjust jogger for squareness.
 h. Move paper stop if necessary.
 i. Continue turning press by hand until stock reaches delivery system.

7. Delivery system adjustments (for chain delivery).
 a. Raise platform to proper height.
 b. Adjust side guides.
 c. Adjust front guides.
8. Delivery system adjustments (for chute delivery).
 a. Set side guides.
 b. Set rear stop.
 c. Position sheet retainer.
9. Dampening system.
 a. Check fountain and fountain roller. They should be clean.
 b. Mix fountain solution.
 c. Place solution in fountain bottle.
 d. Place bottle in fountain holder. Make sure fountain solution does not come in contact with ink rollers.
 e. Place rollers in position.
 f. Turn over press by hand.
 g. Start press.
 h. Run press until rollers are dampened.
10. Inking system.
 a. Place ink fountain in place.
 b. Check fountain and rollers. They must be free of dirt.
 c. Close fountain keys as described in unit.
 d. Place ink in fountain. Amount is determined by type of job.
 e. Set ink control knob.
 f. Set keys for thin ink film.
 g. Start press.
 h. Use manual control until rollers are properly inked. (More ink can easily be added but it is difficult to remove ink without cleaning the press.)
11. Image transfer.
 a. Place blanket on press.
 b. Run press on impression for 10 or more revolutions.
 c. Adjust blanket.
 d. Place image carrier on plate cylinder.
 e. Moisten with fountain solution using cotton pad.
 f. Start press.
 g. Lower dampener roller to image carrier.
 h. Run for at least 20 revolutions. (Check for proper dampening of plate.)
 i. Slowly lower ink rollers to image carrier.
 j. Start air and vacuum motor.

k. Run sheet through press.
l. Check image position on sheet.
m. Make necessary adjustments, vertically as well as horizontally.
n. When quality is reached, set counter.
o. Run number of copies required.
p. Raise ink and dampener rollers.
q. Stop press.

12. Cleaning the press.
a. Remove image carrier.
b. Preserve, if needed, for a later run.
c. Clean impression, blanket and plate cylinders with a rag, using blanket and roller solvent.
d. Clean dampener system.
e. Remove excess ink from fountain.
f. Remove fountain.
g. Clean ink roller system.
h. Clean fountain.
i. Wipe down press.
j. Turn off power.

Things to remember:

1. Only qualified and authorized persons should operate the press.
2. Observe all safety rules when operating the press.
3. Make sure the press is thoroughly cleaned after running a job.
4. Check the press before turning it over by hand to make sure everything is in working order.
5. Only one person should run the press at any one time.
6. Adjustments on the press are critical.

TEST YOUR KNOWLEDGE — UNIT 9

1. Name the systems commonly found on a press.
2. _____ is the name given to all material upon which an image is placed by a press.
3. A fountain solution (check all that apply):
 a. Is a dampening liquid spread on the printing paper.
 b. Dampens non-image areas on the plate.
 c. Should have a pH range between 3.5 and 5.0.
 d. Consists of water from the tap.
4. Balance between ink and fountain solution means:

a. Both ink and solution must be weighed and delivered to the work in equal amounts.
b. Both must have the same pH reading.
c. The right amount of ink to print a good image and the right amount of solution to dampen the plate.
d. None of the above.
e. All of the above.

5. The _____ is the name of the covering which receives the image from the plate and transfers it to the material to be printed.
6. Name the five systems making up the offset press.
7. Which of the following devices have a part in insuring that only one sheet of stock goes through the press at a time:
 a. Elevator control knob.
 b. Suction feet.
 c. Air blowers.
 d. Sheet separators.
 e. Double sheet eliminator.
8. The blanket cylinder of a two-cylinder offset press turns twice as fast as the plate and impression cylinder. True or False?
9. The three-cylinder press has _____, _____ and _____ cylinders.
10. Indicate the purpose of the blanket cylinder and describe its surface.
11. Rollers in a conventional dampening system have _____ coverings on them.
12. Check which of the following conditions will occur if the fountain solution is too acid:
 a. Ink will mix with the solution.
 b. Image carrier will wear out faster.
 c. Ink will not dry.
 d. Ink will fade.
 e. Ink will dry too fast.
 f. All of the above.
13. Describe a method for checking proper dampener roller pressure.
14. The ink form rollers are adjusted right when the inked strips across the image carrier are _____ to _____ wide.
15. The term for cleaning up a press is _____ _____ _____.
16. Which of the following describe a type of system that carries the printed sheet to the printed stack:
 a. Chain delivery.
 b. Chute delivery.

119

c. Ink transfer system.
d. Special delivery.
e. Static electricity.
17. When the ink transfers to the back of a delivered sheet we say the ink has _____ .
18. Name the principle on which photo-offset lithography is based.

SUGGESTED ACTIVITIES

1. Make ready a press for a single color run. After the run, completely clean the press. Be sure to check with your instructor for proper cleaning supplies.
2. Prepare a preventative maintenance chart for the presses to be followed by the press operator. (Preventative maintenance is a daily program of care which prolongs useful life of a machine.)
3. Visit a photo-offset lithography plant and list the sizes and types of presses found in the facility.
4. Make a list of safety precautions and post them near the press.

Unit 10

BINDING AND FINISHING

After an image has been placed on material such as paper, some type of process may be necessary to bind or finish the job. At one time, binding and finishing was done by what is called the service industry. Now, many graphic communications facilities can do the work in their own plant. Although the terms are similar, binding and finishing will be considered as two sections in this unit.

PAMPHLET BINDING

The binding of booklets, folders, leaflets, catalogs, magazines and like materials is referred to as pamphlet binding. This does not include the binding of books which will be discussed later. Some of the more common operations found in pamphlet binding are:

1. Folding.
2. Scoring.
3. Perforating.
4. Tipping.
5. Gathering or collating.
6. Inserting.
7. Stitching.
8. Trimming.

FOLDING

Buckle type folders are commonly used to fold paper. This type has two rollers which force the sheet to touch a fold plate, Fig. 10-1. The plate acts as a stop. Still being pushed by the forwarding roller, the sheet buckles and goes through the fold rolls. Some of the most common folds are shown in Fig. 10-2.

Folders usually make two kinds of folds: parallel and right angle. An example of a simple

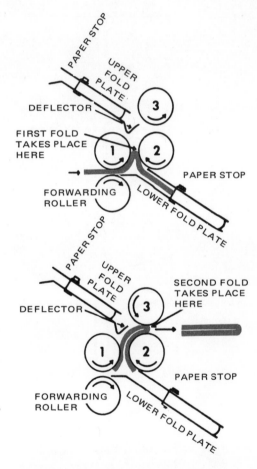

Fig. 10-1. Buckle type folder. Paper is pushed against paper stop; it buckles and folds as it passes between rollers 1 and 2. A deflector plate sends it through rollers 2 and 3.

parallel fold would be the accordion fold in Fig. 10-3. Fig. 10-4 shows another example of an accordion fold.

In a right-angle fold, the first fold is parallel and the second is at right angles, as shown in Fig. 10-5. A table model folder, Fig. 10-6, is a

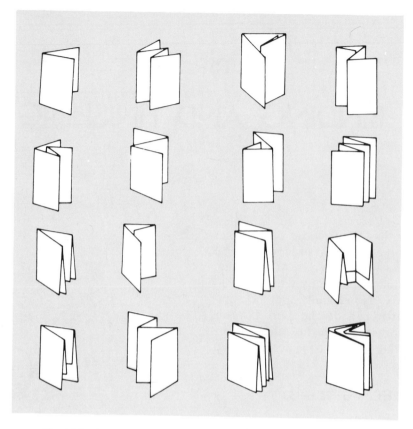

Fig. 10-2. These are some of the folds produced by folding machines.

Fig. 10-3. There are two parallel folds in this accordion type six page fold. (A. B. Dick Co.)

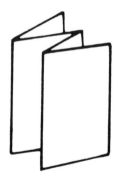

Fig. 10-4. Accordion type parallel folds used in eight pager.

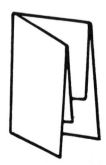

Fig. 10-5. Example of right-angle fold. When printed on only one side this may be called French fold.

small sheet folder. It makes a variety of parallel folds and is simple to operate.

Floor model folders, Fig. 10-7, are capable of folding larger sheets with parallel and right-angle folds. Some folders can be adapted to do other bindery operations such as slitting and cutting.

Fig. 10-6. Table model folder is used for folding letters. Many business offices have them. (A.B. Dick Co.)

The folders just described are not the only types found in the graphic communications industry. But they are the most commonly used for sheet fed operations.

SAFETY

Work with care around the folder. Never attempt to grasp sheets moving through it. Paper edges can produce severe cuts. Keep fingers away from rollers while the machine is in operation. Never engage in any sort of play while operating the folder. Adjustments and setups should be made only as directed or demonstrated by the instructor.

CREASING AND SCORING

A crease in a sheet allows it to be more easily folded. There are two common devices used for creasing.
1. A creasing rule.
2. A rotary creaser.

Both methods tend to compress the paper which gives it a ridge on one side and a corresponding groove on the other side. A round edge of a rule presses into the paper, as shown in Figs. 10-8 and 10-9. This can be done on some presses or by a special creasing machine. Fig. 10-10 shows tongue and groove rotary creases mounted on a shaft.

Scoring, in some plants, has the same meaning as creasing but it also refers to a method where a sharp metal rule cuts into the surface of heavy paper. The stock folds at the cut. Extreme care must be taken not to cut too deep.

Fig. 10-7. Floor model folder can fold larger sheets. (O & M Machinery Div., General Binding Corp.)

Fig. 10-8. Diagram shows how a creasing rule can produce a furrow in the paper so it will fold easily. Round edge of the rule produces the crease. (A.B. Dick Co.)

Fig. 10-9. Tongue and groove of rotary creasers produce a crease line as the paper moves through the folder.

PERFORATING

When a portion of a printed piece is to be removed — such as a stub from a ticket or a check from the checkbook — removal is made easier by slit lines or holes along the tear line.

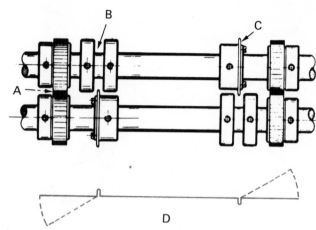

Fig. 10-10. Diagram of a rotary creaser shows part of the creaser and illustrates what it does to the sheet of paper. A—Rubber faced rollers pull the sheet through the creaser. B—Groove. C—Tongue. D—Edge view of paper showing how creaser creates ridges for easier folding. Left side would fold down; right side would fold up, creating an accordion fold.

The process of making slits with a rule, as shown in Fig. 10-11, is called perforating. Perforating may also be done with a rotary (circular) die, Fig. 10-12. In magazines, coupons or reply cards are sometimes perforated to make them easier to tear out.

TIPPING

Sometimes a separate page or a sheet must be attached to a booklet, magazine or other type of publication. It can be attached with a small amount of adhesive applied to the edge

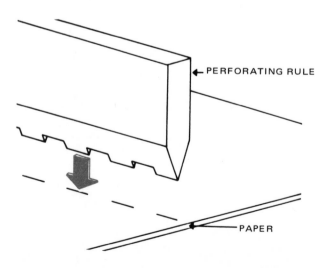

Fig. 10-11. Perforating rule cuts short slits at regular intervals on the paper. (A.B. Dick Co.)

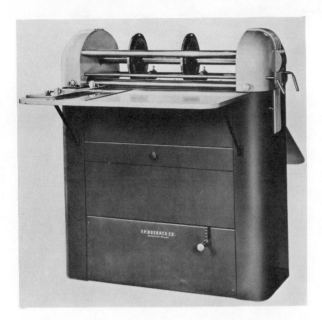

Fig. 10-12. On a rotary perforator, the perforating knife is in the shape of a circle. It rotates as the paper passes under it. (F.P. Rosback Co.)

GATHERING

Once sheets are printed they must be placed in proper order. The process of placing pages in order is called GATHERING. It can be done by hand or by some mechanical means. A sheet gathering machine is shown in Fig. 10-14.

Large gathering machines are used to assemble magazines and books. A larger gathering machine is shown in Fig. 10-15. Some large machines will gather single sheets while others will gather folded SIGNATURES. (A signature is a large sheet containing several pages, folded down to the size of a single page.)

Sometimes the word collator is used rather than gatherer. But the word gather means to assemble while the word COLLATE means to check the sheets after they have been gathered. The purpose of collating is to see that all are in proper position and in the right order. To others "gathering" means to assemble signatures while the word "collate" means to assemble single sheets.

of the sheet. The process is called TIPPING IN. The end sheets of a book are typical examples of tipped in material, Fig. 10-13.

Fig. 10-13. End sheets are tipped in after the book is sewn.

Fig. 10-14. Sheet gathering machine places all pages of a booklet in order. Photo shows one "station" and part of another. There will be as many stations as there are sheets. (Muller-Martini Corp.)

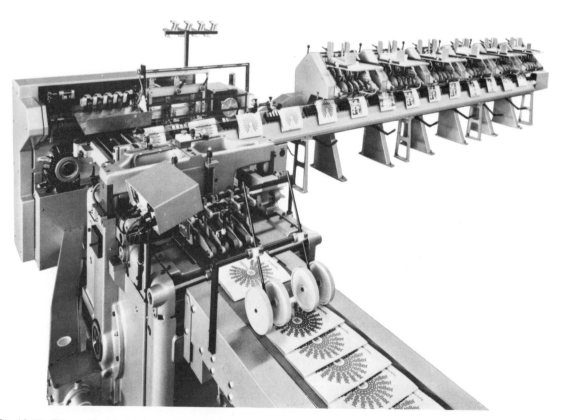

Fig. 10-15. This saddle stitcher is an automatic gathering machine. It places signature and cover together and then stitches each piece with wire staples.

INSERTING

The term INSERTING refers to the assembling of signatures one inside the other. Inserting one section of a newspaper into another section is an example of inserting, Fig. 10-16. This can be done by hand or by a machine. Many pieces of equipment can do this automatically.

STITCHING OR BINDING

After single sheets or signatures are gathered, they often need to be fastened by some means. One method is called stitching. It is a binding operation.

Two types of stitching are commonly found in the industry: saddle stitch and side stitch. In both methods, wire staples are inserted to bind pages together. A wire stitching machine can be manual, Fig. 10-17, or automatic, Fig. 10-18.

Fig. 10-17. Manual wire stitching machine will saddle or side stitch with staples it shapes from wire.

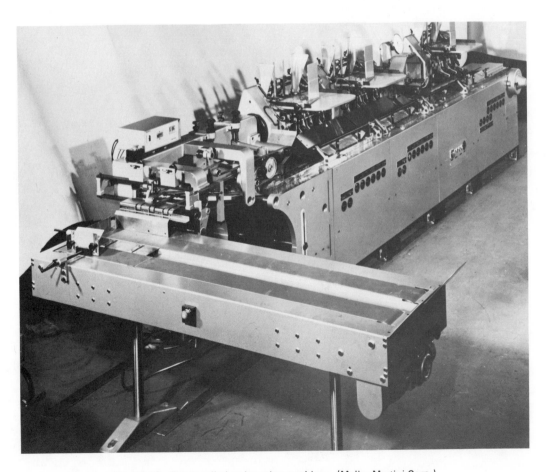

Fig. 10-16. This is called an inserting machine. (Muller-Martini Corp.)

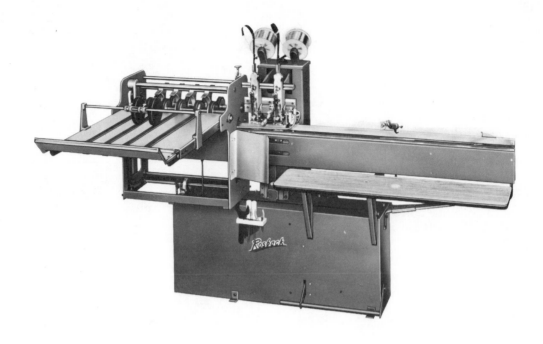

Fig. 10-18. Automatic wire stitching machine is type used by modern printers. (F.P. Rosback Co.)

To make a saddle stitch, each folded sheet or signature is inserted and then placed over the saddle of the stitcher. A staple is driven through the folds, Fig. 10-19. Look at the wire staples in a copy of TIME magazine. It is an example of saddle stitching.

Very few magazines are side stitched any more mainly because the pages cannot be opened flat. Whenever material is to be side stitched the sheets or signatures are stacked one on top of the other and a staple is driven through one edge of the material, Fig. 10-20.

Fig. 10-20. Stapling the edge of gathered paper like the above is called side stitching. (A.B. Dick Co.)

TRIMMING

The last major operation in pamphlet binding is the trimming of each assembled unit (pamphlet or magazine). One way to trim the three unbound edges is to use the guillotine cutter, Fig. 10-21. The sharp knife is brought down through the bound units either by hand or by a power cutter. A clamp holds the stock in place while the knife is cutting it. This operation is shown in Fig. 10-22.

Fig. 10-19. Saddle stitching places staple through folded sheets. (A.B. Dick Co.)

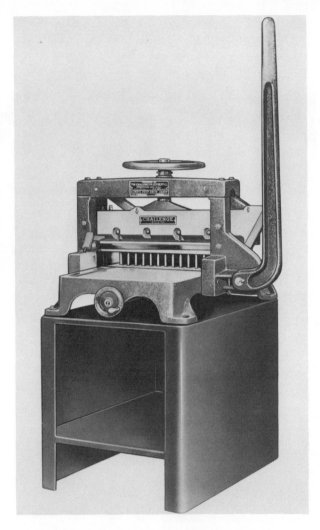

Fig. 10-21. Guillotine type cutter has a heavy knife which comes from the top down. (Challenge Machinery Co.)

Fig. 10-22. Clamp holds paper in place so that it cannot shift as knife comes down. A—Knife. B—Clamp.

This knife is very sharp and extreme care must be taken so that an accident does not occur. Each cutter should be equipped with safety devices such as a two-hand control unit. In this way both hands must be used to operate the machine. If they are used to operate the machine they cannot be placed under the paper cutter blade.

A three-knife trimmer is used in high production plants. The three-knife cutter is often fully automatic. Even the trimmed waste is removed automatically.

EDITION BINDING

Books which must stand up to hard usage need a more durable binding. They receive hard

cloth covers. Two of the terms used for this process are CASE BOUND or EDITION BINDING. The book consists of:
1. A series of signatures.
2. A case or cover.
3. End sheets.

A hardbound book is made up of many pages. The pages must be attached securely to each other so that the book does not come apart from frequent usage. The signatures are sewed together with thread and the back is heavily coated with glue or some other adhesive material. See Fig. 10-23.

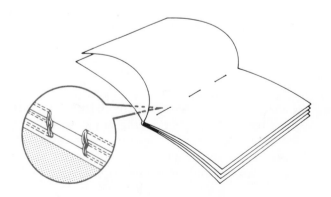

Fig. 10-23. Sewing a book keeps the pages together.

But before this binding operation takes place, three edges of the book are trimmed. The back is not trimmed when the book is to be sewed.

In sewing, the thread is pulled in and out through the folds of the signatures until all the pages and all the signatures are bound together. Often the back of the book is rounded before sewing. In the next step, glue is applied to the back. The glue provides additional support to hold signatures in place. More expensive bindings receive additional support material (backing cloth) over the glue. Muslin is a very good backing cloth, Fig. 10-24.

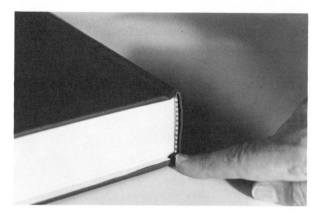

Fig. 10-25. The headband is the fabric glued to the book edges of the pages inside the cover.

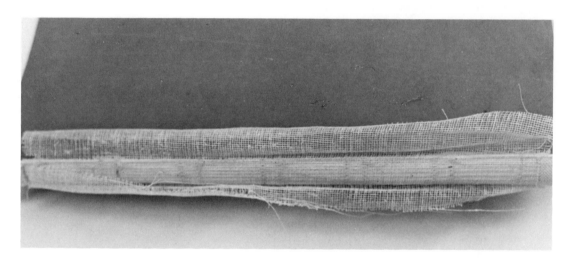

Fig. 10-24. Muslin backing cloth is glued on for extra support.

For better appearance and to hide the binding edge, HEADBANDS are often placed at the head and tail of the book. (These are terms used for the top and bottom edges of the back.) Fig. 10-25 shows such a headband. It is the colored fabric which fits tightly to the backs of the signatures inside the cover.

The cover of the book is called the CASE. It is made of a durable cloth or plastic which is glued to a thick paperboard called BINDERS BOARD. Before the cover is placed on the book, type and images may be printed on it. This decorates and identifies the book.

The term CASING IN means the assembling of the book and the cover. During the process,

glue is applied to the end sheets. Then the book is placed in a press until dry.

ADHESIVE BINDING

Adhesive binding is used in many situations where an inexpensive, less durable binding is suitable. Paperback books use a variation of this binding.

In its simplest form, adhesive binding is called PADDING. It is used to bind together a collection of single sheets. It is used for making up pads of writing paper or note paper.

To produce a pad, a stack of paper is built up. At regular intervals in the stack, a piece of

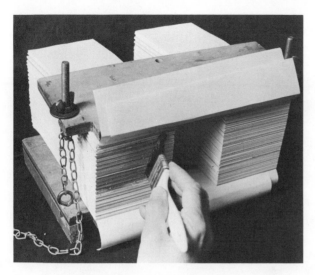

Fig. 10-26. Simple padding technique. Glue is applied with a brush.

Fig. 10-27. Perfect binding machine skives back of books, applies glue and cover. (Muller-Martini Corp.)

chipboard is inserted. The stack is placed in a padding press or in any kind of device that will press the sheets tightly together. Fig. 10-26 shows a simple padding press.

A type of glue called padding compound is brushed on one edge. After the glue is dry, the stock is separated at each piece of chipboard and trimmed, if needed.

Remember if the sheets are printed, make sure the pads are cut apart correctly. The chipboard should be at the bottom of each pad.

Many paperback books are bound by a method called perfect binding. The sheets or signatures are gathered and then held tightly in place while the back is ground (skived) or sawed off. Only a small amount of paper is removed. Grinding or sawing the back makes it rough and exposes the edge of each sheet to the glue. The roughing exposes more of the paper edge to the glue and it will hold together better.

After the back is roughened, a flexible glue is applied over the entire backbone. Before the glue is dry, the cover is attached. The glue on the backbone also holds the cover in place. When the glue has dried the back is trimmed.

Another example of perfect binding is the telephone book. An adhesive binding machine is shown in Fig. 10-27. This type of binding is much less expensive than edition binding.

MECHANICAL BINDING

In mechanical binding, more or less rigid fasteners hold sheets together. Wire and plastic are two of the common materials used. This type of binding allows the book or booklet to open flat. Many of the notebooks on the market are wire spiral bound, Fig. 10-28. Holes are punched to receive a continuous piece of spiral wire which is threaded through all of the holes. This type of binding does not allow sheets to be added.

Fig. 10-28. Wire spiral bindings are popular for notebooks. (A.B. Dick Co.)

PLASTIC BINDING

For plastic binding units (often called combs) rectangular holes (slots) are punched in

Fig. 10-29. Plastic binding machine punches slots in sheets and attaches binding.

the gathered paper, Fig. 10-29. Then the booklet is placed over the plastic binder. The fingers of the binder are inserted in the slots and the binder is closed.

There are several advantages in the plastic binder. It opens flat and the binder can be removed to add or remove sheets. Binding units can be purchased in different sizes. Their lengths can also be shortened by merely cutting the plastic back as in Fig. 10-30.

Fig. 10-30. Plastic can be cut to length using a heavy shears.

LOOSELEAF BINDING

The ring binder is still another example of looseleaf binding. The sheets are gathered, punched and placed in the binder. Sheets can be quickly added or removed. Some come prepunched while others need to be drilled or punched. A small paper drill is shown in Fig. 10-31. Whenever you are working on the paper drill, be careful! Make sure that long hair is tied back. Loose clothing or shirt sleeves could cause an accident with possible injury.

The same punched sheets could also be bound in a post binder, Fig. 10-32. Posts come in a variety of lengths. The bindings are not permanent and allow addition or removal of sheets.

FINISHING

Finishing is a very general term. Some of the most common activities included are: die cutting, flocking, embossing, laminating and varnishing. People in industry might agree that these are supplementary processes rather than finishing activities.

Die cutting

Die cutting converts an image area or a non-image area into various shapes. Die cutting on a cover might remove some of the paper so

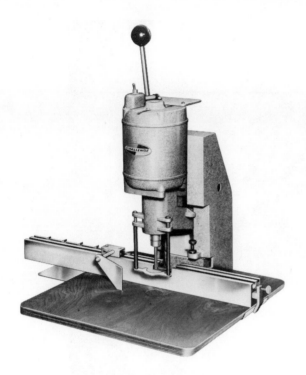

Fig. 10-31. Small paper drill produces holes for ring or post binders. (Challenge Machinery Co.)

Fig. 10-32. Binding posts are inserted through drilled or punched holes. (A.B. Dick Co.)

that the image on another page can be seen. Fig. 10-33 shows a die cut product.

The dies are very sharp and cut through the stock, Fig. 10-34. If the stock is to have an image on it, the printing is done first. Then the die cutting follows.

Another example of die cutting is the envelope. The dies for this operation look very much like cookie cutters. The die is pressed through lifts or stacks of paper. Care must be taken not to cut yourself as the die cutting edge is very sharp. Handle all dies with care.

Flocking

Flocking is not a common process in the graphic communications industry. It can be found on greeting cards, a screen printed shirt or on wallpaper. Tiny pieces of fiber are forced into the ink while it is still wet. The end of the fiber embeds in the ink and, when dry, gives the image area an unusual texture. This is a highly specialized finishing operation.

Embossing

In some promotional materials and annual reports, part of the image area is embossed. The paper in that area is raised. This operation requires the use of two dies. The paper, or similar material, is placed between the two dies. When the dies are pressed together they will form the raised area, Fig. 10-35.

Sometimes before embossing, the image is printed and then shaped between the dies. Another form of image may be transferred at the same time the stock is being embossed. This requires a foil to be placed in the embossed area. Gold or some other color might be transferred. Whenever the die alone is used, it is called blind embossing.

Laminating

Attaching or bonding two or more materials together is commonly called laminating. This process is sometimes used in the graphic arts. One application is the protective plastic coating placed over restaurant menus. Cards are often laminated too.

Varnishing

Varnishing places a coating on the surface of printer matter so that it will resist heat, water or other elements that would damage paper. The surface becomes very smooth and generally is shiny.

Varnish can be placed on the paper using a press. If the whole area is to be coated, the dampener rollers can be removed and the varnish coating on the plate is transferred to the stock. Various kinds of coatings are available today, but are not discussed in this book.

Fig. 10-33. Die cut covers remove a portion of a non-image area for special effect.

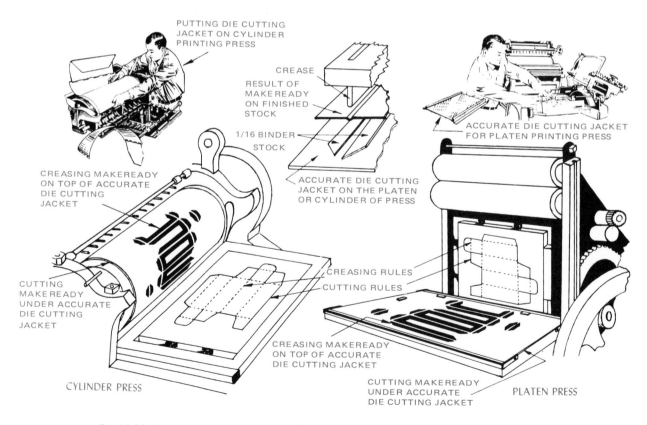

PUTTING DIE CUTTING JACKET ON CYLINDER PRINTING PRESS

CREASE

RESULT OF MAKEREADY ON FINISHED STOCK

1/16 BINDER STOCK

ACCURATE DIE CUTTING JACKET ON THE PLATEN OR CYLINDER OF PRESS

ACCURATE DIE CUTTING JACKET FOR PLATEN PRINTING PRESS

CREASING MAKEREADY ON TOP OF ACCURATE DIE CUTTING JACKET

CUTTING MAKEREADY UNDER ACCURATE DIE CUTTING JACKET

CREASING RULES

CUTTING RULES

CREASING MAKEREADY ON TOP OF ACCURATE DIE CUTTING JACKET

CUTTING MAKEREADY UNDER ACCURATE DIE CUTTING JACKET

CYLINDER PRESS

PLATEN PRESS

Fig. 10-34. Dies can be made in any shape. They are very sharp. (Accurate Steel Rule Die Mfg., Inc.)

Fig. 10-35. Embossed emblem was pressed into paper
with special dies.

the graphic communications industry are:
a. Adhesive.
b. Bosting stitch.
c. Saddle stitch.
d. Side stitch.
8. Cutting the edges of a booklet is called guillotine. True or False?
9. What is the name of the binding used to bind hard cover books.
10. Two ways to bind by adhesives include the following:
a. Casing in.
b. Flexible gluing.
c. Padding.
d. Perfect binding.
e. Pamphlet binding.
12. A process known as _____ is used to cut away or make a window in paper.
13. Raising an image on paper is called _____.
14. What process would protect the surface of paper?

TEST YOUR KNOWLEDGE — UNIT 10

1. _____ is the term commonly associated with the binding of booklets, folders, etc.
2. What are the two types of folds performed by folding machines?
3. What operation will make it easier to fold a cover by hand?
4. When slits or holes are punched in paper to make it easier to tear we say it is _____.
5. Placing sheets in sequence or right order is called:
a. Collating.
b. Gathering.
c. Scoring.
d. Tipping.
6. Placing a folded signature inside another folded signature is called _____.
7. Two common types of stitching found in

SUGGESTED ACTIVITIES

1. Prepare a diagram showing four common types of fold.
2. Position eight pages of equal size on a sheet of 11 by 17 in. paper. After drawing the layout, fold at right angles and parallel folds.
3. Cut up an old telephone directory into three or more sections.
a. Saddle stitch 50 folded pages.
b. Divide a section into five equal parts with at least 50 pages in each part. Place a chipboard on one side. Position the five parts so that they can be coated with padding compound on one edge.
c. Side stitch a lift of the directory which is 1 centimetre thick.
4. Collect at least five examples of perforated and/or die cut materials.

Unit 11

PAPER AND INK

Paper is all around us. You write on it and it allows us to have magazines and books. What are the materials from which it is made? How is it made? What gives it strength? These are just a few of the questions that will be answered in this unit.

Papermaking is a very complex process. It begins with the making of pulp. The most common source material for pulp is wood, Fig. 11-1. But now many facilities are recycling old paper as a means of supplementing new wood fibers. If wood becomes scarce, other types of materials will have to take its place. Plants which have fibers could be that source. Bamboo and sugar cane are two plants whose fibers could be used to make paper.

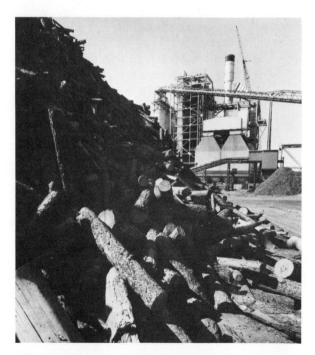

Fig. 11-1. These logs await the process that will turn them into pulp.

One of the plants first used as a writing surface was papyrus. The fibers of this plant were interwoven by the Egyptians and Greeks many years ago. This is considered to be the forerunner of papermaking.

Many kinds of wood are used to make paper. But some fibers are preferred for different types of paper.

Anyone who would put ink on paper (the printer) must know something about the characteristics of paper. Some are smooth while others have texture. Some accept ink better than others. Some are more brittle; some have greater strength. Some are said to have printability. Printability affects the way paper will run through the press and that will determine the length of time it will take to run the job.

MAKING PULP

Logs must undergo considerable change before they become paper products. First they are cut up into lengths and sent to the pulp mill. The bark is removed mechanically, Fig. 11-2. After debarking, the logs are either ground up or sent to a chipper, Fig. 11-3.

Ground fibers are often used to make newsprint. Such paper is rough texture, weak and soon becomes brown and brittle. The chips, on the other hand, are broken down chemically to produce fine papers. This is done in a "digester" which also removes lignins, gums, resins and other unwanted by-products. The resulting pulp is made up of cellulose fibers.

Since the fibers have a brownish color, they need to be bleached, Fig. 11-4. This process lightens the fibers. If the pulp were not

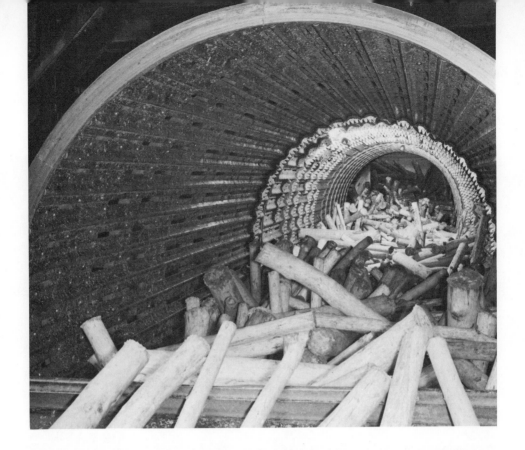

Fig. 11-2. This tunnel-like machine tumbles the logs as the many sharp teeth remove the bark from the logs. (International Paper Co.)

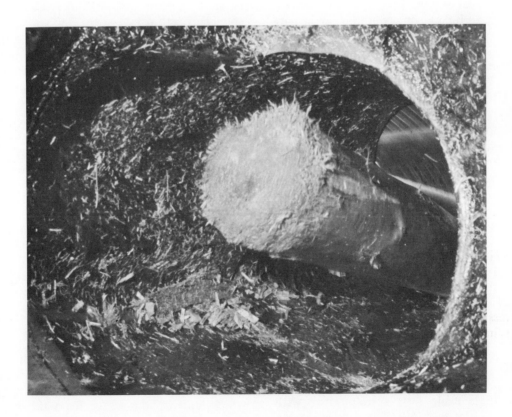

Fig. 11-3. Chips fly as log is reduced to small particles by the chippers. (International Paper Co.)

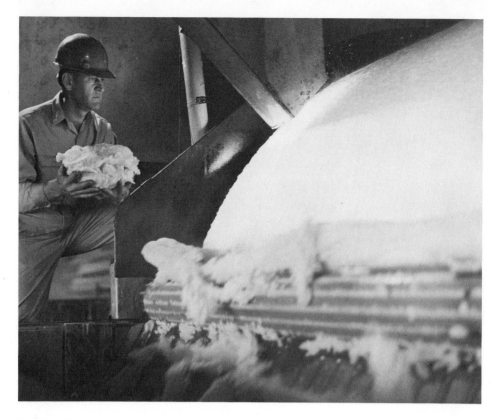

Fig. 11-4. Wood pulp takes on a white color after the bleaching operation. (International Paper Co.)

bleached, the paper would look like the brown grocery bags, boxes or common wrapping paper.

The fibers must go through further conditioning. They are cut, beaten, crushed, and refined. To give the paper the quality required for printing operations, materials must be added to give it smoothness (clay) and opacity (titanium dioxide). When print does not show through paper, it has opacity. Color, if necessary, is usually added to the pulp at this point.

PAPERMAKING

The treated pulp flows into the papermaking machine. This machine is made up of three sections:
1. The wet end.
2. The press section.
3. The drying section, as seen in Fig. 11-5.

WET END

The pulp is made into a soupy mix with water before it is distributed evenly along the total width of the machine. The mixture is spread in a thin layer on a fine wire screen. The screen moves along like a conveyor belt, Fig. 11-6. The water drains through the screen helped by suction boxes underneath. What remains are the fibers which will form a sheet of paper.

Have you ever looked at the trademark on some sheets of paper and wondered how the symbols or words were placed on the sheet even though it was not printed? This is known as watermarked paper, as seen in Fig. 11-7. The mark is placed on the sheet by a cylinder known as a dandy roll. It is located above the screen and smooths the surface of the wet pulp. The roll comes in contact with the wet paper and the symbol or words are pressed into the fibers changing their position.

PRESS SECTION

The web of paper has a high percentage of water when it leaves the wet end. This must be removed. The press section is made up of rolls which squeeze the water from the paper as it moves along on its conveyor. When leaving this

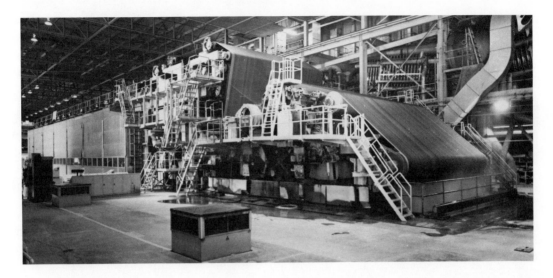

Fig. 11-5. Drying section of a papermaking machine is in the covered section at left. (Southwest Forest Industries)

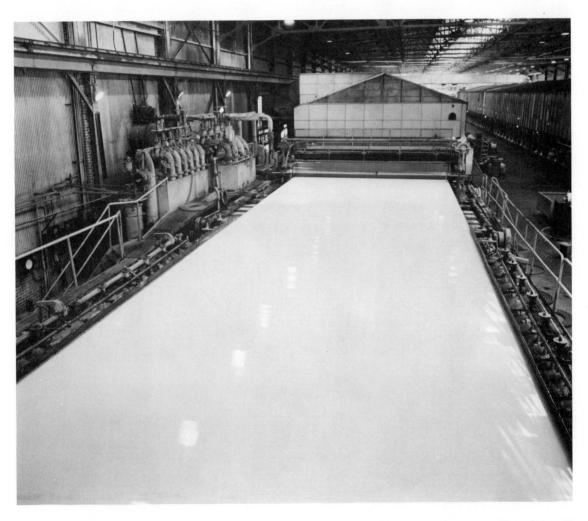

Fig. 11-6. Wet end of the papermaking machine. Wet paper fibers ride on an endless traveling wire screen. Water drains off as screen moves along toward drying section. (International Paper Co.)

Fig. 11-7. Watermark identifies the paper.

section, the paper is still made up of about 60 percent moisture.

DRYING SECTION

Now the web enters the drying section of the papermaking machine. This section of the

machine is very large, Fig. 11-8. The dryers are made up of many rollers called drums. The drums are heated and as the paper passes over each drum, moisture is removed from the web of paper.

Once the right moisture content is reached, the web passes through sections of the machine which gives the paper a surface finish. This operation varies for each kind of paper. If certain finishes are added, the web goes through another drying section.

The web of finished paper is wound on a reel. The reels are long and have a large diameter, as shown in Fig. 11-9.

PAPER PROPERTIES

The variety of paper in use today appears to be unlimited. Paper is constantly changing because of the new materials being developed and introduced. Some of the more important points about paper properties will be discussed in this unit. The designer and the press operator, or any other person, will look at each characteristic from a different point of view.

Grain is one of these characteristics. How can you tell which way the grain is running in a sheet of paper? One of the simplest ways is to

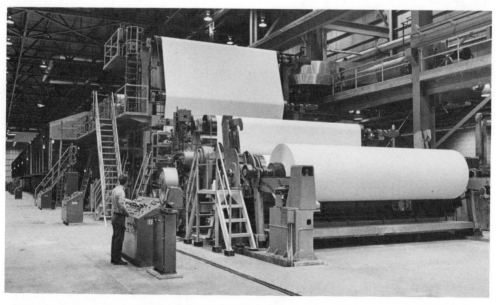

Fig. 11-8. Paper coming from the drying section of the papermaking machine is wrapped onto a huge roll. (International Paper Co.)

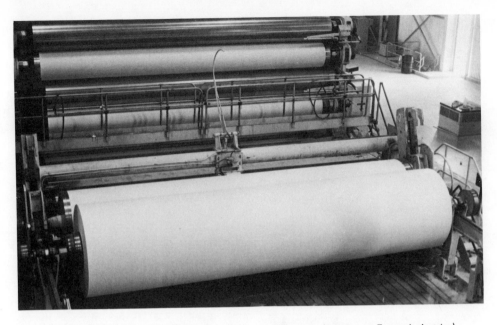

Fig. 11-9. This reel of paper is fresh from the drying drums. (Southwest Forest Industries)

tear a sheet. Generally, the sheet will tear straighter with the grain than against the grain, as shown in Fig. 11-10. Another checking method is to support a sheet on a rod. The paper is stiffer with the grain, Fig. 11-11.

Some of the points to remember are that paper folds easier and leaves a smoother edge when folded with the grain. Paper, when moist from running through a lithographic press, will stretch more across the grain than with the grain. The strength of paper depends upon the type of fibers used to make it.

Some papers will print better than others because of the surface. The surface will also affect ink coverage.

This gives you an idea of how important the properties of paper are. They must be considered when selecting paper for a printing job.

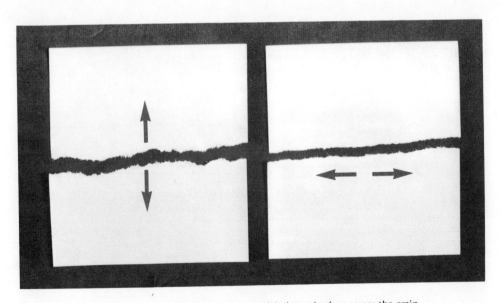

Fig. 11-10. Paper will tear straighter with the grain than across the grain.

Fig. 11-11. Paper sheets are resting on a bar to check grain direction. Paper is stronger along its grain.

PAPER WEIGHT AND SIZES

Most papers are known by their BASIC WEIGHT. The basic weight refers to the number of pounds in a ream of paper cut to its basic size. A ream of paper is generally considered to be 500 sheets. In a few instances it might be 480 sheets.

The basic size is not the same for all kinds of paper:
1. Writing papers (bond, mimeo, etc.), 17 x 22 in.
2. Book (text, offset, etc.), 25 x 38 in.
3. Cover, 20 x 26 in.
4. Index bristol, 25 1/2 x 30 1/2 in.
5. Newsprint, 24 x 36 in.

Usually paper is referred to in its ream weight, such as 20 lb. bond or 70 lb. book. Twenty-pound bond means that 500 sheets of 17 x 22 in. writing paper will weigh 20 lb. If an "M" appears after the weight, it means that now the weight refers to 1000 sheets. An example is: 25 x 38–140M. This means that 1000 sheets of 25 x 38 in. book paper will weigh 140 lb., Fig. 11-12.

Each kind (grade) of paper has many sizes and weights. Fig. 11-12 lists only the basic size.

The categories — book, writing, cover, index, Bristol, tag and newsprint — are commonly called the kinds or grades of paper. Each has special characteristics and common uses. How you intend to use them will determine what kind you will buy. The printer should know about paper but a reliable paper salesperson can be a great help.

METRIC PAPER SIZES

Another measuring system is about to become a part of our industry. It is called the SI metric system.

One area that we will be concerned with is paper size. The letters, A and B will be used to designate a series. The sizes in each series are numbered from 0 to 8.

The basic "A" series, with the designation of 0, has an area of 1 square metre. This sheet is not square but has a proportion of 5:7.

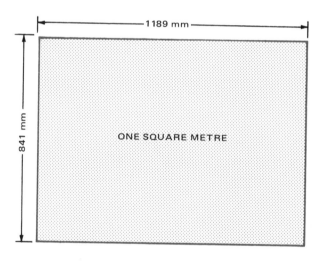

Fig. 11-13. Metric "A0" series.

TYPICAL WEIGHTS (1000 SHEETS) AND SIZES AVAILABLE IN THESE WEIGHTS

BOOK	25 x 38	60	70	80	90	100	120	140	160, ETC.
WRITING	17 x 22	26	32	40	48	56	64, ETC.		
INDEX BRISTOL	25½ x 30½	117	144	182	222	286			
COVER	20 x 26	100	120	130	160	180, ETC.			

Fig. 11-12. Table of standard sizes and weights.

Fig. 11-13 represents the "A0" series. Once we have the one square metre, each smaller size is determined by halving the larger size, as seen in Fig. 11-14. The standard metric sizes are found in Fig. 11-15.

The "B" series is divided the same as the "A" series. But the sizes are in between the "A" series and are to be used for unusual situations. The "B" series sizes are given in Fig. 11-16.

One advantage of the metric is that the proportion of any size in the series is always the same. Each smaller size is always half the larger size. The number represents the number of times a sheet can be folded to obtain that size.

DESIGNATION	mm	INDEX
B0	1000 x 1414	39.37 x 55.67
B1	707 x 1000	27.83 x 39.37
B2	500 x 707	19.68 x 27.83
B3	353 x 500	13.90 x 19.68
B4	250 x 353	9.84 x 13.90
B5	176 x 250	6.93 x 9.84
B6	125 x 176	4.92 x 6.93
B7	88 x 125	3.46 x 4.92
B8	62 x 88	2.44 x 3.46

Fig. 11-16. Metric sizes given in "B" series. Last column is the equivalent in inches and hundredth of inches.

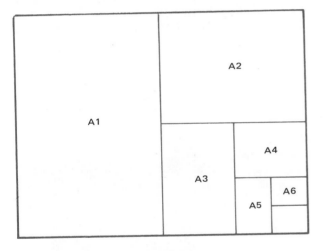

Fig. 11-14. Halving sizes.

DESIGNATION	mm	INDEX
A0	841 x 1189	33.11 x 46.81
A1	594 x 841	23.39 x 33.11
A2	420 x 594	16.54 x 23.39
A3	297 x 420	11.69 x 16.54
A4	210 x 297	8.27 x 11.69
A5	148 x 210	5.83 x 8.27
A6	105 x 148	4.13 x 5.83
A7	74 x 105	2.91 x 4.13
A8	52 x 74	2.05 x 2.91

Fig. 11-15. Metric sizes given in "A" series. The column marked "Index" is the size of the metric sheet in inches.

PURCHASING PAPER

Paper is sold in either sheets or rolls. The common U.S. sheet sizes were given earlier. These sheets can be purchased by the package,

carton or bundle. Anything less than a ream (500 sheets) in some grades would be a broken package. Other grades are packed 100 sheets to a package and anything less would be a broken package. Paper price books give the necessary information so that you can figure stock in the most economical way. Mistakes in ordering stock can be very costly. Estimating stock accurately is very important.

ESTIMATING PAPER

Before printing a job for a customer, a printer has to know how much stock is needed and what size sheet it can be cut from with the least waste. This can be worked out with the aid of mathematics. The following illustrates the problem. A customer needs 3500 sheets of business stationery. The size of the stationery is 8 1/2 x 11 in. The basic size of bond is 17 x 22 in. How many sheets of the smaller sheets can be cut most economically from the 17 x 22 in. sheet? Fig. 11-17 shows you how to find the answer using the vertical as well as diagonal method of dividing.

To see this more clearly let us make a drawing of the vertical and diagonal method, Fig. 11-18.

The vertical method gives us the most economical way of getting the most out of the sheet. Four sheets of 8 1/2 x 11 in. stationery can be cut from each sheet. But the customer needs 3500 sheets.

The next step is to find out how many large sheets are needed. Since each 17 x 22 in. sheet produces four 8 1/2 by 11 in. sheets, 3500 is divided by four. The answer is 875 using simple

NUMBER OF PIECES PER SHEET:

	vertical		cross	
Size of stock	17 × 22		17 × 22	
Size wanted	8½ × 11		8½ × 11	
	2 × 2		2 × 1	
No. pieces/sheets		= 4		= 2

Fig. 11-17. Vertical and diagonal method for determining most economical use of paper.

division. We will need 875 sheets of 17 x 22 in. bond to print the stationery. But we have not figured waste. Usually a percentage of the total is added to allow for spoilage and makeready.

Before printing, the paper is cut as shown by the black lines in Fig. 11-18. If you have a

power or hand paper cutter, use it only after you have been properly instructed. The blade is razor sharp. Use extreme care. Fig. 11-19 shows a modern paper cutter.

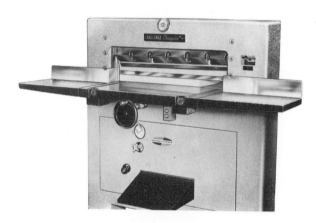

Fig. 11-19. Paper cutters are efficient machines for cutting large stock. (Challenge Machinery Co.)

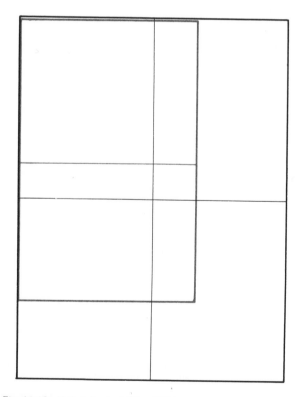

Fig. 11-18. If the sheet of 17 x 22 in. stock was cut according to the mathematical problem in Fig. 11-17, this is how it would look. Black lines represent the vertical method. Colored lines represent the diagonal or cross method.

ENVELOPES

Envelopes, Fig. 11-20, are usually ordered from an envelope company. Each style has a special use. No. 9 for example, is for business use and measures 3 7/8 x 8 7/8 in. A No. 6 3/4 commercial measures 3 5/8 x 6 1/2 in. Window envelopes are the same size as the official envelope. Generally they are used for invoices or statements.

The booklet envelopes are most often used for direct mail. Some of the advertising mate-

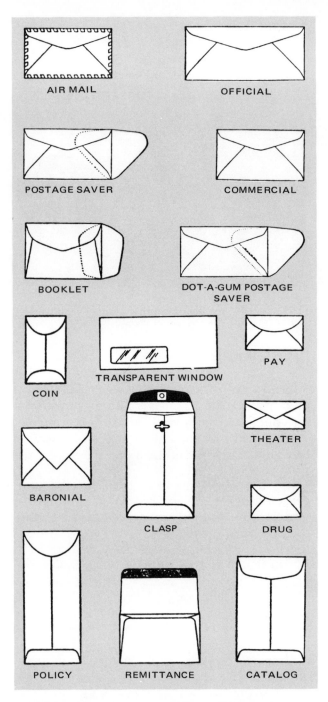

Fig. 11-20. Envelope types. (Carpenter/Offutt Paper Co.)

AIR MAIL · **OFFICIAL** · **POSTAGE SAVER** · **COMMERCIAL** · **BOOKLET** · **DOT-A-GUM POSTAGE SAVER** · **COIN** · **TRANSPARENT WINDOW** · **PAY** · **BARONIAL** · **CLASP** · **THEATER** · **DRUG** · **POLICY** · **REMITTANCE** · **CATALOG**

Open-end envelopes, being larger, are used for mailing reports, pamphlets, magazines and other similar material. A common size is 9 x 12 in. or 8 3/4 x 11 1/4 in. These are a few of the types. They are illustrated in Fig. 11-20.

PRINTING INK

Ink is very important. Without it we would not see the words, artwork or photographs on a printed page. To make ink for today's fast presses and special printing surfaces, the ink manufacturers hire chemists and physicists who make sure the mixture will work. The two principle ingredients of ink are the vehicle and the pigment.

VEHICLE

The vehicle is the liquid. The liquid acts as a carrier for the other material. Many synthetics are used today as vehicles. New types of vehicles are being made and tried over and over to see if they meet the requirements of the new type of plates, new fountain solutions and new drying systems.

The vehicle must remain a liquid while it is on the press, but when it touches the paper or other material it must dry rapidly.

PIGMENTS

The pigments are the powders which are mixed with the vehicle to give the color. Many pigments are available today and this is what we see when we look at a magazine, poster or any other type of printed material. The proportion of pigment to vehicle is very important.

WORKING QUALITIES

Manufacturing ink is a very complex process. Printing by the photo-offset method demands certain qualities of ink. These are called WORKING QUALITIES.

Working qualities of ink have to do with how it will act on the press. For example, all printing ink must have body. This means it have various consistencies. (In this sense, consistency means how thick or how liquid the ink is.) Some inks

rials that come to your house in the mail use this envelope.

A common type used for wedding announcements and invitations or for other formal occasions is called baronial. A No. 6 baronial would measure 5 x 6 in.

will flow more rapidly than others because of these different consistencies. Thus, the slower the press speed the heavier the ink that it can use. The higher the press speed used the thinner the ink must be.

Lithographic inks must be strong in color. The reason for this is that the film of ink applied to the image is very thin. If the color is not strong, the ink will not give good coverage.

Ink must also have tack (stickiness). It must stick to the roller and then transfer to a plate. From the plate it must move onto a blanket and then onto paper. Stickiness is required at all transfer points.

We have learned that the two main ingredients of printing inks are the vehicle and the pigment. But many other compounds are added to make printing ink work better on the press. One important added ingredient is a drier. Some of today's inks even are perfumed. Scratching the printed surface releases the perfume.

Many ink manufacturers have basic colors from which you can get many more by mixing. Color mixing and matching takes practice.

Most inks are ready to be used from the container, Fig. 11-21. The type of ink container also varies. Small amounts of inks can be purchased in tubes, cartridges or cans, Fig. 11-22. Larger cans, pails or drums are used for some inks depending on the process and amount used.

Fig. 11-22. When ink is used in smaller amounts, these types of ink containers are best.

INK STORAGE

Storage of inks requires a small amount of care. While some of today's inks do not dry in the container, others need special care. A plastic sheet placed over the unused ink is one way to help eliminate waste or dried out ink.

When removing ink from a can or pail do not gouge into the ink to remove it, but rather remove it by scraping the needed amount from the top, using an ink knife.

Another way to prevent waste is to place a small amount of oil inside the lid of the can. This tends to help seal the can.

TRANSFER INK

Transfer printing is an important printing process in the textile industry and also in the graphic communications industry. It uses the ability of certain dyes to sublimate. (The dyes go from a solid to a gas and then back to a solid.)

This process really does not use a printing ink with pigments at all, rather it is a dye which is placed in very tiny capsules. These very small capsules are printed onto paper, Fig. 11-23. The transfer sheets are ironed onto clothes. When the heated iron goes over the capsules they

Fig. 11-21. Ink can be removed from the can with an ink knife.

Fig. 11-23. Transfer paper releases dyes as a gas when heat is applied to the paper. This change to a gas is called sublimation.

break and the dye becomes a part of the cloth, Fig. 11-24. The colors are very brilliant depending on the fabric and fineness of the weave. Some of the brightly colored shirts are examples of dye heat transfer inks in the textile industry.

Photo-offset lithography is a fairly recent entry in this field and problems are to be found. The best results are obtained with the following fabrics: 100 percent polyester, nylon and 50-50 cotton-polyester. Heat transfer is not recommended for 100 percent cotton fabrics.

The amount of heat required ranges from 350 F (177 C) to 410 F (210 C) for a period from 15 to 25 seconds.

PRINTING THE SHEETS

The dye heat transfer ink is handled like the regular lithographic ink. The best type of stock is a matte finish paper or smooth offset paper. Do not use coated paper. This ink is very expensive.

Fig. 11-24. Ironed on transfer ink design.

After the image is printed on the paper it will look dull and even dirty. If any of the capsules are in a non-image area when heated they will transfer. This is one of the problems. The results really cannot be checked until the image is heat transferred.

TEST YOUR KNOWLEDGE – UNIT 11

1. What is one of the most common products used to make pulp?
2. _____ is the term used to denote the elimination of show through.
3. What are the three sections of the paper making machine?
4. Which of the following are basic characteristics of paper:
 a. Brittleness.
 b. Printability.
 c. Smoothness.
 d. Strength.
 e. All of the above.
 f. None of the above.
5. The number of pounds in a ream of paper cut to its basic size refers to its _____.
6. What are the two series common to metric paper sizes?
7. Paper is commonly sold in packages of 500 sheets. True or False?
8. List some of the basic styles of envelopes.
9. The two principle ingredients of ink are _____ and _____.
10. List the working qualities needed by lithographic ink.
11. Discuss methods of conserving ink.
12. What industry other than graphic arts uses the dye heat transfer inks?

SUGGESTED ACTIVITIES

1. Collect five examples of different paper classifications.
2. Take a small amount of soft tissue and place it in a pint of water. Using a hand beater (not electric) totally break up the fibers. After it becomes cloudy, dip a fine screen to the bottom and position the screen so that fibers will lay on the screen as it is brought to the top. Experiment with drying and removal techniques such as pressing. If pulp is available in your area, use that in place of the tissue. You have made a sheet of handmade paper.
3. Look at the labels on packaged paper. Do the labels have metric as well as the inch measurements? Convert the English measurement to metric.

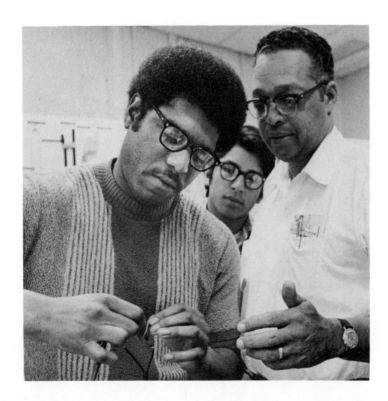

Retraining and updating of skills is an increasingly important aspect of photo-offset printing. Today, with greater industry use of computer driven typesetting, some knowledge of electronics is helpful. Tomorrow, re-education for metrics may be required.

Unit 12

SI METRIC SYSTEM

Our customary system of measurement is a hodgepodge from many countries. The English inch, for example, was based on the length of "three barley corns, round and dry." The foot was approximately the length of a person's foot.

Our measuring system is changing. SI metric is moving into our way of life in various ways. Some of our sports measurements are already in metric. A swimmer's distance is often measured in metres rather than yards. Many cars on our highways are assembled to metric specifications.

Much of our photographic film is metric as we ask for 8, 16 or 35 millimetre film. Scientists have been using the metric system for years.

While it has been used in many ways, it now appears that it will become a part of our industrial society. We need to think metric. We are in the metric era. We will need to understand it so that we will be able to talk to the rest of the world.

Because of our familiarity with another system, we now appear confused. Let us not try to convert from one system to another until we are familiar with the new terms.

BASE UNITS

SI metric measure functions around seven basic measurements called BASE UNITS. These units measure length, mass (weight), time, temperature, amount of a substance and light intensity.

The graphic communications industry will become involved with some of them:

1. The base unit for length is called the metre. It will replace the inch, foot, yard, rod and mile. A metre is slightly more than a yard. This will help you get the picture in your mind. A metric rule is shown in Fig. 12-1.

Fig. 12-1. Typical metric rule. Each number indicates a centimetre.

2. The metric unit for mass (weight) is called a kilogram. It replaces the ounce, pound and ton. If you placed a paperclip on a metric scale it would weigh about a gram which is a thousandth of a kilogram. (The prefix "kilo" means thousand.)

3. The degree Celsius measures temperature and replaces the Fahrenheit thermometer. At freezing the Celsius thermometer would register 0 deg. (0 C) while the Fahrenheit would register 32 deg. (32 F). In Celsius, film development would be done at 20 deg. (20 C) and water boils at 100 deg. (100 C). Fig. 12-2 compares Fahrenheit and Celsius thermometers.

Normally, the Kelvin is the name of the SI temperature unit. But the Celsius degree is equal to the Kelvin degree to express difference in temperature. Celsius will be used in most situations. Kelvin is used in scientific and technical circles where very high or very low temperatures are experienced.

Another unit of measure we will use is the litre. It is not an SI metric unit, but its use is permitted in the United States as the measure of metric volume. It replaces cups, pints, quarts and gallons. A litre is slightly larger than a quart. It is equal to one cubic decimetre (dm^3).

The SI metric system is really very simple. The money we use can help explain this. The metric system is based on multiples of 10. The dime is one tenth of a dollar, while a penny is one hundredth of a dollar.

Prefixes are used in the metric system to name parts or multiples of a base unit. The prefixes are used with the metre, litre and gram. It is easier than changing the name as we do now (inch, foot, yard, mile).

The prefixes are:

A kilo = 1000
A hecto = 100
A deka = 10
A deci = 0.1 (one tenth)
A centi = 0.01 (one hundredth)
A milli = 0.001 (one thousandth)

When the prefix is added to the base unit, the outcome is shown in Fig. 12-3 along with the symbol or abbreviation. Fig. 12-4 shows how the prefixes are applied to multiples and fractions of a unit.

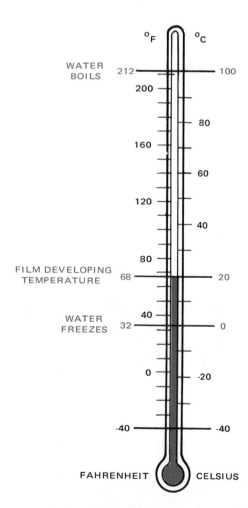

Fig. 12-2. Comparison of temperature units in both Fahrenheit and Celsius.

LENGTH	millimetre centimetre metre kilometre	SYMBOL	mm cm m km
VOLUME	millilitre litre	SYMBOL	ml L
MASS	gram kilogram	SYMBOL	g kg
TEMPERATURE	Celsius	SYMBOL	C

Fig. 12-3. Base units, when multiplied or when smaller than one unit, receive a prefix which is added to the base name.

MASS		LENGTH		VOLUME	
1 kilogram*	= 1000 grams	1 kilometre*	= 1000 metres	1 hectolitre	= 100 litres
1 hectogram	= 100 grams	1 hectometre	= 100 metres	1 dekalitre	= 10 litres
1 dekagram	= 10 grams	1 dekametre	= 10 metres	1 litre	= 1 litre
1 gram	= 1 gram	1 metre	= 1 metre*	1 decilitre	= 0.1 of a litre
1 decigram	= 0.1 of a gram	1 decimetre	= 0.1 of a metre	1 centilitre	= 0.01 of a litre
1 centigram	= 0.01 of a gram	1 centimetre	= 0.01 of a metre	1 millilitre	= 0.001 of a litre
1 milligram	= 0.001 of a gram	1 millimetre	= 0.001 of a metre		

*Most used.

Fig. 12-4. Prefixes in basic units and what they mean. Do you see how the amounts change in steps of 10? This avoids the confusion of fractions (1/2, 1/3, 1/4, 1/8, 1/12 and so on).

Think metric. Understand the system before trying metric conversion. It might be necessary for you to change from inches to centimetres or Fahrenheit to Celsius. The conversion information given in Fig. 12-5 might be very helpful.

As an example, to find the degree Celsius for developing film, take the Fahrenheit temperature of 68 F, subtract 32 and multiply by 5/9.

Other conversions are necessary in some graphic communications areas. These are to be found in books or by using a metric measurement converter such as shown in Fig. 12-6.

METRIC PAPER SIZES

Metric paper sizes include the A and B series for trimmed paper and the C series in envelope sizes. The A paper series, Fig. 12-7, follows a proportion of 5:7. It is found by extending two sides of an 841 mm square to the same length as a line drawn diagonally through the square.

Smaller sheet sizes are made by dividing the long side of the next larger sheet by two. Fig. 12-8 shows each sheet size and gives them identifying letters and numbers.

WEIGHT			
TO CHANGE:	**TO**	**MULTIPLY BY:**	**METRIC SYMBOL**
ounces	grams	28.0	g
pounds	kilograms	0.45	kg
grams	ounces	0.035	
kilograms	pounds	2.2	
LENGTH			
inches	centimetres	2.5	cm
feet	centimetres	30.0	cm
yards	metres	0.9	m
millimetres	inches	0.04	
centimetres	inches	0.4	
metres	feet	3.3	
metres	yards	1.1	
miles	kilometres	1.6	km
VOLUME			
fluid ounces	millilitres	30.0	ml
pints	litres	0.47	L
quarts	litres	0.95	L
gallons	litres	3.8	L
millilitres	fluid ounces	0.03	
litres	pints	2.1	
litres	quarts	1.06	
litres	gallons	0.26	
TEMPERATURE			
Celsius	Fahrenheit	multiply by 9/5 and add 32	
Fahrenheit	Celsius	subtract 32 and multiply by 5/9	

Fig. 12-5. An approximate conversion system.

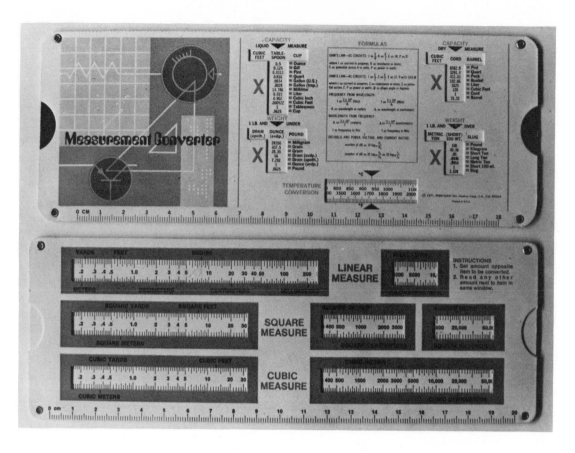

Fig. 12-6. U.S. metric measurement converter.

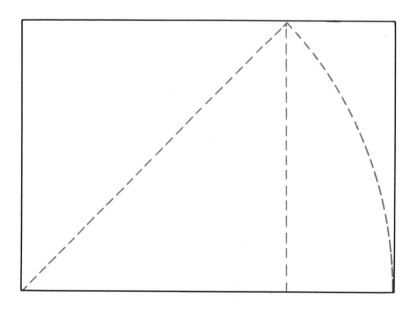

Fig. 12-7. A0 paper size has a 5:7 ratio. This means that the short side is made up of five parts while the longer side is made up of seven parts.

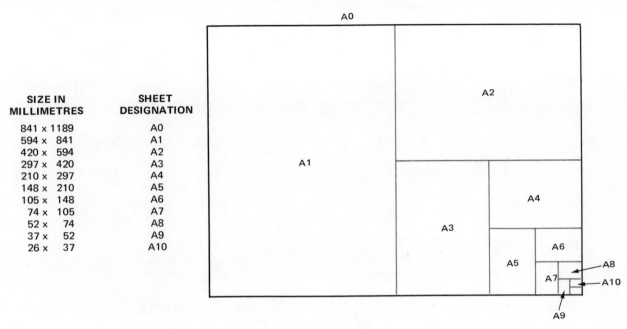

SIZE IN MILLIMETRES	SHEET DESIGNATION
841 x 1189	A0
594 x 841	A1
420 x 594	A2
297 x 420	A3
210 x 297	A4
148 x 210	A5
105 x 148	A6
74 x 105	A7
52 x 74	A8
37 x 52	A9
26 x 37	A10

Fig. 12-8. Each smaller sheet is made by dividing the larger sheet in half.

The B series sizes are in between those of the A size, Fig. 12-9. The largest, the B0 size, is 1000 by 1414 mm. The smallest, the B10 size, measures 31 by 44 mm. The B series is used for posters and wall charts.

The C series of envelopes is designed to be used with the A series of paper. Fig. 12-10 shows how certain A sizes will fit into the envelopes. The DL envelope is close to the No. 10 envelope we now use.

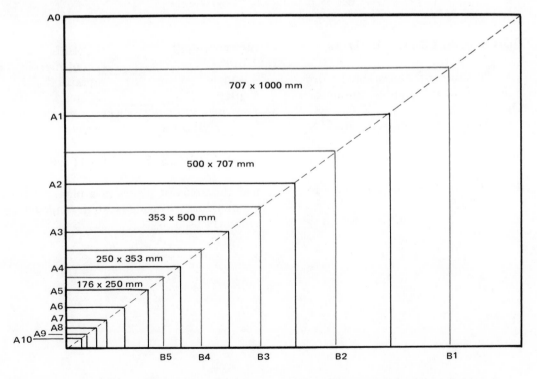

Fig. 12-9. Comparison of A and B series. B series sizes are used for posters and charts.

ENVELOPE SYMBOL	SIZE
C7	81 x 114 mm
C7/6	81 x 162
DL	110 x 220
C6	114 x 162
B6	125 x 176
B6/C4	125 x 324
C5	162 x 229
B5	176 x 250
C4	229 x 324
B4	250 x 353
C3	324 x 458

Fig. 12-10. A series paper fits into C series envelope.

TEST YOUR KNOWLEDGE — UNIT 12

1. What SI metric units of measurement are you likely to need in the graphic communications industry?
2. What are the comparable units in the U.S. system?
3. The metric measurement for temperature is the _____ _____ .
4. Convert the following U.S. measurements to the metric system.

 6 inches = _____ centimetres

 68 Fahrenheit = _____ Celsius
 1 foot = _____ centimetres
 4 ounces = _____ grams
 1 quart = _____ litres
5. The metric paper sheet sizes are in the _____ and the _____ series.

SUGGESTED ACTIVITIES

1. List the areas or places in a plant where the SI metric measuring system will be or is presently used.

DICTIONARY OF TERMS

ACROSS THE GRAIN: At right angles to the fibers of the paper.

AGITATION: Movement of the developing solution by rocking tray during the film developing process.

ALUMINUM PLATE: A type of image carrier used in photo-offset lithography.

ANTIHALATION: A coating on the back of film which does not allow light to reflect back to the emulsion.

APERTURE: Adjustable lens opening of a process camera which changes the amount of light allowed to go through the lens.

BACKING UP: Printing on the back side of a sheet once the first side has been printed.

BALANCE: Placing images on a sheet so that they appear to be equal.

BASE: The film material on which the emulsion is coated.

BASE UNITS: In SI metric measure, the seven basic measurements from which all other SI metric measurements are derived.

BASIC SIZE: The standard size for each classification of paper.

BASIC WEIGHT: The weight of a ream of basic size of paper.

BELLOWS: Part of a process camera which looks like an accordion. It keeps light from entering between the lens and film.

BIND: To fasten together material, such as pages.

BLANKET: A fabric placed around the blanket cylinder of the press. It receives the inked image from the plate cylinder.

BLANKET CYLINDER: A cylinder of the press which holds the blanket.

BLEED: Any printed material which runs off the edge of the page.

BODY TYPE: The type matter used for the main columns of a book, newspaper, magazine or other printed material.

BORDERS: Decorative material placed around type matter or display type.

BUCKRAM: Cloth used for binding books.

BURNING: Process of exposing a photo-offset plate to light. The light shines through a film and transfers image on film to the plate.

BURNISHER: Flat tool with rounded end used for rubbing and pressing type onto a mechanical.

CALIFORNIA JOB CASE: A tray with compartments to store handset type.

CAMERA BACK: Holds film in place while it is being exposed.

CAMERA COPYBOARD: Holds the copy to be photographed.

CAMERA-READY COPY: Copy ready to be placed in the copyboard of a process camera to be photographed.

CASE: Covers of a hardbound book.

CHAIN DELIVERY: Positive control of each sheet as it is placed in delivery position.

CHARACTERS: Letters, figures and punctuation marks of the alphabet.

CLEAN PROOF: Proof which contains few or no errors.

CLEANUP SHEET: Blotter type paper placed on the plate cylinder to clean up ink on a press.

COLD TYPE: All forms of composing copy without the use of hot metal.

COLOR SEPARATION: Separating artwork of colored prints or transparencies into three or four process colors.

COMBINATION PLATE: A printing plate having line negatives and halftone negatives on the same plate.

COMPOSING STICK: Tool for holding handset type while it is set and justified.

COMPOSITOR: Person who sets type.

COMPREHENSIVE: An exact layout of all elements – type, photos and illustrations.

COMPUTER: Electronic device used to assist in typesetting, estimating, inventory, designing and logical processes.

CONTACT SCREEN: A screen which breaks up a continuous tone print into a dot pattern which is capable of being reproduced on paper.

CONTINUOUS TONE COPY: A full range of tones from white to black. A black and white photograph is one example.

CONTRAST: The whitest white to the darkest black on a photograph.

COPY: Furnished material to be composed for printing.

COPYFITTING: Fitting copy into a given area so there will be neither too much nor too little.

COPY PREPARATION: Details on how copy will be positioned.

CPS: Characters per second – phototypesetting speed.

CROP: Eliminating part of the copy.

CROP MARKS: Marks placed on the image (photograph or illustration), telling the printer what portion is to be printed.

CRT: Cathode ray tube. A vacuum tube used in phototypesetting.

CYLINDERS: Drums found on the press to support the plate, blanket and the printing stock while it is being printed.

DAMPENERS: Rollers that distribute moisture to the plate.

DAMPENING SOLUTION: Solution which keeps the non-image area of the plate clean.

DANDY ROLL: A roller which places a watermark in paper while it is being made.

DARKROOM: Room generally used to handle and develop film.

DELIVERY END: Part of a press which receives the printed sheet.

DENSITOMETER: An instrument that measure densities of film.

DENSITY: A very dense area will not allow light to pass through or reflect light from it, while a light area will allow more light to pass through or reflect from its surface.

DESENSITIZE: Using a solution on a printing plate which removes a light-sensitive coating so that fountain solution and not ink will adhere to it.

DEVELOPER: A chemical solution which creates an image on a piece of film after the film is exposed to light.

DEVELOPING: Preparing the image carrier (printing plate).

DIRECT IMAGE: Placing an image directly to a master by typing, writing or similar operation.

DISPLAY TYPE: Larger type used to draw attention.

DISTRIBUTOR ROLLER: Rollers between the fountain roller and the form roller.

DOTS, HALFTONE: Small to large clear areas in a negative or positive made by contact screen.

DUCTOR ROLLER: In the offset inking system, a roller which alternately contacts the fountain roller and a distribution roller.

DUMMY: As it will appear after printing; a sample specification.

DUPLICATOR: Small printing machine.

EDITION BINDING: Hardcover book.

EM: A printers' measure which is the square of any size.

EMBOSSING: A raised image in the paper.

EMULSION: Light-sensitive coating; typical example is film.

EXPOSURE: The amount of time and the amount of light striking the light-sensitive coating of film and plates.

FEEDER: Section of press which delivers a sheet to be printed.

FELT SIDE: Top side of a sheet of paper.

FILM: Light-sensitive material which develops as a negative or positive.

FIXING: The process of making an image permanent.

FLAT: A material which supports the film negative or positive.

FONT: Metal pieces of type including the letters of the alphabet, numbers and punctuation marks.

FORM ROLLERS: Ink roller which re-inks the plate.

FOUNTAIN SOLUTION: Water-acid mixture which covers the non-image area while printing.

F-STOPS: Settings for camera lens opening.

GALLEY: Shallow tray for holding handset or machine cast type.

GATHERING: Assembling sheets or signatures in page order.

GOLDENROD: A paper used by the stripper to attach negatives.

GRAIN: Direction of fibers in paper or the surface of an image carrier (printing plate).

GRAPHIC COMMUNICATIONS: An industry concerned with communications in printed form.

GRAY SCALE: A control device used in photography which has many tones ranging from white to black.

GRIPPER: Devices on the impression cylinder which hold the sheet while it is being printed.

GRIPPER EDGE: The leading edge or first part of a sheet to go through the press.

GUIDE: A device which allows for exact positioning of the sheet before it goes through the press.

GUM: Liquid placed on the surface of the image carrier to protect it when it is not being run.

HAIRLINE: A very fine line.

HALFTONE: A photograph broken up into a variety of dot sizes which gives a graduation of tones.

HALFTONE SCREEN: A contact screen which breaks the photograph into dot patterns.

HEADBAND: Pieces of cloth which are glued across the bound edge of a book at the head and foot of the back.

HIGHLIGHT: The lightest area of a photograph.

HOT TYPE: Type made from molten metal.

HYPO: A solution used to fix the film image.

IMAGE CARRIER: Thin sheet of paper or metal on which the message to be printed is placed photographically.

IMPRESSION: Placing an image on stock, such as paper.

IMPRESSION CYLINDER: Holds and presses the sheet against the blanket cylinder of the press.

INK: The material, which comes in many colors, that adheres to the image area of the image carrier.

INK FOUNTAIN: Ink supply area on the press.

INK ROLLERS: Supply ink to the image area of the image carrier.

INSERT: Printed piece inserted into a publication.

JOG: Straightening the edges of a stack of paper.

JUSTIFICATION: Right and left edges of a column of type made even.

KEY PLATE: The plate which normally has the most detail.

LACQUER: Developer which coats the image area of some surface plates.

LATENT IMAGE: Area of a film exposed but not yet developed.

LAYOUT: The plan of any piece to be printed.

LEADING: Spacing between lines of type.

LENS: Elements which focus light rays.

LIGHT TABLE: Back lighted, frosted glass topped table.

LINE COPY: Any material to be printed that is solid, without graduation of tones.

LINE GAUGE: Printers' measuring instrument.

LITHOGRAPHY: Printing from a flat surface; based on the principle that oil and water do not readily mix.

LOWER CASE: Letters that are not capitalized.

MAGAZINE: On a line casting machine, a compartment for storing and retrieving type.

MAGENTA CONTACT SCREEN: A screen that is magenta colored; used to make halftone negatives.

MAKEUP: Assembling all of the elements for a page or pages.

MARKUP: Written instructions on the layout or on the copy.

MASKING SHEETS: Stock which will filter out ultraviolet rays to which negatives or positives are attached. Often called goldenrod.

MASKING TAPE: A light blocking tape used to attach negatives or positives to the masking sheet.

MATRIX: A mold for a piece of type.

MECHANICAL: Camera-ready copy.

METRIC SYSTEM: Measures and weights (mass) based on the metre and the kilogram.

MOLLETON: Covering on dampener rollers.

MULTICOLOR: Printing more than one color.

M WEIGHT: Weight per thousand sheets of paper.

NEGATIVE: A photographic image in reverse of the original, clear and opaque areas.

NEWSPRINT: A kind of paper commonly used for printing newspapers. Normally of high groundwood content.

OFFSET LITHOGRAPHY: Printing from a flat surface using the transfer image process; based on principle that oil and water do not readily mix.

OPAQUING: Painting out an area so that light cannot pass through.

OPTICAL: Refers to use of lens, light and light-sensitive materials.

OPTICAL CENTER: A point slightly above the mathematical center of the page.

ORTHOCHROMATIC: A light-sensitive film which is sensitive to blue, green and yellow but not red light.

OVERLAY: A flap over the original artwork sometimes used to protect it, to give instruction or carry additional art for color.

PADDING: Gluing one edge of stacked sheets together, used for making scratch pads.

PAPER: Writing or printing surface, usually made of cellulose vegetable fibers from either wood or rags.

PAPER MASTER: Paper image carrier.

PARALLEL FOLD: Second fold running same direction and alongside the first.

PASTEUP: Camera-ready copy; a mechanical.

PERCENTAGE TAPE: The reduction or enlargement scale on the process camera.

PERFORATION: Holes or slits which allow a portion of a sheet to be torn away.

pH: Scale showing alkalinity or acidity of a solution.

PHOTOCOMPOSITION: Images, such as type, are placed on light-sensitive paper or film.

PHOTOMATRIX: A piece of negative film from which a type character is printed on photographic paper.

PICA: Printers unit of measurement.

PIGMENT: The particles which give the ink color.

PLANOGRAPHY: Printing from a flat surface.

PLATEBAND: Space needed to attach the plate to the cylinder of the press.

POINT: Printers unit of measurement.

POSITIVE: Image on film or plate, which is the same as the original.

PRESENSITIZED PLATE: Printing plate which has been coated with a light-sensitive material.

PRESS: The unit which prints a printed product.

PRIMARY COLORS: Process printing ink in magenta, cyan and yellow.

PROCESS CAMERA: Graphic communications camera capable of converting line images and graduations on film.

Dictionary of Terms

PROGRAM: In computers, a set of coded instructions that is fed into the mechanism.

PROOF: A copy of the final material which is checked against the original.

PROOFREADERS' MARKS: Symbols which indicate changes in copy.

PULP: Fibers used to make paper.

PUNCHED TAPE: A perforated tape placed on a reproducer which types copy for reproduction.

REAM: Five hundred sheets of paper.

REDUCTION: To make an image smaller.

REGISTER: Accurate positioning of material so that it will all line up in proper position.

REGISTER MARKS: Symbols used to line up one image with another.

REGISTER PINS: Pins which hold plate and flat in exact position while burning plate.

REPRODUCTION PROOF (REPRO): Camera-ready proof of set type.

REVERSE: Black and white copy is switched.

REVISE PROOF: Corrected proof.

RIGHT-ANGLE FOLD: Fold at 90 deg. to one another.

ROMAN: Classification of type characters.

ROUGH: Sketch or idea of a design.

RUN: Number of copies to be printed.

SAFE LIGHT: Lights used in the darkroom which will not expose certain types of light-sensitive materials.

SANS-SERIF: A style of letter which has no short angular lines extending from the end of the strokes.

SCALING: Amount of enlargement or reduction of copy.

SCORING: Putting a crease in paper.

SCREEN: Film used to break up continuous tones into graduated dot patterns.

SERIF: Short angled lines found at end of stroke on some styles of type.

SETOFF: Unwanted transferring of ink from one surface to the back of another sheet after printing.

SHADOW: The dark area of a photograph.

SIDE STITCH: Fastening sheets together by stitching or stapling along one edge.

SIGNATURE: Large sheet of paper, containing several pages, folded down to size of single page.

STRIPPING: Positioning negatives or positives on a support sheet called goldenrod.

TINT: Color often used as a background.

TIP-IN: Pasting an inserted sheet to a printed page.

TRANSITIONAL: Style of type.

TYPE: All the characters necessary to set a job.

TYPEMASTER: Plastic type discs.

UNDERDEVELOP: Not allowing enough developing time.

UNDEREXPOSE: Not allowing enough light.

VACUUM FRAME: A frame which forces good contact of materials to glass surface.

VDT: VISUAL DISPLAY TERMINAL: Displaying type or other symbols.

VEHICLE: Oily liquid which carries the pigment of ink.

WASHUP: Cleaning the press with a solvent.

WATERMARK: Symbols on paper made by a dandy roll while paper is being made.

WAXING: Coating back of copy to make it stick to a mechanical.

WEB: Printing from a roll (web) of paper.

WITH THE GRAIN: With the direction of the fibers.

WRONG FONT: Different style of type than used in finished copy.

ACKNOWLEDGEMENTS

Thanks to the many students and individuals who assisted in various ways to complete this book. Some of the people are: Dr. Carl Bartel, George A. Bedell, Susan Berdico, Aaron Berkowitz, Robert Boley, Ann Cawley, Walt Colditz, Steve Crandall, Ed Delph, Ernest DeVries, Dale Dillon, James Donelz, Gerald Halfmann, Tim Hanst, Paul Jensen, George Jenson, Alan Kabakoff, Jo Litten, Jennifer Loan, Marta Manjeot, Joe Marling, Bill Milkofsky, Dave Redding, Bill Reutter, Kevin Ringer, Candice Stapley, Alfred T. Steeves, Andrew Stewart, Robyn Sweesy, Judy Tice, Matt Torrance, J. H. Turner, George Walker and Kent Zimmerman.

Sincere gratitude to Donna Jones, an outstanding typist, to Martha Beakley for artwork in Unit 3, and to Pat Krahenbuhl for artwork occasionally presented throughout the book.

Special thanks to colleagues in the Division of Technology, Arizona State University, and to Dr. Walter C. Brown, Professor of Technology, and Scott Williams, Assistant Professor of Technology for their encouragement and assistance.

To my wife, Mary Ann, our sons Randall and Donald, my gratitude for their assistance, patience and encouragement.

Appreciation is extended to the following companies for contributing pictorial material used in preparation of this text:

A. B. Dick Co., Chicago IL, American Paper Institute, New York NY, Accurate Steel Rule Die Manufacturers, Inc., New York NY, ACTI Products, Inc., El Monte CA, Addressograph Multigraph Corp., Mt. Prospect IL, Alphatype Corp., Skokie IL, American Color Corp., Phoenix AZ, American Type Founders, Whitensville MA, Anchor Chemical Co., Hicksville NY, Associated Lithographers, Phoenix AZ, Caprock Developments, Inc., Morris Plains NJ, Carpenter/Offutt, Los Angeles CA, Carpenter/Offutt Paper Co., Phoenix AZ, Challenge Machinery Co., Grand Haven MI, Eastman Kodak Co., Rochester NY, Foster Manufacturing Co., Philadelphia PA, F. P. Rosback Co., Benton Harbor MI, Freund Can Co., Chicago IL, Gans Ink and Supply Co., Inc., Los Angeles CA, Harris Corp., Easton PA, Heidelberg Pacific, Inc., South San Francisco CA, Hensohns/Phoenix, Inc., Phoenix AZ, Impression Makers . . . Printers, Tempe AZ, International Paper Co., Newport Beach CA, Killgore Graphics, Phoenix AZ, LogEtronics Inc., Springfield VA, Muller-Martini Corp., Hauppague NY, Olivetti Corp. of America, New York NY, O & M Machinery Div., General Binding Corp., Fort Lauderdale FL, Polychrome Corp., Yonders NY, Prestype, Inc., Carlstadt NJ, Southwest Forest Industries, Phoenix AZ, Strip Printer, Inc., Oklahoma City OK, Sun Chemical Corp., Pine Brook NJ, Tempe Daily News, Tempe AZ, 3M Company, St. Paul MN, Ulano, New York NY, United Bank, Tempe AZ, Valley Printers Supply, Phoenix AZ, Western Gear Corp., Lynwood CA.

INDEX

Index